Philip C. Brown

Winslow Homer's
Magazine Engravings

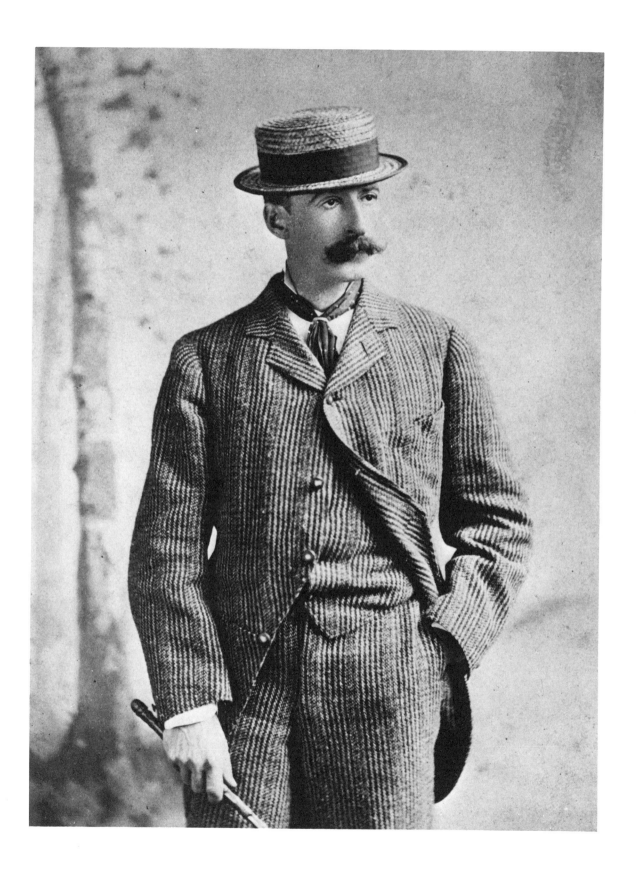

Winslow Homer's Magazine Engravings

PHILIP C. BEAM

Icon Editions

HARPER & ROW, PUBLISHERS

New York, Hagerstown, San Francisco, London

FIRST EDITION

Designer: C. Linda Dingler

Library of Congress Cataloging in Publication Data

Homer, Winslow, 1836–1910.
 Winslow Homer's magazine engravings.
 (Icon editions)
 Bibliography: p.
 Includes index.
 1. Homer, Winslow, 1836–1910. 2. Magazine illustration—United States. I. Beam, Philip C. II. Title.
NE539.H6A4 1979 769'.92'4 78–24825
ISBN 0–06–430381–0

79 80 81 82 83 10 9 8 7 6 5 4 3 2 1

Contents

Contents

Preface

If, in publishing a book on Winslow Homer At Prout's Neck before offering this study of his magazine engravings, the author seems to have approached Homer's development in reverse order, the reason is that the material about his life at Prout's, made available to me by the Homer family, was furnished in the early years of my studies. Such timing of accessibility to research materials often affects the serendipity of scholarly efforts. An engagement with the formative years and early maturity of the artist was, however, never far from my mind in trying to understand the roots of Homer's development in relation to his career as a whole. As that examination progressed it focused, of necessity, upon his work as an illustrator for the popular magazines of the day, which comprised his principal activity between 1857 and 1875 while he was slowly disciplining himself in the handling of the oil and watercolor media which came to full development in his later years. It would be injudicious to say that if Homer had never done any painting, he would still be remembered as an outstanding master. It is fair to assert, however, that the experience he gained in the graphic field as a young man made an important contribution to his realization of his full powers at the end of the century, that he was clearly the leading American designer of wood engravings of his day, and that many of the engravings are now loved and admired as masterpieces of their kind. The main body of his wood engravings is thus a subject worthy of attention in its own right. In addition, when seen together independently, they possess a coherent character and appeal of their own, and offer a valuable view of American life during the time they appeared.

In transferring the results of this special study of the magazine engravings from a private project to the public, the author wishes to thank at least a few of the many people who made this outcome possible.

Particular acknowledgement should go to Cass Canfield, Jr., and Carol E. W. Edwards of the editorial staff of Harper & Row, and to the designer C. Linda Dingler. The author is grateful, too, for the timely help of many friends and colleagues on the faculty and staff of Bowdoin College: especially Dr. Alfred H. Fuchs, the Dean of the Faculty; the

members of the Faculty Research Committee; Mrs. Mary H. Hughes, Librarian of the Special Collections; and Dr. R. Peter Mooz and Dr. Katharine J. Watson, former and present Directors of the Museum of Art, who developed the college's collection of Homer's wood engravings to its current nearly-complete state.

Encouragement and important assistance for which I am grateful was also given me by Mrs. Charles L. Homer, Mrs. Lois Homer Graham, Mrs. John Sloane, Dr. Marvin Sherwood Sadik, and the Reverend and Mrs. Frederick Peet Taft.

Finally, to say that Homer's art has attracted the serious attention of numerous scholars is to recognize that the study of his career as a whole is now properly a specialized collective enterprise; a debt is therefore owed by any one scholar to many others. I have tried to indicate something of the scope of my own obligation by the names of the authors and books included in the *Selected Bibliography*. I must proffer sincere thanks, however, to certain colleagues to whom I am especially indebted: John Wilmerding, David F. Tatham, Mrs. Katherine S. Howe, and most particularly Lloyd and Edith Goodrich for years of leadership in the field of Homer studies.

<div align="right">P.C.B.</div>

Winslow Homer's
Magazine Engravings

1

Introduction

The upsurge of interest in the work of Winslow Homer, and especially in the wood engravings which predominated his early period, may have been stimulated by the Bicentennial Year revival of American culture generally. But the renewed concern for Homer's early years also stems from a fact of longer standing. Homer had during his life two separate careers. Over the past decades, however, the emphasis on his career as the foremost marine painter of America and its greatest nineteenth-century watercolorist has overshadowed his earlier work in the major exhibitions. The recent appreciation of his engravings from the earlier years has therefore been a rediscovery, at least in attention. These engravings have always been present, but have been valued by a limited number of collectors, displayed only occasionally on the walls of museums, or been outnumbered in the major exhibitions by the more glamorous oils and watercolors. The more colorful, eccentric, and appealing years of Homer's career have long been associated with the latter.

Homer's two separate careers occurred in two entirely different places and times and according to two drastically contrasting life-styles. From 1883 until his death in 1910 Homer lived an almost hermit-like existence in the comparative isolation and desolation of Prout's Neck, Maine, a rocky and then little-settled promontory a few miles south of Portland harbor. There he lived as a bachelor in a wooden studio-home whose balcony overlooked the Atlantic. It was an ideal vantage point for a marine painter who wished to observe the sea and its perpetual conflict with the land in all moods and seasons. It allowed his interpretive eye to produce in time universal studies of the natural drama—consistent in its meaning but infinitely varied in its examples. His paintings became symbols which, though rooted in specific, identifiable formations of the cliffs, speak in such broad terms that they transcend the particularity of *Cannon Rock* (1895) or *West Point* (1900) and achieve a general importance for any viewer who loves the seas and their global significance. By 1890 Homer had so intensely concentrated on the power and impressiveness of the ocean and so often eliminated the human presence from his marines to make us remember him most vividly as one who was transfixed by the grandeur of the ocean and na-

[1]

ture, and momentarily oblivious of human activities. Such large and awe-inspiring canvases as *The Northeaster* (1895) are now held up as quintessential Homer, the pictures which set him apart from all other American artists of his day. Although he continued through every decade of his life to include human figures in his watercolors and drawings, it is for the great unpopulated oils that he is especially remembered.

Along with this sense of the sea's power, there is frequently a quality which caused George Heard Hamilton to refer to the marines as often gray, bleak, even repellent. These forbidding and formidable characteristics—chilling, intimidating, and remote—may well have inspired the conception of Homer which prevailed during the latter part of his life. It assumed that one who painted such pictures must in fact be a terrible-tempered recluse who chased visitors from his studio door with a shotgun. Whether true or not, it was a legend too colorful to reject. What Homer created out of the fervor of his imagination when he was inspired by the tempestuousness of the ocean or its perils for human life—depicted so gruesomely in his *Gulf Stream* (1899)—had no necessary carry-over into his character when he was not working.

After painting hours were over he could be as congenial with friends as any of the gentlemen who gradually turned Prout's Neck into the affluent summer resort it is today. He was not devoid of human sympathies because he painted ocean waves and barren cliffs. But the colorful reputation was irresistible to the public and has only slowly been revised. Homer himself lent it credence by living a withdrawn life during his last years, avoiding publicity, traveling only with his brother into even more secluded wilderness areas, and staying mainly within his family circle for companionship. He rarely visited exhibitions unless he was invited to serve on a jury, and usually slipped into New York quietly. When at the Century Club, he often ate alone. Goethe said that genius thrives on solitude; and Homer was, as his letters show, at peace with himself. He had so little need for publicity and acclaim that he nearly disappeared from sight during the last two decades of his life and was modestly embarrassed by the honors which came to him. When he appeared in Pittsburgh to do jury duty for his friend, John W. Beatty, director of the Carnegie Institute, Cecilia Beaux did not recognize him as the famous artist Winslow Homer, so little was his appearance known.

Homer missed, he said, the convivial evenings "with the boys," which he had enjoyed during the early, and very different, days of his career in New York City. At the end he resembled Degas, who could wander about Paris unrecognized. It was the kind of sacrifice Homer made in order to fulfill his own artistic ideas and urges. It also produced the image of the man which emerged during the last twenty-seven years of his life. Since that period is the closest to us in time, it is the hardest conception to change.

Homer has been described as a single man with two sides as drastically different as Dr. Jekyll and Mr. Hyde because his voluminous body of engravings seems to have come from an entirely different personality, time, and place than the paintings most often associated with his career. Looking at one group and then the other, one finds the contrasts be-

tween them far greater than the similarities. In order to avoid too great a contrast, it is necessary to seek out the marks of continuity and to observe all of the signs which point to one career as an anticipation and preparation for the other. If the engravings which were produced for popular magazines during his years in New York and were full of people engaged in the pleasantries of social life, and which made him a household figure, differ so greatly from the visions of the recluse master of the sea as to seem like the creations of two entirely different men, some means must be found to account for this transformation.

The turning point in Homer's life came during a brief two-year period in 1881 and 1882 with the suddenness of a revelation. It was in 1881 that Homer paid his second visit to Europe, but eschewed Paris and the continent in favor of a stay at Tynemouth, England, a combination summer resort and fishing center just east of Newcastle, on the coast of the North Sea, one of the most turbulent and dangerous bodies of water in the world for sailors and fishermen. As he studied and painted nature and human activities in that area, principally in watercolor, Homer had a new conception of life virtually thrust upon him. He often described himself as a "realist," that is, one who could see and learn with an open mind. And no one who had become as observant as he had through his long service as an illustrator could have failed to respond to the rigors imposed upon the fisher folk of the area by the character of the North Sea. There was, in fact, no way that Homer could have continued the outlook which ran through the halcyon years when he celebrated with "the boys" in his New York studio or summered among the vacationers at Gloucester, Massachusetts, or Long Branch, New Jersey, without being a blind and callous person, which he was not. In the former days he was in complete harmony with his pleasant environment. But at Tynemouth he saw the fishermen, and especially their stalwart, hard-working women, in a newly serious, sometimes grim and tragic light, and painted them accordingly. His recognition of the facts of life for those of the workaday world brought a new and sudden vision of the relation of nature and human beings. One vivid watercolor of two women waiting anxiously beside the coast guard station above a storm-wracked sea for the return of the fishing fleet was entitled, significantly, *Perils of the Sea*. In mood and content it is something that he could not have executed prior to his experience at Tynemouth. It is therefore revealing to compare the products of that visit or his later years with any design he created before 1881.

The change in attitude which came over Homer in England was sufficiently profound to render him out of tune with cosmopolitan Manhattan when he returned there at the end of 1882. Before the spring of 1883 had ended, he abandoned New York and the studio which had been his base of operations for many years and made the radical move to Prout's Neck, to an environment as different as a new continent or a new planet. Recognizing the change that came over Homer—even more dramatic than Gauguin's move from Paris to Tahiti, John Wilmerding compared Homer's gregarious, grass-roots years to the outlook of a Walt Whitman and his somber, Olympian years to the cosmic philosophy of a Melville.

Although the contrast between Homer's careers could hardly be greater—the charm and human interest of his genre scenes being almost at the opposite pole from the starkness of his marines—his life was, nevertheless, a continuum in which the early years provided an important base for the later development of his artistic sense.

It is important to remember that he began his career as a creator of graphic designs after he showed little aptitude for academic studies or an intellectual career, and that he never forgot the lessons he learned from graphic procedures. They affected the form of his art as long as he lived, most notably because of the relative coarseness of the medium, in the mastery of linear expression, broad effects and the exploitation of light and dark areas in the black-and-white medium. In his later marines, different in spirit as they were, he continued taking advantage of these features.

Throughout his life Homer's career was a cross-product of individual responses to circumstantial influences. The fact that he was born on Friend Street within a stone's throw of Boston Harbor in 1836, of a father, Charles Savage Homer, Sr., with a sea-faring family background and a mother, Henrietta Maria Benson Homer from Bucksport in down-east Maine, meant that he had a combination of salt water and cosmopolitanism in his veins at the outset. Although he followed the latter bent until he was nearly fifty, he was only one generation removed from being a native of Maine, and his ultimate settlement there was not strange, even if not preordained. Had Homer been born near Boston Harbor ninety-eight years before, as was John Singleton Copley, the opportunities allowed by his artistic milieu would have been entirely different. He would have been obliged to restrict himself to the portraiture demanded by the colonial elite. It was a limitation under which Copley bridled, despite his prodigious ability for it. Homer would have suffered even more. He did a large number of engraved portraits on commission competently, but without enthusiasm. And in the latter part of his life, when he painted according to his own bent, he avoided portraiture almost entirely. It was fortunate for Homer that his birth came after the horizons of the federal portrait school had broadened enormously as, according to Wilmerding, the American people were discovering their new nation and artists were allowed to join in the excitement and variety of that process.

When Homer was a boy of six his father moved the family to semirural Cambridge in the vicinity of Harvard College. This offered the double advantage of a greater access to nature and an opportunity for higher education to his three sons. Winslow's older brother, Charles Savage Homer, Jr., availed himself of this chance, and went on to become a distinguished and prosperous industrial chemist. But Winslow and his younger brother, Arthur Benson Homer, showed much less interest in study in the classroom than they did in freedom in the out-of-doors and the nearby countryside, a love which continued throughout their lives, whether in Boston, New York, or Maine. The father did not press the point. Arthur found a respectable place in the business world, and Winslow, who had drawn in his schoolbooks with more interest than he had read them, was not forced to study beyond his eighteenth birthday. Instead, he was enrolled as an apprentice in the

[4]

graphics shop of J.H. Bufford, an acquaintance of Mr. Homer. The son found the work tedious and developed a lifelong yearning for freedom, but he learned his craft. As Charles Childs and Wilmerding have pointed out, he may also have come, without knowing it, under the beneficial influence of Fitz Hugh Lane, a Gloucester-born artist who practiced lithography in Boston until 1848 and then set a precedent of outstanding marine paintings.

It was common at that time for a young man of artistic rather than academic talent to be largely self-taught or schooled through the apprentice system and especially in the graphic media employed in studios which were professional but commercially oriented. They served a practical function by catering to the needs of music publishers, advertising firms, and the popular magazines of the day. Business-like workshops, rather than Left-Bank Bohemian ateliers, they instilled discipline and met schedules. Homer drew from them his habit of subordinating temperament to productivity. Even when he gained his liberty and became permanently a free-lance artist at the end of his apprenticeship, at age twenty-one, he was able to accept editorial requirements and deadlines as a normal part of a productive artistic life for nearly twenty years.

If Homer had wished to go immediately into painting and the higher levels of the fine arts, he would have met with difficulties peculiar to the time just before the Civil War. Few art schools were available—the National Academy of Design in New York and the Pennsylvania Academy of the Fine Arts in Philadelphia being exceptional, and more receptive to young men with loftier ideas than Homer's at that time. Ease of travel provided by the railroad and the ocean-going steamship became common only after the Civil War, revolutionizing America's artistic relationship to Europe through a flood of travelers and students. It was then that the French capital under Louis Napoleon first became Gay Paree. But this was not the time of Homer's boyhood, youth, and early manhood. The essentially American quality of pre–Civil War life which De Tocqueville found so distinctive was an outgrowth of the times and its restrictions. The predominately agrarian environment, combined with the Jacksonian Revolution in favor of "the common man" and the excitement and optimism generated by new frontiers created in the second quarter of the century—the quarter of Homer's formative years—an outstanding school of genre painters (or scenes of everyday life), exemplified so admirably by William Sidney Mount, George Caleb Bingham, and Richard Caton Woodville. There appeared as well a school of landscape, known as the early and later phases of the Hudson River School, with Thomas Doughty, Thomas Cole, and Asher B. Durand in the vanguard. They were followed by John Frederick Kensett, Sanford Robinson Gifford, and others who added a new interest in light and are now known as the Luminists—prophets and precursors of Homer's own paintings, *Early Morning After a Storm at Sea* (1902) and *Sunset, Saco Bay* (1896).

Equally important, and more ambitious, were Albert Bierstadt and Frederick Church, whose wide travels and enlarged enthusiasms created a more global and heroic

landscape. The efforts of these men transformed American art during the nineteenth century, bringing it of age in response to the needs and interests of a new and expanding country. Taking advantage of these opportunities for different areas of study were the artist-explorers in the persons of John James Audubon and George Catlin, who were of the era of expansion, and not of the later era of international prosperity and gentility exemplified by William Merritt Chase, John Singer Sargent, James McNeill Whistler, and Mary Cassatt, internationalists who were as European as they were American. Homer's growing up years fell in between the two groups, when European realism was to the fore and appealed to America's practical streak.

Thus Winslow Homer had in mid-nineteenth century America a much wider choice of paths to follow than the young Copley had in eighteenth century colonial Boston. In the course of time he availed himself of them and became, in turn, a popular master of the genre scene, a widely traveled artist-explorer, and a famous painter of heroic landscapes.

Homer's career was also shaped by the fact that it unfolded over time and could not ignore changing conditions. His boyhood and youth were spent in the half-urban, half-rural environments of pre–Civil War Boston and New York. His early maturity was conditioned by the atmosphere of the war years and post–Civil War America and the New England area in particular. The trauma of the Reconstruction period in the South affected him little. One of the happiest periods of his life was that spent in rural Cambridge; and though he adapted himself to the post–Civil War years with the resilience of youth, he continued for a long time to apply the pleasant and peaceful outlook of William Sidney Mount's rural and agrarian America to the new costumes and customs of the seventies, as both Goodrich and Wilmerding have pointedly observed. It was the prolongation of that simpler view of life in the face of increasing sophistication, gentility, and prosperity which endowed Homer's engravings, watercolors, and paintings of the middle period with much of their charm. Whether viewed nostalgically or as reports of actual conditions, they have an uncommon power to please. By the same token, their lighthearted quality makes the passage to the work of his second career seem all the more different and abrupt.

The later years were passed in totally different environments: Prout's Neck and in travels to favorite, more or less isolated haunts far from the big cities—in the Adirondacks, Canada, and in the tropical regions of Cuba, Bermuda, Florida, and the Bahamas, pursuing a new and different artistic program, usually in the company of his older brother or a solitary guide. The Prout's Neck marines earned him fame and a secure place in American art. Even these developments were anticipated in many ways during the early and middle years when he was most widely known as an observer and recorder of the American scene and expressed himself primarily through the leading popular magazines and the medium of the wood engraving.

Through these outlets he made connection with lifelong features of his career. He

traveled widely and observed closely, until they became established habits, and continued both until the end of his life. He joined the genre painters and the realists of his time by drawing his subjects primarily from the contemporary and the visible world. The religious, allegorical, and visionary are so rare as to be meaningless. Called by Richardson a romantic-realist, he expressed his interpretation of the world through real objects and scenes but endowed them with overtones of feeling, powerful in his later years, gentler, even sentimental, in the earlier days. He thus reflected both of the major movements of his era: realism and romanticism.

Homer exhibited the American energy and confidence of his day, both before and after his settlement at Prout's Neck. He was, consequently, one of the most productive artists in our country's history. He also emphasized Yankee practicality and versatility, adapting himself with professional flexibility to the requirements of a wide variety of media: lithography, pen-and-ink and pencil drawing, wood engraving, oil and watercolor painting, and tile painting. Late in his career he took some lessons in etching and handled it with finesse in a venture which was an artistic, if not a financial, success. Even silhouette figures appear among his oeuvre. Thanks partly to the moral restrictions of his day—a combination of Victorian attitudes and lingering Puritanism—he had no formal schooling in the nude, and yet was able through sheer power of observation to render the superb physiques which he found among the natives of the tropics with a grasp which Lloyd Goodrich ranks second only to that of Thomas Eakins. Inasmuch as disciplined observation does not come overnight, this too was a legacy from his engraving and genre scene days.

During the nineteenth century America broadened its artistic horizons so dramatically that, within fifty years after the beginning of the century, the country was holding a mirror up to every facet of daily life and was fascinated by the pictures which were reflected there. What had formerly been the province of the fine arts was now the business and interest of everyone. The demand for a visual accounting became voracious at the time when the improved presses of the weekly journals reached a new level of productivity and a new capacity to meet the demand. The ability to know what was going on in the world as it happened became both a mania and a right of democratic government. De Tocqueville recognized this self-consciousness as one of the most noticeable features of the new American democracy.

Abundant proof of this concern with every facet of American life can be found in the color lithographs produced by Currier and Ives, usually based on paintings by a multitude of artists—George H. Durrie being a creditable example—who are now little known except by connoisseurs. The prints were everywhere, as ubiquitous as newspapers. Of only modest artistic quality, today more Americana than museum treasures, they were nevertheless signs of the times and fashioners of its imagery.

The Currier and Ives prints did not, however, cover the American scene with

greater thoroughness than Winslow Homer's wood engravings. The popular magazines of the day gave him an opportunity to excel in their own field. His achievement was to show how this could be done on a higher artistic plane.

The prevailing sentiments of the day were similarly shared by Homer and most of the artists, both limited and talented, who worked for the popular magazines. They were paralleled in spirit by the American versions of the Victorian novels and by the innumerable Rogers's groups in plaster devoted to everyday scenes which filled the houses of the time. The common denominator in either pictures or sculptural groups is the story-telling element which was dearly loved in the closing decades of romanticism. A reading of reviews of art exhibitions will show how much the subject element predominated over style and form in the views of most exhibition-goers. That it prevailed in the minds of readers of popular magazines can be assumed. Neither Winslow Homer nor any other illustrator could ignore this emphasis so long as he and his editors wished to satisfy popular taste. The values which Homer achieved through superior designs were gained in spite of the limitations of sentiment to which he had to adhere, and were probably lost on most of his audience at that time. Indeed, working within these limitations became a habit which Homer shed only slowly. His first masterpiece in oil painted after he moved to Prout's Neck, was a powerful, almost melodramatic picture theme, *The Life-Line* (1884), an easily understood account of a heroic maritime rescue. The paintings which followed—*The Fog Warning* (1885), *The Herring Net* (1885), and *Eight Bells* (1886)—continued to offer themes but in more subtle, less obvious ways. Consequently Homer lost his following as quickly as he became more profound. Whereas *The Life-Line* was purchased at once, the others were sold only slowly. He continued to lose favor as he turned away from public thoughts to the larger meanings of natural forces in his pure marines. By the end of the century there was a wide gap between the artist and his contemporaries, causing the grim story implied by the great *Gulf Stream* of 1899 to confound and confuse his best-intentioned viewers. It was also the measure of his separation from an audience of earlier days.

In that earlier period, it is important to note, Homer probably occupied in the affections of an enormous public the same position that Norman Rockwell enjoyed through *Saturday Evening Post* covers in the twentieth century. There is, of course, a major difference. While Rockwell continued to be satisfied throughout his career with his place as America's best-known and best-loved popular illustrator, Homer abandoned his leadership in that field and struck out into new and more difficult areas. The break involved a shift not only from engraving for widely read, but essentially temporary outlets and a broad cross-section of the public, but to oil and watercolor painting intended for a quite different public—that of the more limited world of art exhibitions, and the academicians, dealers, connoisseurs, critics, scholars, and collectors who patronize them.

The spiritual and emotional drives and dissatisfactions which caused Homer to cross over from the one world into the other, from popular to fine art, with the risks of failure, as well as the opportunities for growth and lasting fame, possibly even immortal-

ity, can only be guessed at, for Homer was not prone to bare his feelings in letters or speech. The only thing that can be known with certainty is that he took the step deliberately and decisively. One day early in 1883 he said to a friend, J. Alden Weir, "I'm going to leave New York for good." He did not explain. The results alone are certain.

Nevertheless, Homer had earned for himself a lasting place in the world of popular magazine illustration in the nineteenth century which is paralleled for scope, variety, and appeal by few and exceeded by none. He had his finger on the pulse of American life and his eye on the American scene in an unexcelled fashion during a vibrant and important time in our national life, the years just before and after the Civil War. The magazine engravings of Winslow Homer reveal the look and interests of America with unmatched breadth as they unfolded during the years between 1857 and 1875. Few aspects of life, either rural or urban, which engaged the American people during that particular span of years cannot be examined in Homer's engravings for their leading magazine, *Harper's Weekly*, the *Life* magazine of its day. For insights into what people felt and did on street corners, in parks, on battlefields, or in backyards, as the times moved along, there are few better sources of our visible history. Week by week they inform us of what was going on, or "the way it was."

Even if Homer had not become a major artist and had simply continued to serve the public with the sharp eye of a skillful reporter and the sure touch of a fine designer and craftsman, his magazine engravings would have been a considerable achievement. At their best they rank with his watercolors and oils for style and beauty. And Homer's techniques in his engravings became important parts of his paintings. His great wood engravings of 1873 and 1874 compare favorably with his paintings of the same subjects in strength and interest. After 1875 his energies, talents, and development went into his watercolors and oils.

2
Subjects and Themes

During the years he worked as a designer of engravings Homer expressed himself through the emotional and idea content of his pictures and the aesthetic form with which, as an artist, he endowed them, conferring properties which make them valuable still. The sense and pace of life to be found in the themes and subjects derived from a combination of the spirit of the times and Homer's personal view of his surroundings. The factors were conditioned by the days before the Civil War when Homer was himself a young man; the traumatic upheaval of the war itself, which engrossed the whole country and which neither Homer nor anyone else could ignore; and the postwar period which gave him his best chance to express his view of life. During the last period, when he was well past his apprenticeship and had the intense experience of the war behind him, he produced the largest number of magazine engravings. It might well be called the heyday of magazine engravings in wood for Homer and all other American artists.

As the chapters of this period unfolded, Homer's art changed in both spirit and subject, with his own age playing a part. In assessing the kind of man Homer was as a youth, we have only two means at our disposal; the recorded opinions of friends and relatives with whom he talked or to whom he wrote, and the evidence of his pictures.

Those who knew Homer at the end of his life described him as of medium height, lean, almost wiry, and unusually youthful in both physique and spirit. He enjoyed the good-natured company of his two equally vigorous brothers and was fond of exchanging practical jokes with them. He was both a vital and well-coordinated man to the end, able to scramble over the rocks at Prout's Neck and enjoy his favorite sport of fishing. In letters and speech he was terse and laconic, a keen observer, and in conversations more prone to listen than to expound. He was a man of action. His reading was limited to the journals and topics of his day. If he had a religious interest, it was directed more toward nature, as one eloquent letter attests, than to any formal subscription to faith. He was never seen inside the church at Prout's Neck, though his father was a leading member.

It seems that Homer preferred from his earliest days in Boston and Cambridge a

healthy, carefree outdoor life. The content of his early engravings conveys this personal view abundantly. The titles are, with few exceptions, lighthearted and youthful. It should be noted in passing that Homer was to the end of his life musical. He played the banjo, and sang for his amusement; attended performances of the Metropolitan Opera, and knew serious musicians, the members of string quartets in particular. He enjoyed, and was proficient in, outdoor sports and was graceful as well as controlled in his movements. That he skated and danced well and enthusiastically as a young man is not hard to imagine.

The themes and subjects of the engravings Homer designed for *Ballou's Pictorial* and *Harper's Weekly* during the prewar years of the late 1850s were those of an ebullient young man in his early twenties, who thoroughly enjoyed life in the city or nearby countryside. *Blind Man's Buff* [8], *Family Party Playing at Fox and Geese* [9], *Coasting out of Doors* [10], *The Match Between the Sophs and Freshmen* [11], *Class Day, at Harvard University* [17] are scenes of play rather than study. *Spring in the City* [22], *Picnicking in the Woods* [26], *The Dance After the Husking* [29], *Skating on Jamaica Pond, Near Boston* [38], *Sleighing in Haymarket Square, Boston* [39], *Cricket Players on Boston Common* [48], *A Cadet Hop at West Point* [57] were also the products of a carefree mind. Only the *Expulsion of Negroes and Abolitionists from Tremont Temple, Boston* [75] points to darker and more serious times. More usual is the rollicking quality of the *Emigrant Arrival at Constitution Wharf* [5]. A rambunctious, almost belly-laugh type of humor entered into a number of the engravings. *The Sleighing Season—The Upset* [61] and *A Snow Slide in the City* [62] contain touches of slapstick. In the latter, snow from a roof falls upon some proper and well-dressed Bostonians in Keystone comedy fashion. In *August in the Country—The Sea-Shore* [56] an impish young dandy startles the ladies with a hand-held lobster. And in *The Bathe at Newport* [25] a handsome man and a belle splash each other flirtatiously.

Homer's treatment of other subjects coincided with his age. During his Boston days he referred to the natural elements—a subject which engrossed him in his later oil paintings in *The West Wind* (1891), *The Northeaster* (1895), and *A Summer Squall* (1904)—only incidentally for their effect upon the social scene, as in *March Winds* [53] and *April Showers* [54]. Similarly, his focus upon recreational activities in and around the Hub city postponed his concern for farm life until a later date. The spirit of these early city scenes was not unlike that exuded by the young John Sloan when he first moved to New York City. In the early work of both men life was made to appear good, and the war clouds which were gathering for the Civil War and the First World War were still distant.

Two engravings stand out for qualities which predict more mature things to come. *The Boston Common* [23] is a superior work in its composition and dignified behavior, and still ranks among the best engravings Homer did in the early period. *Skating on the Ladies' Skating-Pond in the Central Park, New York* [63] is the epitome of the type of pleasant, graceful, out-of-door activity which Homer represented well and with relish just before and after he moved to Manhattan. Despite the crowded composition it is clearly or-

ganized, and conveys a new strength, possibly inspired by his reaction to the big city. It is not a coincidence that Homer used a skating scene in his first important watercolor, *Skating in the Central Park* of the same year, 1860. Skating was, then and later, one of his favorite subjects. Now in the City Art Museum at St. Louis, it was the first painting he exhibited at the National Academy (in the spring of 1860).

Seeing the Old Year [1860] *Out* [76] was prophetic. In one half a family or group of friends drinks a toast, one of the last untroubled gestures they would be able to make for several years; in the other half, people who fill a church are praying. A new sobriety and seriousness enters the titles of the engravings with the start of 1861, to remain there until the Civil War is over. The new mood begins with the engraving of *The Inaugural Procession at Washington* [77], *The Inauguration of Abraham Lincoln as President* [78], and *The Great Meeting in Union Sq., New York, to Support the Government* [79]. As the nation anxiously watched the inauguration of the new president and the moves which would spell war or peace, Homer responded appropriately. He was now working steadily for *Harper's Weekly* as a free-lance designer and would soon, when the war became irrevocable, be sent to the front during the Peninsula Campaign as an artist-correspondent.

In assessing Homer's complex and voluminous output during the war years, it is important to remember his title of artist-correspondent. He was a reporter. He did not spend an endless amount of time at the front itself, but moved around and back and forth to cover the action. His view was necessarily kaleidoscopic and piecemeal. It was also selective and personal. In view of these limitations, his coverage of the many facets of the far-flung encounter still conveys a remarkably broad picture of the Civil War as it moved, or dragged on, year after year.

If the engravings are lacking in apparent editorializing or philosophizing on the nature or horror of war, this too can be explained. Unlike Goya, who was able to reflect on the invasion of his country in his deaf-ridden and embittered old age while creating his *Disasters of War*, Homer was thrust into an extraordinarily complex fray while he was still in his twenties, without any preparation and with little formal education. He was not yet thirty when the struggle ended. That being the case, he was obliged to rely upon the realistic practice of reporting things and events as they met the eye, letting objective truth speak for itself, and trusting the viewers to reach the proper conclusions. In doing that he gave the world an abundance of visual history to consider. It is a view which is varied but balanced, recognizing the home front as well as the battlefield, the hijinks along with the violence; and, in view of the artist's age, sympathetic. Compared with any group of engravings of the Boston days, those of the Civil War years stand out in sharp contrast.

In her searching study of the Civil War, *Reveille in Washington,* the historian Margaret Leech observed the duality, contrasts, and panoramic character of the conflict, which was fought not only on the battlefield but through a vast and collective effort by the citizenry at large and the unprecedented marshaling of the North's industrial might. In this upheaval some men made fortunes while others died in the mud, revelry persisted

[13]

within the sound of the southern cannon, corruption appeared with idealism, and suffering, fun, and bravery existed simultaneously if not side by side. A passion was generated which made the American Civil War one of the bloodiest in history. Although Winslow Homes was not a trained historian and lacked the advantage of historical perspective, he perceived with his eyes at once and on-the-spot many of the same attributes of the war observed by historian Leech. Indeed, his engravings provide an excellent complement to her written analysis.

The engravings of the fighting front carry us to the battlefield and behind the lines, conveying graphically a sense of on-the-spot experience. *A Night Reconnaissance* [84], *A Bivouac Fire on the Potomac* [86], *Rebels Outside Their Works at Yorktown Reconnoitring [sic] with Dark Lanterns* [90], *The Union Cavalry and Artillery Starting in Pursuit of the Rebels up the Yorktown Turnpike* [91], the *Charge of the First Massachusetts Regiment on a Rebel Rifle Pit Near Yorktown* [92], *The Surgeon at Work at the Rear During an Engagement* [96] speak of probings and skirmishes, actions and aftermaths which characterized the early, deadly, and indecisive days of the war. Unusually vivid is the intensively observed *Sharpshooter on Picket Duty* [99]; and more violent are *A Shell in the Rebel Trenches* [101], *A Cavalry Charge* [95] and *A Bayonet Charge* [97]. The last two large engravings are among his masterpieces of the fray.

The periods of tedium and waiting, between battles or during the cold and muddy winters, which comprised much of the life of the infantry soldiers, were also observed with understanding in *Winter-Quarters in Camp—The Inside of a Hut* [102], *Thanksgiving in Camp* [100], and *Pay-Day in the Army of the Potomac* [103]. Homer did not start his career in the historical tradition set by Trumbull, Copley, and West; instead, he always showed an affinity for the genre school. His tendency was to depict a cross-section of the war as it ebbed and flowed from day to day, not its momentous battles. His realism presaged the literary realism of Stephen Crane's *Red Badge of Courage*. He was thus able to make these behind-the-lines war engravings especially credible. When, after the war was over, he was able to return freely to this vein, something of the earlier, carefree Homer reappeared in the lively *Holiday in Camp—Soldiers Playing "Foot-Ball"* [112]. Before that day arrived, however, the North used its seapower to blockade the Confederate coast while it steadily mobilized its overwhelming industrial resources. Homer alluded to the war on the ocean, too, in *The Approach of the British Pirate "Alabama"* [105], a blockade runner. It was an exceptional reference, as the war was for him mainly a land-based struggle.

Measured numerically, Homer's engravings relating to the fighting stand in a ratio of twenty to seventeen to those depicting the homefront. The latter, still however, possess a special poignance. Where the bygone military scenes appeal through action, those of anxious waiting, patient suffering, endurance, nursing and comforting address a lasting set of emotion.

Typical of the engravings which illustrate the effect of the conflict on the domestic

front are *The War—Making Havelocks for the Volunteers* [81], *Filling Cartridges at the United States Arsenal, at Watertown, Massachuestts* [83], *Great Fair Given at the City Assembly Rooms, New York* [87], *News from the War* [94], *Our Women and the War* [98], *Home from the War* [106], *"Anything for Me, If You Please?" Post-Office of the Brooklyn Fair in Aid of the Sanitary Commission* [110], and *The Great Russian Ball at the Academy of Music, November 5, 1863* [108].

The Great Russian Ball shows life on the home front raised to a feverish pitch by the stress of war. It serves as a counterpoint to *A Cavalry Charge* and *A Bayonet Charge* which raised the battle scene to the same level. If the swirling, frenzied dancing of the huge, elegantly dressed crowd seems anachronistic in view of the life-and-death struggle going on only a few miles from Washington, it was, Margaret Leech observed, one anomalous feature of a nation in turmoil. Through momentarily carefree pageantry the citizens and soldiers on leave released the tensions of war, which might otherwise have become intolerable. When asked why he told funny stories during war, President Lincoln said, "To keep from crying." This dichotomy was not lost on Winslow Homer.

Homer's sharp eye observed another of the contrasts of the day when the end of the conflict finally came. Reminders of the war and overwrought emotions persisted and are illustrated by the two principal engravings of the transitional period, *The Empty Sleeve at Newport* [113] and *Horse-Racing at Saratoga* [114], the one showing what could not be forgotten and the other illustrating through an excess of excitement a way taken to forget.

In 1866 Homer himself had a chance to put the war behind him and turn to a more normal life and career: a large world's fair was to be held in Paris the following year—one of a series in a century which loved expositions. His oil, *Prisoners at the Front* (1866), which had earned him consideration as a serious painter, was due to be exhibited there. He must have wished to see how it would fare in foreign company in the new art center of the Western world. *Harper's* agreed to pay for some of his traveling expenses in exchange for designs for engravings. For a young man of thirty recently freed from the hardships of the war, an opportunity to visit the pleasure capital of Europe under these terms could hardly be refused. Traveling to France in 1866, he remained in Paris and the surrounding countryside until the autumn of the following year.

Since Homer seldom explained his motives or actions, scholars who have conjectured about the influences of this trip on his artistic development have had to rely mainly on circumstantial evidence, and the evidence to be found in his work. Was this trip simply an event in the sequence of his life's activities, a turning point with far-reaching consequences for his art, or something in between? Conclusions have varied from scholar to scholar.

Albert Ten Eyck Gardner concluded that the sojourn in Europe was a turning point of major importance, probably the most critical in his life. Lloyd Goodrich and John Wilmerding agreed that it was less crucial than the visit to Tynemouth a few years later, which was followed immediately by Homer's permanent move to Prout's Neck. Goodrich

and Wilmerding maintain, and agree, that the European trip of 1866–67 confirmed tendencies which had appeared in Homer's work prior to that time and were, in fact, available in the international artistic air, with or without a journey abroad. Further, that it was not inconceivable that a highly original American artist could be in the vanguard of new pictorial developments without depending on European leadership.

Three sources are cited as conceivable influences: the mid-century realism of Millet and Courbet, who were established figures, the early work of Manet, Monet, Degas, and the rising Impressionists who were due to dominate the third quarter of the century, and Japanese prints, which were widely popular. Of the three groups Homer may well have borrowed some of Millet's farmland themes, as he is known to have done a number of oil studies in a similar style in the countryside, and turned frequently to farm subjects upon his return to America. Courbet's honesty and his handling of oil pigments in heavy impastos would also have appealed to him. He would have found the world of the young Impressionists congenial, for he had painted croquet scenes and musicians along the same lines as Manet, Monet, and Degas before he sailed for Paris. Manet had been, of course, a celebrated figure since the Salon des Refusées of 1863, but the other Impressionists were young and little known before 1870. Moreover, Japanese prints had been popular in America since Commodore Matthew Perry had reopened Japan to Western trade in 1853. A selection of Hiroshige's prints had been included in the official report. Homer's fondness for clear outlines, relatively flat forms, juxtapositions of light and dark areas in striking patterns, and asymmetrical compositions is evident in his work. But France had no monopoly on Japanese prints.

Another source of influence was available abroad at the time. Through their own illustrations for periodicals the English had developed a tradition which was rich in political cartooning, satire, caricature, and comments on everyday life and social customs. Hogarth and Thomas Rowlandson had raised this genre to a high level in the eighteenth century in both content and execution. These illustrations were widely available in America during Homer's boyhood, and his was a nature that would have been attracted to them and enjoyed them. He subscribed to the London *Illustrated News* until the end of his life.

The affinity of Homer's designs and the more advanced European artists arose from a similarity of point of view rather than a specific influence. It tended to confirm Homer's practices instead of creating them. There is no sudden or drastic change in Homer's outlook after he returned from Paris, nor any that can be accounted for mainly by his trip abroad.

Homer created four important engravings of his visit which tell in his own way what he saw that interested him. As a man who enjoyed pleasure and dancing, he depicted *A Parisian Ball—Dancing at the Mabille, Paris* [121], a symbol of Louis Napoleon's Gay Paree, and a similar scene, *Dancing at the Casino* [122] in which he includes portraits of himself and his tall traveling companion, Albert Kelsey. Homer was plainly able to make these engravings striking because he could easily identify himself with such activities. He

also anticipated by several decades the Parisian night life recorded by Toulouse Lautrec but without Lautrec's penetrating familiarity. For Homer the action is all surface fun, but ingratiating nevertheless.

Art-Students and Copyists in the Louvre Gallery, Paris [128] is revealing because it pertains to Homer's profession. Although the Long Gallery of the Louvre is shown, the pictures on the walls are unintelligible. The scene is a social study, dominated by human figures, and especially the pretty girls who fill the center. Through this picture and his attitude in general Homer tells us that he visited the Louvre but had little interest in the work of the old masters. Both attitude and picture are in direct contrast to Samuel Morse's philosophy or his own painting of the *Gallery of the Louvre*. If Homer accepted instruction from the European artists during his visit of 1866–67, it would have been from the modern artists, not from the older masters or the contemporary academicians.

Homer reported to *Harper's* on his return voyage in a fine engraving, *Homeward Bound* [123]. It is of particular interest for his career because of his later devotion to sea, to ships and the people who sail them. At this point in his development the relationship is reversed. There is no interest in the handling of the vessel, as there is in the great watercolor *Diamond Shoal,* of 1905. Both seamanship and the sea itself are relegated to the background. As in the *Art-Students and Copyists in the Louvre,* the emphasis is entirely social, and dwells upon the appearances and conduct of the somewhat travel-weary tourists who are returning to America.

Both the *Homeward Bound* and *Art-Students and Copyists* were designed after Homer returned to New York, the latter a number of months later. Neither interpretation—of the ocean on the one hand and the art world on the other—denotes any remarkable change in his outlook.

Homer's relation to contemporary French painting may be put best as a question: if he felt that he had learned valuable lessons from his stay, why did he never go back to Paris?

During the years following the Civil War, the American nation settled gradually into a pattern of life which was on the surface at least peaceful and prosperous. It was a mode in which Homer was confortable. The wrenching problems of slavery and internecine war were over, and it was possible to enjoy existence in a relaxed way. Because of his location and background, Homer identified himself most readily with the attitude of the prosperous middle classes on the eastern seaboard, and found bucolic farmlands available nearby. With the new leisure and gentility, people were able to spend a good deal of time in outdoor games and recreation, most agreeably at the Atlantic seaside resorts, the so-called watering places at Saratoga and the lakes and mountains of New England and the Adirondacks. With these pursuits Homer was, by temperament, in easy harmony.

Homer's acceptance of his environment enabled him to produce between the time of his return from Europe in 1867 and his departure from engraving in 1875 the largest group of magazine illustrations to come from his hand: nearly one hundred, or almost one-

half of his total output. Because he was not pulled in various directions by a Civil War, with its reportorial needs and limitations, and benefited from the freedom to capture the diversity of life within a congenial range, his work was characterized by an unusual unity of spirit and idea. This eight-year period also saw Homer at his highest level of artistry. It culminated, fittingly, in the "children's series," which is regarded as the peak of his achievement in this medium.

During this last stage of his engraving career, Homer worked for a wide variety of magazines, a number of which included short stories, serials, and novels. Homer had begun his career as an illustrator of stories before the war, notably in his designs for Ella Rodman's "Mistress of the Parsonage." This early effort was successful, despite the extremely small size of the illustrations. He was willing to continue in this vein, and imbued his work with the somber overtones of the late Victorian novel as it perpetuated the sentiments and emotions of lingering romanticism. Many postwar titles speak for themselves: *"She Turned Her Face to the Window"* [135], *"You Are Really Picturesque, My Love"* [136], *Jessie Remained Alone at the Table* [137], *"Orrin, Make Haste, I Am Perishing"* [138], *"I Cannot! It Would Be a Sin! A Fearful Sin!"* [139], *Weary and Dissatisfied with Everything* [163] almost conjure up the scenes in the stories they illustrated.

These story illustrations were done for *The Galaxy* and *Appleton's Journal*. They were popular and effective enough to admit Homer to a tradition of magazine story illustrations which was continued into the twentieth century by James Montgomery Flagg, Arthur William Brown, and others, especially for the *Saturday Evening Post*.

Homer's forte, however, was the scene in nature and daily life which he could observe directly, for his cast of mind was always more visual than literary. Thus the emphasis that *Harper's Weekly* placed upon contemporary news continued to furnish Homer with his most natural outlet and to bring out his best qualities. It is for that reason, as well as his ultimate emergence as a noted painter, that Homer's name has endured and Flagg's and Brown's reputations have not. Popular magazine story illustrations being essentially temporary, it was important for Homer to portray through *Harper's* scenes and ideas which contained a measure of lasting interest.

He continued to reside in New York and to reflect the interests of city-dwellers and city life, as in *Fire-Works on the Night of the Fourth of July* [132], *Opening Day in New York* [140], *Jurors Listening to Counsel, Supreme Court, New City Hall, New York* [150], the *Watch-Tower, Corner of Spring and Varick Streets* [209] and *New York Charities— St. Barnabas House, 304 Mulberry Street* [211]. But the old zest and fun exuded by the engravings done in Boston and New York before the war had subsided into matter-of-fact reporting. Homer sustained his spirits in another area and direction.

During the late sixties and seventies he often left the city to visit his older brother, sister-in-law, and parents in a residence they had at West Townsend, near Belmont, Massachusetts, and the employers of his brother Charles, the Valentine family, at their country home, Houghton Farm, near Mountainville, New York. Both were in rural areas.

[18]

There Homer turned often to the scenes of farm life which resemble Millet's pictures, but were rendered from Homer's own personal and American point of view. Without exception they avoid the hard side of the agricultural life and portray it as healthy and happy. There is a noticeable fondness for the activities of boys and girls who seem to play far more than they work. Mark Twain's benign view of youth, expressed in *Tom Sawyer* rather than *Huckleberry Finn*, is frequently brought to mind by the Homer engravings. There are many of these engraved scenes of rural life; typical are: *Swinging on a Birch Tree* [125], *The Bird-Catchers* [126], *Watching the Crows* [144], *The Last Load* [156], *The Dinner Horn* [174], *Chestnutting* [181], *The Last Days of Harvest* [206], and *Spring Farm Work—Grafting* [172], the last being outstanding.

Prior to his move to Prout's Neck, where his world became largely adult, an accent on carefree youth had always been prominent in Homer's work and he brought it to a climax in the mid-seventies with his "children's series." The best known of these are also masterpieces of his work in the engraving field: *Sea-Side Sketches—A Clam-Bake* [201], *Gloucester Harbor* [203], *Shipbuilding, Gloucester Harbor* [204], *Raid on a Sand-Swallow Colony—"How Many Eggs?"* [212], *Waiting for a Bite* [215], the *See-Saw—Gloucester* [216], the fine *Gathering Berries* [213], and the superlative *"Snap-the-Whip"* [202], probably the finest of all his engravings. The setting shifts in some of these from farm to seashore resort, but the ebullient spirit is the same. In these studies of youthful life Homer came full circle, as John Wilmerding observed, to reaffirm the recollections of his own pleasant boyhood. It was a world that was being challenged by the industrial age, the new wealth, and the growth of the cities, but Homer was loath to see it pass.

Akin in spirit to the scenes of youth are others which continued the interests of his own early days. Among these are several scenes of skating, a longtime love, which epitomized graceful recreation in the out-of-doors: *Cutting a Figure* [190], *Our National Winter Exercise—Skating* [119], and *"Winter"—A Skating Scene* [129], a design with strong reminders of Japanese prints, and perhaps the finest of all his skating studies.

Homer witnessed after the Civil War the first widespread liberation of women in our country's history. The women had played a major role in the total mobilization of the North in its all-out effort to achieve final victory. They were a bulwark of energy in all noncombatant areas: in munitions factories, arsenals, distribution centers, and many other supportive areas. Having done men's work, they achieved after the war a new freedom to do things which had been socially taboo. They took to the out-of-doors in great numbers. With the new leisure and affluence they engaged actively in sports and recreational pastimes across New York State and New England's vacation land, promenading or bathing at the seaside resorts from Long Branch to Gloucester, playing croquet, riding horseback, picnicking, fishing, going for buggy rides in the summer and sleigh rides in the winter, following the races at Saratoga or climbing Mount Washington in the White Mountains. The usual ladylike amenities were preserved in *Waiting for Calls on New-Year's Day* [165], but by and large young women insisted upon enjoying life in many directions.

Out of this revolution in social attitudes Homer drew a large number of subjects for engravings which are still conspicuous in his work as a whole. Typical expressions of the new mores are *Christmas Belles* [147], *The Summit of Mount Washington* [151], *On the Road to Lake George* [155], *The Picnic Excursion* [157], *The Beach at Long Branch* [158], *The Fishing Party* [159], *The Straw Ride* [167], *At the Spring: Saratoga* [168], the superb *On the Bluff at Long Branch, at the Bathing Hour* [175], and *The Bathers* [199]. The ever-present element in these pictures is the pretty girl. *The Bathers* [199] is plainly what we would call today a "cover girl" scene.

Through his engravings of handsome young women enjoying life Homer recognized the social revolution and joined another longstanding American tradition, that of paying tribute in art to attractive women. In later decades Charles Dana Gibson, James Montgomery Flagg, Harrison Fisher, and others earned national, if momentary, reputations by creating popular types within this tradition. Homer's own type favored an oval face framing large eyes, a small but pert mouth, and a short but straight nose. In the seventies he was probably better known on the national scene for his version of feminine pulchritude than for any other aspect of his art. The proprieties of the day frowned upon any blatant seductiveness. Appeal was achieved through plain good looks, good health, and good spirits.

Much of Homer's art is related to his personal life. This is true, too, of his portrayal of young women. Although a lifelong bachelor, he appreciated handsome women as evidenced in scores of pictures in all media. However, he was personally shy about approaching them in real life. This has caused some observers to feel a slightly remote, sometimes doll-like quality in his feminine figures, as though he was not fully able to realize in normal terms what he admired from afar. He took refuge and found friendly companionship in the circle of his family. There he was comfortable and at ease. It was a simple step for him to use his handsome older brother, Charles, and his beautiful wife, Martha—the Mattie of so many of Winslow's letters—as models during the years when they were a young married couple and exemplified marital bliss. A watercolor portrait of Charles painted in 1880 and photographs of his wife show plainly that they were the couple depicted in *A Quiet Day in the Woods* [177], *"All in the Gay and Golden Weather"* [152], and numerous other engravings and paintings.

The discrepancy between Homer's large gallery of beautiful girls and his own bachelorhood gave rise to much conjecture about unrequited love and disappointments which drove him to solitary retirement at Prout's Neck. That move was prompted by a change in his artistic philosophy which came immediately after his stay at Tynemouth, England. There is, of course, a plaintive note in the engraving *On the Beach—Two Are Company, Three Are None* [195] which might have spoken for a moment of loneliness on Homer's part. But these expressions of longing are few in his predominately healthy art. Mrs. Charles Homer herself tried to provide a credible love life for her brother-in-law. But Charles Lowell Homer, the artist's nephew, offered the only opinion which can be ac-

cepted as fact: "My uncle probably had his share of romances, but he never talked about then."

The similarity of Homer's work to tendencies which were appearing in European impressionism in the seventies tempts one to describe him as an "American Impressionist." The likeness is apt only up to a point, and should be qualified. Despite a growing interest in effects of the transitory world of light, shadow, color, and atmosphere—effects which he realized brilliantly in oil and watercolor in his later work—Homer was never willing to sacrifice the world of substantial forms and masses, either in engraving or painting, so completely as Monet was at the end of the century. In the last oil he painted, the great *Driftwood* of 1909, the rocks are still as massive as the waves are mobile. It was a balance of sky and terra firma which he never entirely lost, nor was he so engrossed in optical problems as Monet or Seurat.

The most prominent similarity between Homer's impressionism and the French variety lies in an outlook which favored the pleasant aspects of contemporary middle-class life—its recreations, sports, picnics, and other diversions in a park-like setting, all enjoyed by young, attractive men and women. If the young Homer resembled Renoir, it was because of a similar attitude, not because of direct influence from abroad.

Like Renoir, Homer eschewed the Industrial Revolution, although from the end of the Civil War until after the turn of the century the railroads altered the face of New England and the country as a whole as drastically as the airplane has changed our own time. It linked the mill towns with their markets and made their burgeoning existence possible. It also made possible the development of New England's resorts at seashore, lake, and mountain centers.

Homer was aware of the new benefits, and accepted them to visit repeatedly pleasure centers, or watering places as they were then called, cities, and far-off places. He adopted them, however, as mere conveniences. If one judges by the evidence of his work, the railroad hardly existed. By preference he clung to the more picturesque and graceful conveyances of the past. Sleighs, buggies, and carriages abound as carry-overs from an earlier way of life. Only one train appears in the entirety of his engraved output, and none in his later paintings and drawings. Called *Danger Ahead* [176], it resembles an illustration for an adventure novel. Hardly a profound expression of the new age, it is of only fair interest in design or technique. Through these omissions Homer tells us plainly what he accepted but plainly did not like in his changing times. By choice he comes down strongly on the side of the beneficiaries of the new travel, the tourist centers and the travelers thereto, rather than the means which made the new leisure possible.

Having been born into a middle-class family, Homer adhered to the conservative attitudes of the middle classes throughout his life. On the evidence of his pictures drawn during the years when he filled them with people, his orientation was seldom toward the socially disadvantaged. He was not socially conscious even though millions of immigrants were pouring through Ellis Island into the United States, creating a revolution in the

character of our larger cities and transforming the country. Although this was especially true of the cities where Homer resided, Boston and New York, his references to conditions of misery, as shown in *Station-House Lodgers* [208], or *The Chinese in New York* [210] were exceptions and probably done at the behest of his publishers. It is to his credit that he illustrated these scenes well when he did portray them, employing the detachment of the realists and avoiding either sentimentality or overdramatization.

One of the major influences on life during the nineteenth century was the rapid growth of industry and manufacturing, with its prosperity and restructuring of society. Its effect was no less drastic than the revolution in travel. Although Homer could not escape it, he reacted in a personal way. During the years he lived at Prout's Neck, large mills arose at Saco and Biddeford, Sanford, Portland, and other nearby cities. By traveling only a few miles to the coast, Homer could turn his back on these environments and exclude all references to the mills and manufacturing from his oils and watercolors. If, as Wilmerding believes, Homer changed his outlook from that of a Whitman to a Melville, he also managed to retain his preference for the pastoral spirit of a bygone era until the end of his life.

His engravings which reflected the Industrial Revolution were so few as to be remarkable. Outstanding among them are *The Morning Bell* [207] and *New England Factory Life—"Bell Time"* [133]. Except for one weary elderly woman in the foreground, the engraving portrays the tiny New England country mills of the day which preserved some rural, if not idyllic, quality. The *New England Factory Life* is his one concession to the dreary effect produced by mass production upon masses of workers in massive factories. According to the text it was "sketched at Lawrence, Massachusetts," near Homer's brother's country home. In atmosphere it resembled the somber facts of life depicted in the European realism of Millet's *Man with the Hoe* or Courbet's *Stone-Breakers*. When Homer recognized the world of industry he preferred a conception of a farmwork which was much less laborious than Millet's and pleasant in its connotations. The handsome, healthy young farmers who bring in *The Last Load* [156] in Homer's engraving live in a different and more benign world than Millet's *Gleaners*. Even more favored, from Homer's point of view, were those participants in industry who practiced the skills of the old crafts in building sailing ships rather than those of the new steamboat era, a preference shown clearly in his engraving of *Shipbuilding, Gloucester Harbor* [204]. Homer retained this love of the sailboat days to the end of his life, treating it in his last watercolor, *The Wrecked Schooner* (1908), albeit the picture pertained to a huge sailboat which, built to compete with the new iron cargo ships, was tragically destroyed in a storm. Homer must have seen all around him in the closing years of his life the inevitable trend from one way of living to a more hurried, modern existence, but he never left any doubt as to which he preferred.

As a middle-class product of Victorian New England, Homer differed markedly from Renoir and the French Impressionists in that his own joie de vivre did not extend to representations of the female nude. If he was constrained by his Puritan inheritance he

appears to have been comfortable within it. In later years Homer proved that he could paint the nude expertly, but his figures were always male and always in genre settings.

Near the end of his activity as an engraver Homer began to anticipate a number of subjects which would be prominent in his second career and to construct a bridge from one period to the other. In 1870 he visited Baker's Farm in the Adirondacks, later the site of the North Woods Club. This experience was to prove significant as he turned from a plethora of boys and girls and fashionable young men and women to a way of life in the wilderness. The titles carry their own imports: *Trapping in the Adirondacks* [182] appeared soon after his first visit to Baker's Farm, to be followed by *Camping Out in the Adirondack Mountains* [218], *Deer-Stalking in the Adirondacks* [188] and *Lumbering in Winter* [189]. These engravings presaged scores of similar watercolors which filled exhibitions during ensuing years. He also began to give thought to subjects dealing with the sea. In time these two new directions reoriented his career.

Few in number, but also prophetic, were *Winter at Sea—Taking in Sail off the Coast* [149]; *The Cold Embrace—"He Sees the Rigid Features, The Marble Arms, The Hands Crossed on the Cold Bosom"* [115]; *At Sea—Signalling a Passing Steamer* [192]; and *The Wreck of the Atlantic—Cast Up by the Sea* [197], a singular picture in that it is the only one Homer ever based upon another man's design, Daniel Huntington's engraving for Longfellow's *Wreck of the Hesperus*. Although these subjects were outnumbered by the more typical social scenes, they portended a recognition of the ocean as a source of hard and dangerous toil and even death. They provided a beginning for the step-by-step process by which Homer brought the ocean from an incidental background for vacationers and bathers to the fore-front of his great marines.

Over the years Homer often painted the same subjects in watercolor and oil that he depicted in his engravings. When the results were especially satisfactory he based engravings directly upon them. Some of his best known pictures in both media—*High Tide* [178], *Low Tide* [179], *The Noon Recess* [198], *The Nooning* [200], *Gathering Berries* [213], and *"Snap-the-Whip"* [202] illustrate this reciprocal relationship.

Homer surely abandoned engraving for a number of different reasons, not least among them being the technical changes which were impinging upon the medium in the seventies—photogravure, photography, etc. But a plausible reason for his desertion must have arisen from the fact that, as he turned his attention gradually to new areas of subject matter, he also found that he could achieve effects in oil and watercolor which were beyond the reach of his finest engravings. This was especially true of his development of skill in the handling of watercolor which occurred rapidly in the seventies. A comparison of his engraved *Gathering Berries* [213], outstanding though it is, with the watercolor prototype of the same subject, almost explains why Homer wished to leave engraving for other areas of expression and technique.

3

Compositions, Designs, and Aesthetic Content

The description most often applied to Winslow Homer is realist. It was a definition he encouraged, saying in response to John W. Beatty that he painted things exactly as he saw them. In letters he invited a reputation for exactitude by stressing, for example, that he had painted a sunset to capture a specific moment in time, not a minute sooner or later.

Homer's realism was in harmony with the prevailing conception of art in the nineteenth century, as exemplified by its artists, the advent of photography, and the theories and teachings of Thomas Eakins and his master, Léon Gérôme. In addition, the American people were strongly inclined toward a materialistic and practical view of life and fascinated with images of themselves and their activities. These attitudes combined to exalt the representational side of art until it occupied the ruling position in creativity, criticism, and public esteem.

In the twentieth century, starting with the post-impressionists, the pendulum has swung to the opposite extreme, placing structure, design, and even total nonobjectivity as most important. The brilliant *trompe l'oeil* painting of William Harnett is, therefore, seen in a different light now from the time of its introduction at the end of the nineteenth century. The representational miracle is still admired, but arrangement and composition are cited as equally important, and possibly paramount, qualities.

Thus it is now a disservice to Homer to overemphasize his realism and accept his justifying opinions at face value. If Homer was indeed an outstanding artist, much of what he did to show taste, judgment, and organizing power was intuitive, making him a master in spite of his spoken views. It is therefore well, when we turn to the aesthetic content of Homer's engravings, and observe the role of technique in the expression of his inspiration, to be reminded of the ancient Ovidian principle that the greatest kind of art is often the "art that conceals its art"—even from its creator. If, through his engravings, Homer addressed himself to his viewers by the subjects he portrayed and the sentiments they aroused, he also expressed his aesthetic sense through the way he organized his designs and handled his medium.

[25]

Engraving is at its best when its intrinsically linear quality is preserved and exploited. Homer was gifted enough to encompass the full range of engraving techniques. His early works are highly linear; his later engravings often tonal. This spectrum is illustrated by the designs he did for *Ballou's* and *Harper's* before the Civil War, simple and bold in their linearity, and the final engravings of *Gathering Berries* [213] and *"Snap-the-Whip"* [202] which were based on a watercolor and an oil painting.

Homer had to be sensitive to his medium to extract the optimum effects from it. Fortunately, he possessed throughout his life a natural talent for linear expression, whether used to convey elemental movement in *March Winds* [53] and *April Showers* [54] or outline the graceful silhouettes of skaters or dancers or young women promenading on a windswept bluff. It is these properties which invite comparisons with such Japanese prints as Hiroshige's *Porters in a Rainstorm*. Examples of linear control abound in the engravings, even in the curvilinear configurations of a billowing skirt or trees in a rural setting, making them a source of spiritual and aesthetic pleasure. A delightful instance is *Gathering Evergreens* [34].

Another opportunity open to the wood engraver lay in the composing of figures and forms within the picture space. Here, too, Homer exhibited a natural gift. His ability to group waves and masses of rocks in simple but powerful compositions was anticipated at an early date. A fine example of a direct manipulation of human and natural forms in both lateral and receding space is *The Boston Common* [23]. He was especially skillful in relating figures and groups by harmonies and balances of attitude, playing sloping, diagonal lines against each other. In his skating scenes the repetitious echoing of rhythmic figures is especially effective. The emphasis on diagonal lines became a hallmark of his later marines, when the axes seemed to arise naturally from the forty-five-degree slopes of the cliffs at Prout's Neck, but this preference was latent in Homer's work from the outset, as can be plainly seen in *Skating on the Ladies' Skating-Pond in the Central Park, New York* [63] of 1860.

Like the Japanese, Homer preferred clearly defined, pattern-like pictures and asymmetrically balanced compositions. The one clarified the image for the eye, the other gave it vitality. The results were both simple and striking, and in accord with the informal character of his everyday scenes. These were attributes of Homer's earliest designs, not stylistic methods he borrowed from the Japanese at a later time.

In later years Homer became noted for his ability to reduce a given scene to its essentials, a talent used to great effect in *The Northeaster* (1895). He had, however, begun this selective organizing process in his earliest years, as in his *View in South Market Street, Boston* [4] of 1857.

In filling an area in a visual composition an artist uses both forms and voids, as a composer relates sound and silence in music. The great Chinese Sung landscapes induce a sense of infinite, cosmic depth through subtle gradations of ink washes on paper or silk.

This is tonal art at its subtlest. Wood engraving, a coarser medium, requires a different handling of space when refinement is the objective.

Homer achieved that refinement by filling otherwise empty areas in a plausible and pictorially orderly way. In *A Cadet Hop at West Point* [57] he relieves the emptiness of a part of the dance floor by dropping a lady's glove in the center, giving interest to an ordinary area as well as a symbolic touch. The engravings are replete with similar instances of sensitivity in the handling of space.

Near the end of his engraving career Homer achieved a shadowy effect of great richness in *A Country Store—Getting Weighed* [191], but through most of his years of work in this medium, he gained his finest effects by combining his feeling for line with his talent as a composer. If one judges by the pictures most often cited as his finest work, he was at his best when he struck this balance, that is, when he avoided the extremes of bald linearity and excessive tonality, and left for his later years as a painter the full exploitation of the world of color and tone.

4
Processes and Techniques

The fact that Homer began his artistic career as an apprentice and a graphic artist conditioned his outlook for the rest of his life. The first caused him to place a high premium on independence, even when he worked on free-lance assignments for various magazine editors. Although it is impossible to differentiate today between the signs of Homer's wishes and the editor's preferences in the area of subject content, there was nothing in this relationship which prevented Homer from exercising his aesthetic skill. In later life he asserted that as a professional he would "paint anything for money," an assertion clearly refuted by results. His artistry and taste were intuitive attributes which transcended money.

Homer's schooling in engraving had a profound and positive effect upon his artistic style long after he ceased to be a popular illustrator. Most noticeably, the graphic arts taught him how to work within the limits of the black and white media and how to exploit the world of blacks, whites, and grays for the fullest effect. He retained this ability when he shifted mainly to oil and watercolor painting, playing off pattern-like areas of lights and darks adroitly. The Japanese may have taught him more subtle ways of refining this method of picture-making, but it was instilled in Homer from his earliest days in Buford's lithography shop. Consequently, more than one observer has pointed out that Homer's paintings retain their character to a high degree when reproduced in black and white, and suffer from loss of effect far less than those of such Impressionists as Monet, who thought progressively more in coloristic and atmospheric terms and less and less in three-dimensional forms and clear-cut outlines and areas. Whereas the Impressionists tended to dissolve their forms in envelopes of colored light and atmosphere, Homer kept his respect for a balance between the solid and transitory worlds in *Driftwood, Diamond Shoal,* and *The Wrecked Schooner,* the last oil and watercolors he produced.

Meanwhile, he demonstrated in later years through numerous watercolors and oils that his predilection for black and white was not a passing phase: *Three Men in a Canoe; Fishermen, Lake St. John, Canada; Two Men in a Canoe; Wolfe's Cove; Trout Fishing, Lake St. John;* and *The Fountains at Night, The World's Columbian Exposition, Chicago,*

1893 are not only instances of monochromatic painting but outstanding pictures. It is not strange that Homer was able to master etching in later life in a remarkably short time.

Even after Homer added color to his pictorial arsenal, he continued to apply a principle which is equally relevant to neutrals and tones. His guide was a book by Chevreul, a French student of color organization from a scientific point of view, which Downes says Homer read until it was "dogeared." The central principle of Chevreul's theory was that the manipulation of visual effects lay in controlling color contrasts. Homer learned this thesis so well that a high percentage of his oils and watercolors can be appreciated for the contrasts which give them their striking appearance. Though we take contrasts for granted in the engravings, the principle is no less applicable.

The magazine texts frequently contained statements on the process by which engravings were created: "the accompanying engraving is from a drawing made expressly for us by Mr. Homer" or "from the pencil of" This information is helpful in corroborating authorship when the block was not signed.

So far as can be ascertained, the designer drew directly on the surface of the block, which had been polished and whitened for the purpose and resembled a sheet of paper on which a pencil drawing was made in the normal way. This facilitated the method and contributed to the high productivity demanded by the mass media. The surface of the block was usually of Turkish or South American boxwood or American maple, in that order of preference, with the first being the rarest and most expensive and the last the cheapest and most plentiful. These hard, fine-grained surfaces were sufficiently durable to permit tens of thousands of printings, and this durability was crucial for the publication of the magazines with nationwide readerships which arose in the second half of the nineteenth century, the period of Homer's activity. It was also possible at this time to transfer a wood engraving to a metal plate which made the printing of illustrations faster, easier, and less expensive.

The appearance of the drawing in its initial stages probably resembled the unusual and revealing *The "Cold Term," Boston—Scene, Corner of Milk and Washington Streets* [16]. In it the outlines are fully drawn, but shadows and modeling are only implied. This limited indication may well have been sufficient for the engraver in many instances, once he became familiar with the designer's style and wishes. Both, in fact, were working within a common idiom, permitting the engraver to create an acceptable effect more easily if he were allowed some freedom in the final cross-hatching than if he had to follow an exact pattern of lines.

The major contribution of the designer was thus confined to the outline drawing and the compositional layout and groupings. These two factors are, however, at the heart of great drawing. The inimitable Ingres, who distrusted the sensuous appeal of color and texture, asserted that "drawing is the probity of art." If one judges by his own work, he intended that statement to mean a high degree of reliance on outlines.

The nineteenth century wood engraving differed from the contemporary lithogra-

phic drawing on stone in an important way. Though both were used for the magazines of the day, in the lithograph the designer drew directly on a smooth white stone. He could therefore see, control, and anticipate the final effect, which resembled a shaded crayon drawing. Only one chemical process intervened between his work and the stone which was ready for printing. No engraver was present or needed. After printing, the stone could be preserved as an artistic memento or ground smooth and reused, the latter being more usual.

In wood engraving, the engraver intervened, making a qualitative contribution to the final effect. In preparing the block for printing, the engraver cut away all of the white surfaces, leaving a linear design which consisted of a series of ridges. The method was referred to as engraving in relief, as distinct from intaglio, or the employment of grooves, as in copper engraving. All of the white areas of the block were cut away by a gouge or graver, destroying the designer's work for the sake of a printable image. Once the image was reproduced, there was apparently no incentive to preserve the design itself. On the other hand, the block could be planed smooth and reused. This was probably done in the majority of instances. It seems more than a coincidence that many of Homer's engravings are the same size to the fraction of an inch—certainly more a practical advantage than an artistic requirement. This suggests that the blocks were indeed used more than once. In any case, the blocks are now either rare or nonexistent. I have never seen one, nor met anyone who has. A probable explanation is that the wood engravings which appeared in the magazine were considered ephemeral in their day, and the blocks of even less importance. There is a historical parallel in the Japanese wood block prints. Though esteemed today, even of classic stature, they too were regarded as of little worth when they first appeared.

5
Professional Aspects

As long as he worked as a designer of wood engravings, Homer had to relate his efforts to the nature of the process, its economic elements, and the audience of magazine readers. The illustrations of his day were the result of the three-sided teamwork of the designer, the engraver, and the publisher. The designer created the image, the engraver executed it in wood block form, and the publisher printed it and distributed it to the public. The materials used were cheap, the blocks inexpensive but durable enough for large editions of a mass medium addressed to a vast audience and replaced week after week.

Although the engraver was viewed as a craftsman rather than a creative artist, it was recognized that some technicians who were more skillful than others had a beneficial effect on the character and quality of the published product. Homer's finest engravings, notably those of the seventies, benefited from the superior skill of a Lagarde or a Langridge, as some of his earlier work had suffered from inferior execution. The engraving of *Presidents Buchanan and Lincoln Entering the Senate Chamber Before the Inauguration* was so crudely executed that some scholars doubt its authenticity.

The designer was dependent upon the publisher for commissions and an outlet to the public, and upon the engraver for the execution of his ideas in printable form. These relationships distinguished Homer's first career from his second. In the latter he had to rely on dealers and collectors for the sale and purchase of his paintings, but he gained complete control over their final form by executing them directly on paper or canvas. The mediation of the engravers during the earlier years created a greater diversity of style among the engravings than among the paintings. It is in the nature of wood engraving that the artist sacrifices a measure of control in order to reach a far-flung audience.

During his years as a woodcut designer Homer or his publishers employed at least twenty different engravers. How many more hands contributed anonymously cannot be known today. That is, only twenty engravers were permitted to sign their names on the blocks. They were, in chronological order: Charles F. Damoreau (1857, 1859), Fred E. Fox (1857), George H. Hayes (1859), Edmund H. Tarbell (1859), William J. Peirce

(1858), John Andrew (1867), John Andrew and Son, George T. Andrew (1867), Edward Sears (1868), John Parker Davis (1865, 1868), John Karst (1865, 1869), John Filmer (1869), Nathaniel Orr Co. (1869), Kingdon (1870), G. A. Avery (1871), W. H. Morse (1871), W. J. Linton (1871), William H. Redding (1873), W. H. Lagarde (1873, 1874), R. S. Morse (1874) and James L. Langridge (1874).

Statistics cannot measure quality, but they do denote status and recognition. Among the twenty known engravers, there is a total of only forty-seven signatures in a checklist of two hundred and twenty titles. One hundred and seventy-three of the craftsmen who labored on the blocks were obliged to do so anonymously. The presence of a signature suggests special credit. Recognition, however, could be short-lived, as nine of the signators were not invited to sign blocks a second time, and three-quarters of the engravers signed no more than twice. The elite, or favored few, were only four in number. Damoreau's name appears ten times, J. P. Davis's four, J. Karst's five, and LaGarde's five times. The first-named, Damoreau, is associated with Homer's earliest efforts for *Ballou's Pictorial* in Boston in the late fifties. He had learned engraving in his native France, and may well have been Homer's instructor in the rudiments of the art.

LaGarde's name is connected with the great "children's series" of the seventies and the masterpiece, *"Snap-the-Whip"* [202], which marked the climax of Homer's career as a designer in this field. LaGarde was certainly one of the master engravers of his day.

The acknowledgment accorded most of the engravers was meager and their financial rewards probably poor. Despite the important difference their contributions could make, they were craftsmen; the designer was the artist. Mary Bartlett Cowdrey referred to them as the unsung laborers in the field, and expressed the hope that study might someday resurrect them from obscurity, if enough information can be found to make that possible.

Whereas only forty-seven signatures of engravers appear among the titles in the checklist, Homer's authorship is given credit, by signature, inclusion in the title or references in the text, in no fewer than one hundred and eighty-seven engravings. That is, in eighty-five percent of the subjects. The name of the engraver never appeared with the title, nor was it mentioned in the text. The chances for enduring fame favored the artist by a ratio of three to one.

By the 1870s Homer was probably the best known designer of engravings in America. There was a time in his early days, however, when he was almost undistinguishable from a considerable group of talented artists. The names of the others are now generally forgotten. But in the 1860s W. J. Hennessey, Jasper Green, and A. R. Waud—to name only a few—worked in a common graphic mode determined to some extent by the medium and the engravers. Their work was so like Homer's that scholars still have difficulty in differentiating it with certainty. Some examples are *The Union Meeting in the Open Air Outside the Academy of Music* which Foster attributed to W. Hennessey and Goodrich to W. Homer; the *Army of the Potomac—Sleeping on Their Arms,* recognized by Gelman as Homer's but assigned by Foster and Goodrich to A. R. Waud, and *Our*

Army Before Yorktown [89]. The publisher gives credit for the seven panels jointly to Homer and Waud, but makes no distinction between them. Foster concluded that it is "impossible to determine" one hand from the other.

If that is true today, one may assume that the publishers did not regard an exact assignment of credit as a matter of great importance, so long as their purpose was served. *Harper's* foremost need while the Civil War raged was for as many artists to illustrate the flood of news as *Life* magazine required of photographers during World War II. No one artist could meet the demand, and the corps of artists-correspondents must have seemed much alike at the time.

Viewing Homer in retrospect, we recognize that it was only later that he emerged from the crowd with a distinctive style. The signs of this emergence can be traced indirectly by the supporting evidence, as well as the style. It is a story of slow but steady recognition.

Some small signs of credit came early in his career. His first illustration in *Ballou's Pictorial, Corner of Winter, Washington and Summer Streets, Boston* [1], of June 13, 1857, carried his initials W. H. By October of the same year he was allowed to sign his name: Homer. In his first illustration for *Harper's Weekly, The Match Between the Sophs and Freshmen* [11], vol. I. August 1, 1857, he was permitted to identify himself further by signing the block: W. Homer. In subsequent engravings he used WH, Homer Del., or simply Homer. In his early engravings he shared double-billing with his friend and informal instructor in engraving: Homer–Damoreau Sc. At that moment Damoreau's name was probably better known in Boston than that of the twenty-one-year-old Homer.

By 1862 Homer's importance was given more consideration by the inclusion of his name as an integral part of the title, as in *Rebels Outside Their Works at Yorktown Reconnoitring (sic) with Dark Lanterns—Sketched by Mr. Homer* [90]. This practice was continued by *Harper's Weekly* during the following years, with a further distinction added in such titles as *The Army of the Potomac—A Sharpshooter on Picket Duty—From a Painting by Winslow Homer, Esq.* [99], alluding to his entrance into the more prestigious world of the arts associated with exhibitions, dealers' galleries, and the National Academy. It was his first major oil. Two years later (1864), he was elected an Associate of the National Academy and the following year, a full member at the age of twenty-nine.

A further improvement in Homer's career came with the appearance of his *Bright Side* [120] in the July, 1866, issue of *Our Young Folks*. A note in the text states that it was "copied by the artist from the original painting . . . Prepared for Thos. Bailey Aldrich's article, 'Among Our Studios.' " The latter was one of the first accounts of Homer as a serious artist. The engraving design, which Homer drew himself, was a reproduction of his painting instead of an original illustration. The practice of using the graphic arts to duplicate his paintings was one which he employed more and more as he gradually shifted to the unique media of oil and watercolor. This was true of his venture into etching in the 1880s, all subjects being transferred from previously done paintings.

[35]

That one's reputation could be enhanced by citing the connection between engravings and paintings was plain to both *Harper's* and their artist-engraver. When *Under the Falls, Catskill Mountains* [196] was published on September 14, 1872, it was pointed out in the title that the design was "From a painting by Winslow Homer." Similarly, when *"Snap-the-Whip"* [202] appeared in September 20, 1873, the text carefully stated: "Our illustration is engraved from the original picture." This reciprocal relationship was stressed in many other cases and gradually established Homer's reputation among the magazine reading public as a painter to be reckoned with.

There are, of course, essential differences between thinking in terms of wood engraving, making graphic reproductions of paintings, and creating paintings on canvas or paper. One skill does not necessarily match the others. This discrepancy was destined to have a profound bearing on Homer's long-term reputation. Homer started his career as an illustrator for the popular journals. So too did many other talented artists. But whereas they remained in the ranks of illustrators throughout their careers—most notably in the long life of the *Saturday Evening Post,* Homer graduated from journalistic illustration and established himself as a major artist. Before he died his works were acquired by leading museums and known on both sides of the Atlantic. If Homer had not pursued a second career, he might be little remembered today. Hennessey, Waud, and Green, virtually his peers in the 1860s, are now forgotten.

By the 1870s Homer was America's foremost popular engraver. His "children's series" was superior to anything else being done in the field at that time. Yet he must have sensed that acclaim as an engraver would not be enough in the long run. His motives for abandoning it suddenly are not easy to assess, as he never talked about them. He was not unduly eager for fame, and often appeared indifferent toward it, keeping the medals he acquired in an old cigar box. Neither was he greedy for money. His personal needs were always simple. He had, however, a practical mind and a professional attitude toward his calling. He wanted to be paid well enough to indulge his two pleasures in life—traveling and fishing. These wishes run like a refrain through his letters. The drive for more freedom than magazine illustration gave him, as well as his growing interest in painting, may well have influenced him in the decision to move from one to the other before the decade of the seventies ended.

As a finale, Homer designed two engravings in 1875. The first was entitled *The Battle of Bunker Hill—Watching the Fight from Copp's Hill, in Boston* [219]. It appeared in the June 26 edition of *Harper's Weekly* and marked the end of a long and memorable association with that magazine. It was the leading journal of the day, as Homer was its leading illustrator. The second and final engraving for the year was called *The Family Record* [220]. It was published in *Harper's Bazar* in the issue of August 28. The caption bears the words "Drawn by Winslow Homer, NA." Although Homer had been a member of the National Academy for ten years, since 1865, this was the only time he added his academic title to his name on a wood engraving. The Academy was an institution which

favored the fine arts of painting and sculpture over popular engravings. Was Homer implying by this conscious gesture that he wished to be associated henceforth more with the former than the latter, as proved to be the case? If so, it shows that he regarded it as a turning point in his life.

Eighteen seventy-five was significant for Homer's career in another prophetic way. In that year his younger brother, Arthur Benson Homer, married Alice Patch of Lowell and took her for their honeymoon to Prout's Neck, whose unspoiled scenic beauties he had heard about. Winslow visited them there briefly and made a drawing of the couple in the vicinity of Kettle Cove. It was his introduction to Prout's Neck, an event that was to have a far-reaching effect upon his art within a few years.

In 1875 Homer made another important journey. He returned to Virginia to study once more the southern blacks he had seen during the Civil War. As a result of this trip he painted several important pictures, most notably *The Carnival* which is now in the Metropolitan Museum. The sojourn in Virginia recaptured the past, the visit to Maine looked to the future. Eighteen seventy-five was an important link between the early and later chapters of his life, and a suitable termination for that portion of his career which he had devoted extensively to magazine engravings.

6
Technical Changes and Developments

Engraving techniques changed progressively during Homer's years of activity in the medium. What might be described as a predominately linear mode of expression in the middle of the century was refined to permit the representation to a much greater degree of effects of atmosphere, light and shadow, and the suggestion of nuances of color. Engravers achieved an important technical advance by cutting blocks which allowed them to engrave across the ends of the grain instead of with or against the grain. This step permitted them to narrow lines until they almost disappeared, creating a tonal or shadowy appearance.

The greater refinement achieved by the use of the fine, uniform end-grains necessitated, however, a subdivision of the single block into an assemblage of smaller blocks whose square outlines are faintly visible in some of the engravings, such as *The Beach at Long Branch* [158] and *Waiting for Calls on New-Year's Day* [165]. Fortunately, the effect on the design was negligible and not unpleasant.

In company with this change, engravers were able to indicate movement by a blurring of outlines as well as by linear directions. The difference between these techniques can be seen by comparing *Under the Falls, Catskill Mountains* [196] of 1872 with *March Winds* and *April Showers* [53 and 54] of 1859, in which the weather phenomena are captured by linear means.

It would be misleading to imply that Homer simply moved steadily from a linear to a tonal means of expression with each passing year. He experimented freely with atmospheric and luminous effects at an early date, when they were appropriate for the subject, as in the *Boston Evening Street Scene* [6] of 1857. Contrariwise, his late *Battle of Bunker Hill* [219] of 1875 retains a strongly linear, even sculpturesque, appearance. Nevertheless, in the broad movement of his art he took advantage of the general refinement and finesse of engraving skill which appeared in the medium at large between 1857 and 1875. This change was not all gain. It was attended by a loss of strength and a tendency, in the hands of lesser artists, toward preciosity, effeteness, or mere virtuosity. Prior to his death in 1908, the English-born engraver, Timothy Cole, carried the representational capacity of

wood engraving to the point where it rivaled photogravure or the new heliotype reproductions of noted paintings. This achievement of facsimile was gained, however, at the cost of great labor, which the speedy and inexpensive photomechanical methods soon rendered pointless.

Having struck a balance between strength and refinement in his outstanding "children's series" of the mid-seventies, and withdrawn from the field at the same time, Homer avoided the extremes and the rivalry which affected Cole and others by 1910, after which wood engraving, save for Rockwell Kent and a few illustrators, became a rare, if not a lost, art. The days of its great popularity coincided with Homer's first career and dwindled after it.

A parallel change occurred in the methods by which the Japanese created the wood engravings that interested Homer and many other nineteenth century artists. The first woodcuts by Moronobu and his generation were highly linear and limited to black and white. In the course of time the linear effects were refined until they could imitate the elaborately embroidered costumes of the theatrical actors who were popular subjects. At the same time, color designs, originally limited and simple, were improved to match the richest patterns contrived by textile and costume designers. Ultimately, through skillful wiping of the blocks, gradations of skies and other scenic effects were captured adroitly. A comparable decline in strength attended this technical mastery in the final days of the art—a seesaw effect which appears to be the price art usually pays as a medium moves from a primitive to a highly refined stage. The optimum effect fell somewhere in between for both the Japanese wood-block print and the major illustrations of Homer's America.

Photography, it is now widely acknowledged, had a strong influence on art and artists on both sides of the Atlantic in the nineteenth century. The relationship changed with the passing decades. During most of the years that Homer designed engravings photography was a cumbersome and static medium. It employed either tiny metal plates or oversized glass plates. Photographers who toured the Civil War front had to carry heavy equipment in caravans. Another serious limitation was the slowness of the emulsions, which required up to a minute per exposure. The sitter for a portrait had to have his head held in a clamp to avoid movement. Much of the seriousness of expression which we now attribute to dignity and character probably arose from this technical limitation, as did the static or frozen quality of the battle scenes. Consequently, Brady, Gardner, and O'Sullivan were at their best when reporting the starkness of death in the aftermath of a battle. Some of this stiffness carried over into Homer's early painting. His noted *Prisoners from the Front* exhibits this characteristic.

Insofar as the slowness of the emulsion worked against scenes of action in the early days of photography, the imaginative painter or engraver had an advantage in representing action during the sixties and seventies. Homer demonstrated this superiority a number of times in his battle scenes, such as *A Cavalry Charge* [95] or *A Bayonet Charge* [97], and in numerous scenes of skating and dancing, both before and after the war.

During the last quarter of the century the relationship between photography and painting was reversed. In July of 1888 the Eastman Company introduced its revolutionary Kodak No. 1, a roll-film camera which took a 2½-inch circular image and was ideally light in weight for the traveling artist and the general public. With its new and faster emulsions it could capture action with an unprecedented facility, permitting a breakthrough in the history of photography. By the turn of the century the pendulum had swung to the opposite extreme: the experiments of Eadweard Muybridge, Thomas Eakins, and others carried sequential scenes of action to the threshold of the motion picture, and photogravure had seriously hurt the field of hand-drawn illustrations, as John Sloan and the Philadelphia journalist-reporters discovered.

As early as the 1860s, the camera, despite its slowness, could record large static crowds in detail; thus it had an advantage in this area over the slower-working artist-reporter. It is likely that Homer used a photograph as a guide while depicting the (first) *Inauguration of Abraham Lincoln* [78]. Under the pressure of war, photography was improved steadily, a process which continued until it was a formidable rival of engraving and a threat to its existence. Homer, who was always a technically alert artist, may have guessed that by 1875 the handwriting was on the wall for engraving and other hand-drawn illustrations. This may well have provided another reason for his steady withdrawal from the medium after that date.

One of our leading historians of photography, Beaumont Newhall, has pointed out that the problem of the nineteenth century artist was to survive the challenge of photography by exploiting its special features (such as its capacity for recording detail clearly, quickly, and easily), or shifting to fields which the camera had not yet mastered. Homer did both shrewdly: he withdrew from the engraving of illustrations after 1875 and devoted his talents to oil painting and watercolor in which color was a paramount feature. Decades would pass, and Homer himself would die, before that advantage would narrow or disappear.

Having bypassed the camera by transferring his principal efforts to painting during his second career, Homer wisely made the camera a friend instead of a foe. He acquired an Eastman Kodak No. 1 shortly after its appearance on the market in 1888 and used it extensively for the rest of his life to make record-photographs of the scenes he saw during his almost ceaseless travels up and down the Atlantic seaboard, from the north woods to the tropics. That he also allowed the camera to affect his visual thinking beneficially is apparent in the similarity between the photographs and a large number of his watercolors, such as *The North Woods* of 1894; *Canada Skyline, Shooting the Rapids, Three Men in a Canoe, Homer's Cabin, Tourilli Club,* and *Two Men in a Canoe* of 1895; and *Young Ducks* of 1897. Only Thomas Eakins used photography more consciously as an aid to art during these years.

7
Magazines and Economics

Not surprisingly, there was an economic side to Winslow Homer's career as an illustrator. His family was of the solid middle class, and, except for his highly successful older brother, never affluent. Winslow received comparatively small financial returns throughout his career, and even at the height of his fame in the nineties he wrote to his family that he was "standing on one foot and then the other in the hope of making some money." It was not a time when American artists grew rich.

The largest sum ever paid Homer for a painting during his lifetime was the $4,500 given by the Metropolitan Museum in 1906 for the now famous *Gulf Stream*, a pittance by today's standards. Throughout his life he had to earn a living to serve both pride and necessity.

One can only conjecture what amounts the publishers paid him for his designs for engravings, but in the beginning, and probably at the end, the rewards were probably meager. To earn a living Homer must have worked very hard. This need may account, along with his natural vitality and urge to be independent, for the large number of engravings he produced, well over two hundred between 1857 and 1875. It was, furthermore, a pace that he had to sustain throughout his second career. For the watercolors, which are today eagerly bought by museums and collectors for small fortunes, Homer never received more than $200 each during his own lifetime. Thomas Eakins fared even worse; his superb portraits found few buyers.

The publishers of magazines were Homer's only reliable patrons during the first half of his artistic career. He had to rely on their commissions in order to earn a living. The relationship must have entailed a constant compromise between editorial wishes and popular demands, and the artist's drive to create freely. It has been suggested that, as his reputation became established, Homer was given a free hand, yet adjustments must have been implicit when neither the publisher nor the artist could ignore the popular wishes of the day and earn a living. When Homer abandoned engraving, he gained a larger degree of independence but had to accept a precarious income to attain it.

The magazines which provided Winslow Homer an outlet and livelihood during the years when he earned his income primarily as a designer of wood engravings were eleven in number, by name and in chronological order: *Ballou's Pictorial, Harper's Weekly, Frank Leslie's Chimney Corner, Frank Leslie's Illustrated Newspaper, Our Young Folks, Riverside Magazine, The Galaxy, Harper's Bazar, Appleton's Journal, Hearth and Home,* and *Every Saturday.* The specific contributions by title, date, and volume can be found in the checklist, but certain interpretations emerge unavoidably.

The magazines of the nineteenth century were as diverse as those of our own time and played a large role in informing the public on contemporary matters before motion pictures, radio, and television took over that function in our national life. Within that earlier framework of communication, the several magazines addressed constituencies which differed widely in size, interests, and social status. According to their own subtitles, *Our Young Folks* and the *Riverside Magazine* were aimed at a youthful audience; *Harper's Bazar,* by contrast, bore the elaborate subtitle of "A Repository of Fashion, Pleasure, and Instruction," presumably for older and more sophisticated readers. In the center was the largest and most successful of all, *Harper's Weekly,* which struck the right or median chord for the majority of readers of the day.

The journals varied so widely in character and spirit that a man of Homer's personality must surely have had a favorite. He probably worked for such a disparate group because of ambition or economic necessity, rather than pure preference. There were, in other words, a number of factors which restricted Homer's "free hand."

Opportunity and timing also played their parts in Homer's activity. The majority of his youthful efforts appeared in *Ballou's Pictorial,* because both he and it resided in Boston. Indeed, his first studio as a free-lance artist was in the Ballou's Pictorial Building. After he moved to New York City, in 1859, his connection with *Ballou's* rapidly came to an end. At the other end of the time spectrum, he worked for other magazines that came into existence at later dates. *Riverside Magazine*'s first volume was published in 1867, *Appleton's Journal* appeared on the scene in 1867, and *Every Saturday* came, belatedly, in 1870. It should be noted that all three of these appeared after the Civil War, probably in response to the new prosperity.

It is significant that engravings by Homer were published in the initial or early volumes of most of the journals for which he worked. Either he offered his services or they were solicited, or both: either would have contributed to his enterprising productivity as a popular graphic illustrator.

The most important of these associations, that with the celebrated and influential *Harper's Weekly,* was both early and long. Thanks to the wide circulation of that outlet, Homer's name must have become a household word; obscurity was not one of his problems, as it was for Eakins. Homer contributed a design to *Harper's* opening volume—*The Match Between the Sophs and Freshmen* [11] in 1857, while he was still living in his native Boston. During the ensuing years he furnished designs for volumes one through nine,

eleven through fourteen, and sixteen through nineteen. He failed to submit designs only for volumes ten and fifteen. This activity spans the effective range of his career as a popular engraver, from its start in 1857 to its essential conclusion in 1875.

During this period of time, Homer supplied *Harper's Weekly* with 127 of the 220 titles listed in the checklist, or 169 if portraits are included; meaning over half of his total production as an engraver. More important, in any carefully selected exhibition of the best of Homer's engravings, a high percentage would be those done for *Harper's*. Indeed, such an exhibition could be based exclusively on that output without undue loss from a qualitative viewpoint. Moreover, no choice of his best work could omit the best known *Harper's* engravings which are also, for the most part, his recognized masterpieces. Homer was known most widely in his own day through his illustrations for *Harper's Weekly*. And though his designs for other journals gave his oeuvre richness and variety, his reputation would not have been greatly diminished if he had never worked for any other publisher.

One can only conclude from these circumstances that Homer's long affiliation with *Harper's Weekly* was a union which served both the artist and the publisher well. Further, that the arrangement brought out the best in the artist. It was no coincidence that the finest of Homer's engravings appeared during the seventies as a result of long experience and that they appeared in the pages of *Harper's Weekly*. Conversely, Homer conferred no small measure of memorable worth on *Harper's Weekly* through his illustrations. Scores of people remember the periodical today mainly because of his connection with it.

Homer rounded out his career in the engraving field after 1875 by sending a total of six designs in five years to the *Art Interchange, Saint Nicholas,* and *Scribner's Monthly*. For him, this was a low rate of productivity and indicated plainly that he had turned his attention to other fields and other media. It is significant that he did no more engravings at all after he settled at Prout's Neck in 1883, and embarked upon his second career in earnest.

1857

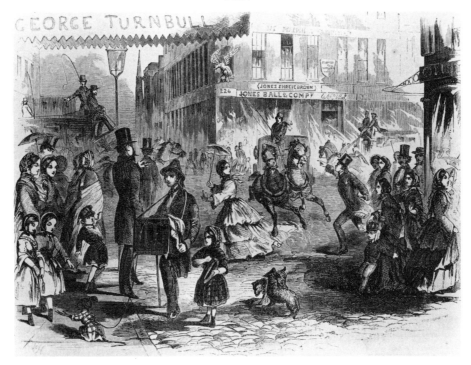

1. Corner of Winter, Washington and Summer Streets, Boston
 Ballou's Pictorial, June 13, 1857, 7¼″ x 9½″.
2. The Fountain on Boston Common
 Ballou's Pictorial, August 15, 1857, 7¼″ x 9½″.

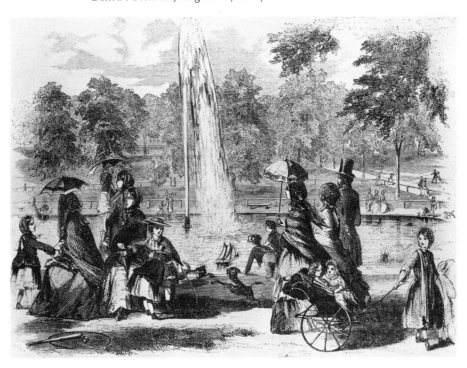

3. A Boston Watering-Cart
 Ballou's Pictorial, September 12, 1857, 7¼″ x 9½″.

4. View in South Market Street, Boston
 Ballou's Pictorial, October 3, 1857, 7¼″ x 9½″.

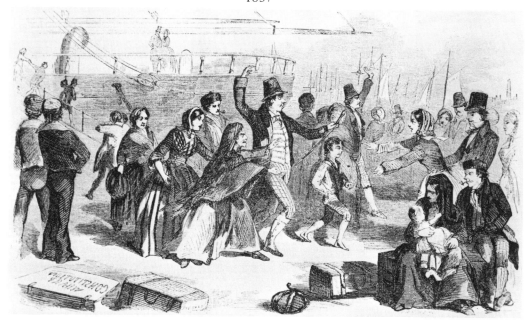

5. Emigrant Arrival at Constitution Wharf, Boston
Ballou's Pictorial, October 31, 1857, 5½″ x 9½″.

6. Boston Evening Street Scene, at the Corner of Court and Brattle Streets
Ballou's Pictorial, November 7, 1857, 6⅜″ x 9⅜″.

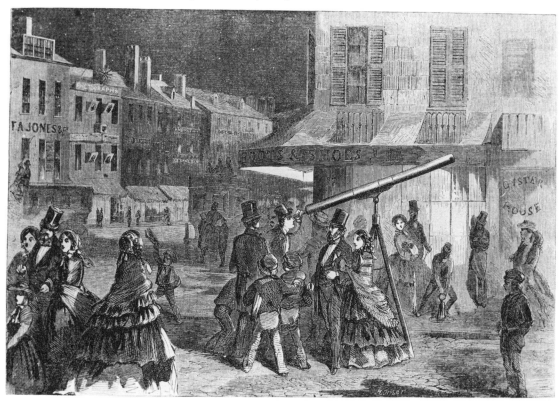

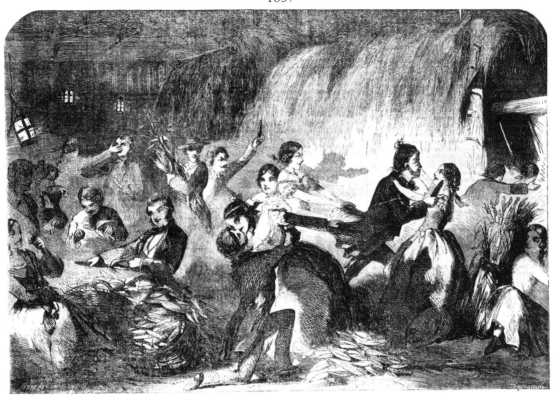

7. Husking Party Finding the Red Ears
 Ballou's Pictorial, November 28, 1857, 6⅜" x 9⅜".
8. Blind Man's Buff
 Ballou's Pictorial, November 28, 1857, 4½" x 7".

9. Family Party Playing at Fox and Geese
Ballou's Pictorial, November 28, 1857, 5⅜″ x 9⅜″.

10. Coasting Out of Doors
Ballou's Pictorial, November 28, 1857, 4½″ x 7″.

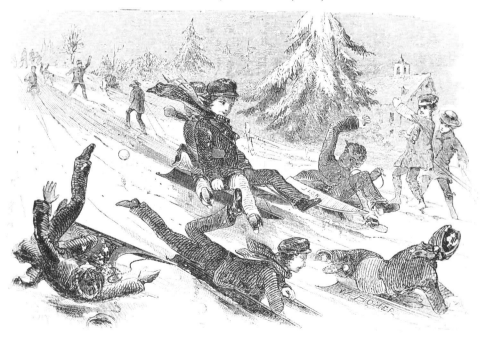

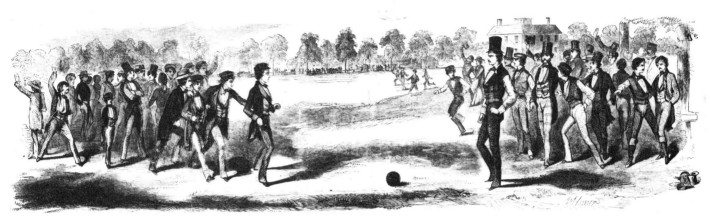

11. (1) The Match Between the Sophs and Freshmen—The Opening
Harper's Weekly, August 1, 1857, 6″ x 21½″.

12. (2) Freshmen
Harper's Weekly,
August 1, 1857, 7″ x 5″.

13. (3) Sophs
Harper's Weekly,
August 1, 1857, 7″ x 5″.

14. (4) Juniors
Harper's Weekly,
August 1, 1857, 7″ x 5″.

15. (5) Seniors
Harper's Weekly,
August 1, 1857, 7″ x 5″.

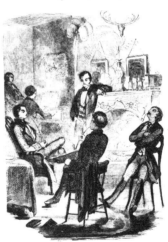
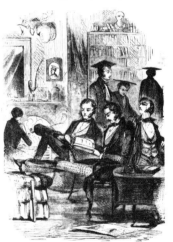

1858

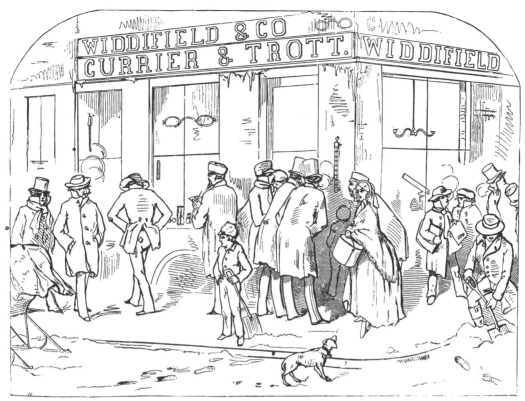

16. The "Cold Term," Boston—Scene, Corner of Milk and Washington Streets
 Ballou's Pictorial, March 27, 1858, 6⅞″ x 9⅜″.
17. Class Day, at Harvard University, Cambridge, Mass.
 Ballou's Pictorial, July 3, 1858, 5½″ x 9⅜″.

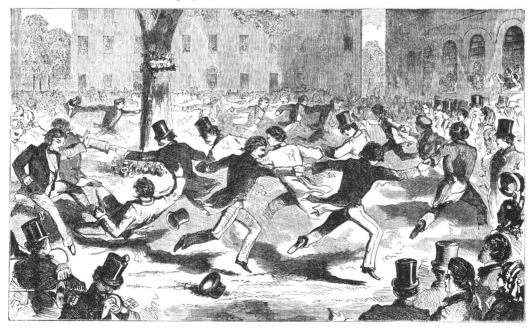

18. Camp Meeting Sketches (four separate blocks), Landing at the Cape
Ballou's Pictorial, August 21, 1858, 5″ x 9⅜″.

19. Camp Meeting Sketches, Morning Ablutions
Ballou's Pictorial, August 21, 1858, 5″ x 9⅜″.

20. Camp Meeting: Cooking
 Ballou's Pictorial, August 21, 1858, 5″ x 9⅜″.

21. Camp Meeting Sketches: The Tent
 Ballou's Pictorial, August 21, 1858, 5″ x 9⅜″.

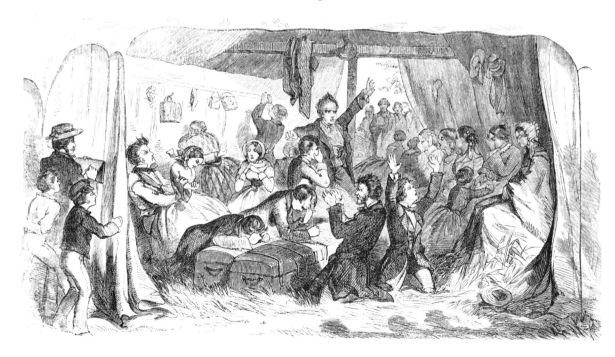

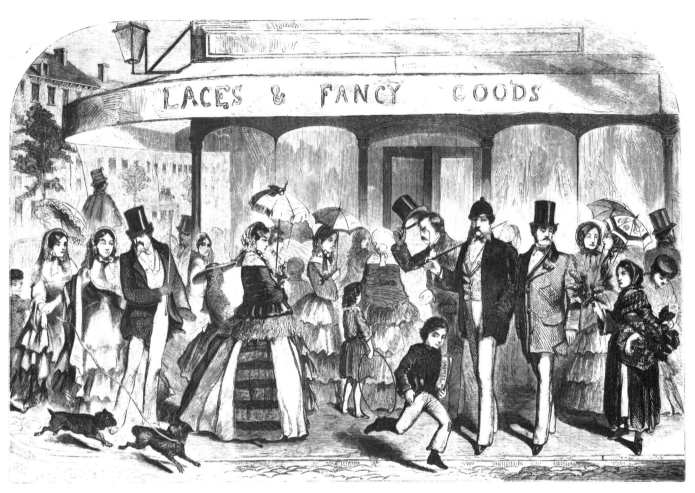

22. Spring in the City
Harper's Weekly, April 17, 1858, 9⅛″ x 13¾″. ·

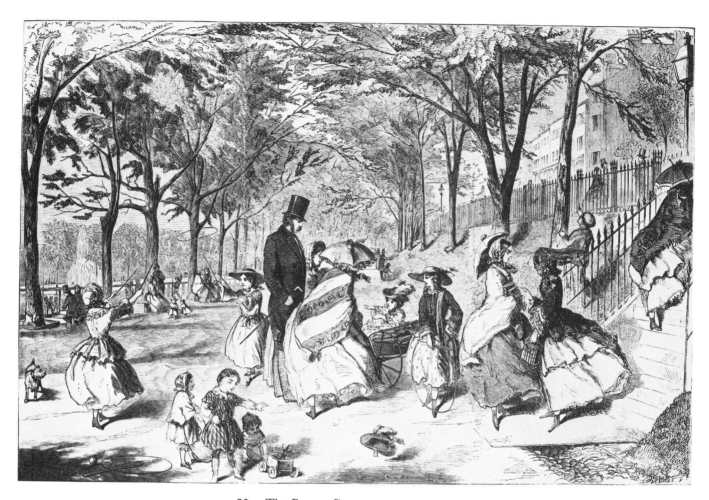

23. The Boston Common
Harper's Weekly, May 22, 1858, 9¼″ x 14″.

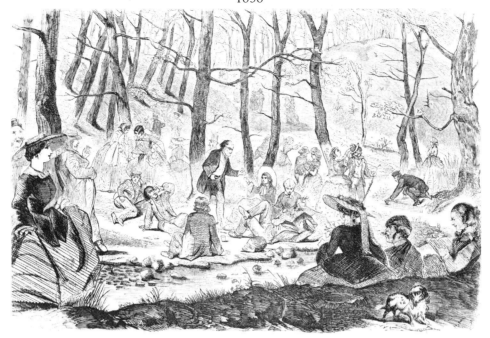

24. A Picnic by Land
 Harper's Weekly, June 5, 1858, 9⅛″ x 13¾″.

25. The Bathe at Newport
 Harper's Weekly, September 4, 1858, 9¼″ x 13¾″.

26. Picnicking in the Woods

 Harper's Weekly, September 4, 1858, 9¼″ x 13¾″.

27. Husking the Corn in New England

 Harper's Weekly, November 13, 1858, 9¼″ x 13⅞″.

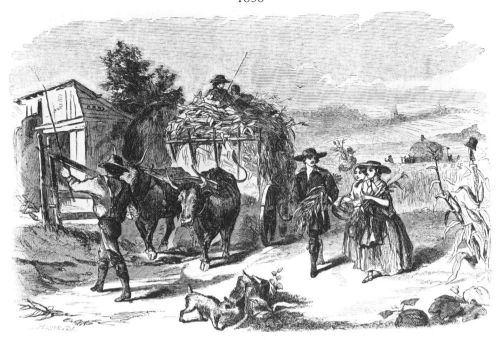

28. Driving Home the Corn
 Harper's Weekly, November 13, 1858, 5⅞″ x 9¼″.

29. The Dance After the Husking
 Harper's Weekly, November 13, 1858, 6″ x 9¼″.

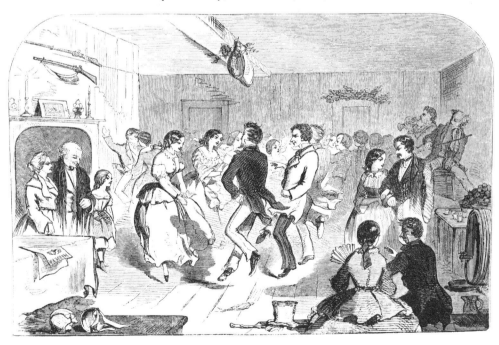

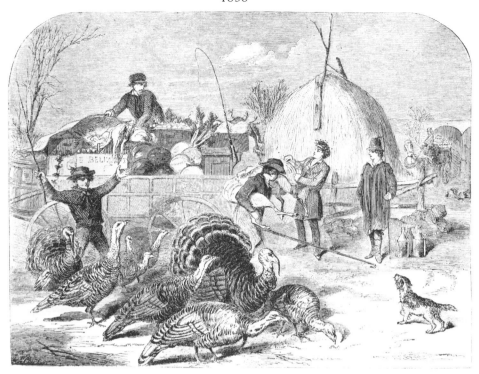

30. Thanksgiving Day—Ways and Means
 Harper's Weekly, November 27, 1858, 6⅞″ x 9¼″.

31. Thanksgiving Day—Arrival at the Old Home
 Harper's Weekly, November 27, 1858, 6¼″ x 9¼″.

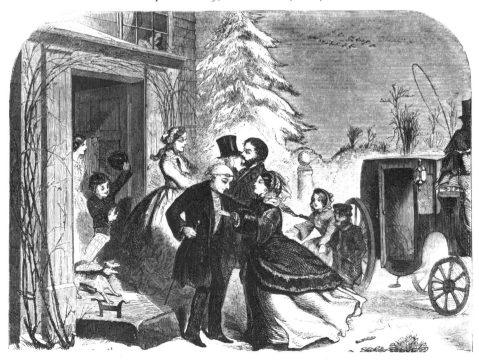

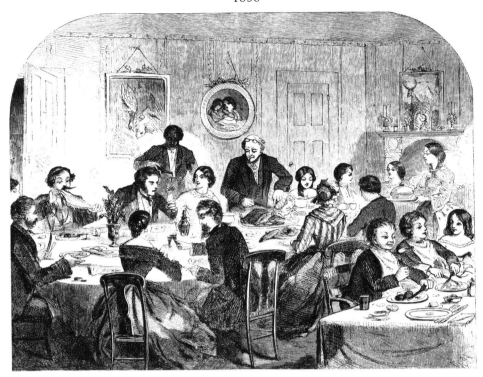

32. Thanksgiving Day—The Dinner

Harper's Weekly, November 27, 1858, 6⅞″ x 9¼″.

33. Thanksgiving Day—The Dance

Harper's Weekly, November 27, 1858, 6½″ x 9¼″.

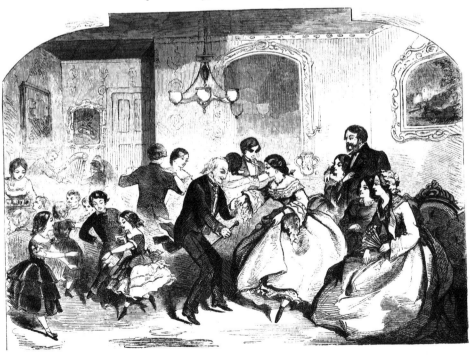

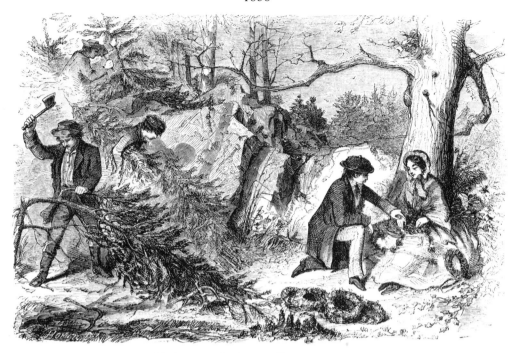

34. Christmas—Gathering Evergreens

Harper's Weekly, December 25, 1858, 5⅞″ x 9⅛″.

35. The Christmas-Tree

Harper's Weekly, December 25, 1858, 5⅞″ x 9⅛″.

36. Santa Claus and His Presents
 Harper's Weekly, December 25, 1858, 5¾″ x 9⅛″.

37. Christmas Out of Doors
 Harper's Weekly, December 25, 1858, 6″ x 9⅛″.

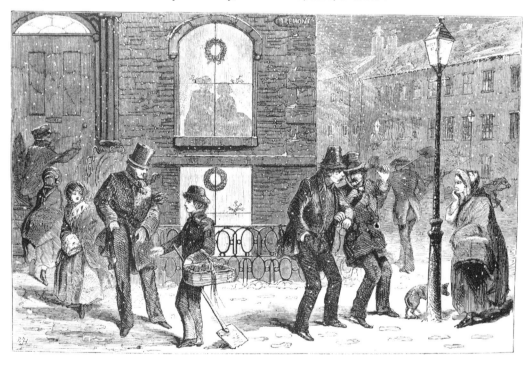

1859

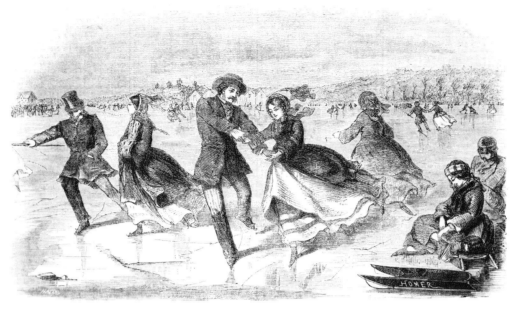

38. Skating on Jamaica Pond, Near Boston
Ballou's Pictorial, January 29, 1859, 5½″ x 9½″.

39. Sleighing in Haymarket Square, Boston
Ballou's Pictorial, January 29, 1859, 5″ x 9⅜″.

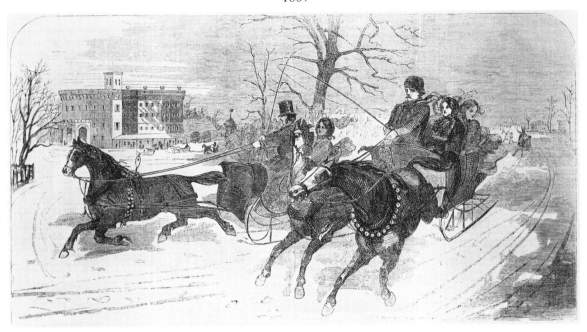

40. Sleighing on the Road, Brighton, Near Boston
Ballou's Pictorial, January 29, 1859, 5″ x 9⅜″.

41. Trotting on the Mill Dam, Boston
Ballou's Pictorial, February 12, 1859, 5″ x 9½″.

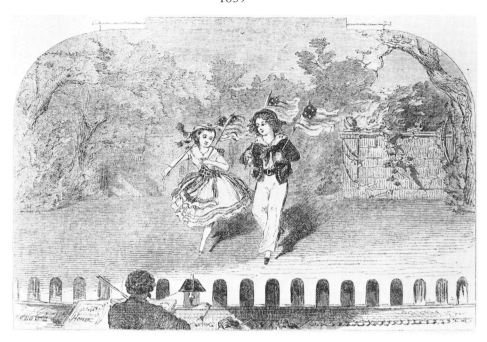

42. La Petite Angelina and Miss C. Thompson at the Boston Museum
Ballou's Pictorial, March 12, 1859, 4½″ x 6¾″.

43. Evening Skating Scene at the Skating Park, Boston
Ballou's Pictorial, March 12, 1859, 4⅞″ x 9¼″.

44. The New Town of Belmont, Massachusetts
 Ballou's Pictorial, April 23, 1859, 4⅞″ x 9¼″.

45. The Wonderful Dutton Children
 Ballou's Pictorial, May 14, 1859, 6¾″ x 5″.

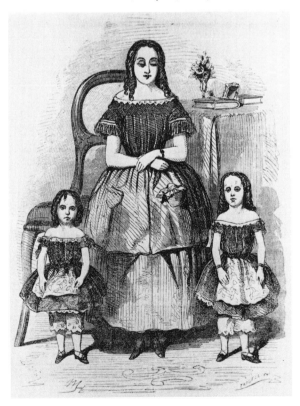

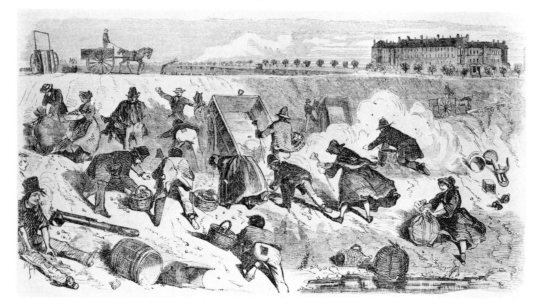

46. Scene on the Back Bay Lands, Boston
Ballou's Pictorial, May 21, 1859, 5″ x 9½″.

47. The Aquarial Gardens, Bromfield Street, Boston
Ballou's Pictorial, May 28, 1859, 6½″ x 9⅜″.

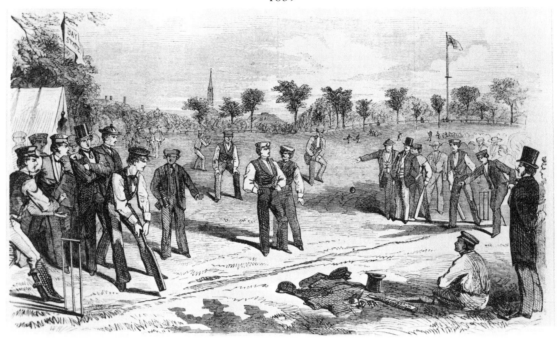

48. Cricket Players on Boston Common
 Ballou's Pictorial, June 4, 1859, 5½″ x 9½″.

49. Cambridge Cattle Market
 Ballou's Pictorial, July 2, 1859, 6″ x 9½″.

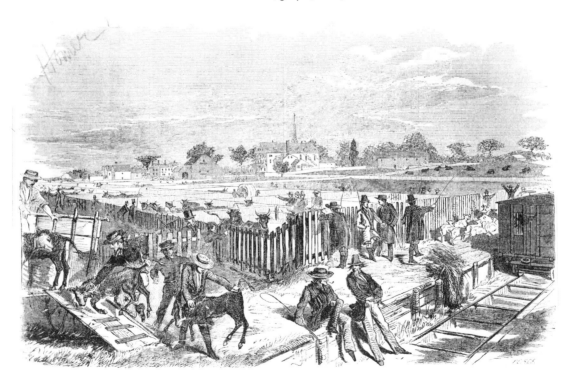

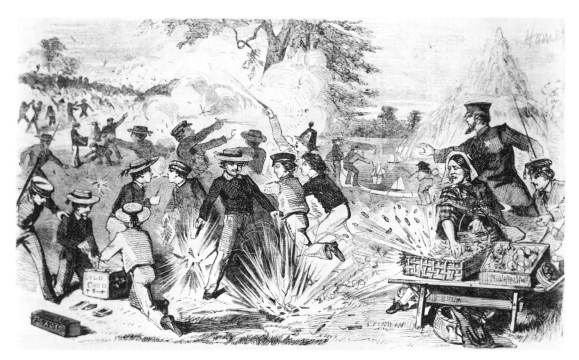

50. Fourth of July Scene on Boston Common
Ballou's Pictorial, July 9, 1859, 5½″ x 9½″.

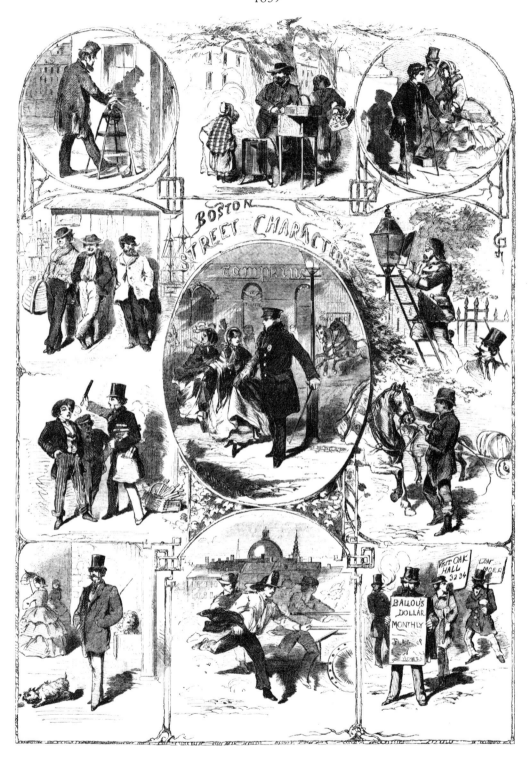

51. "Boston Street Characters"

Ballou's Pictorial, July 9, 1859, 13½″ x 9½″.

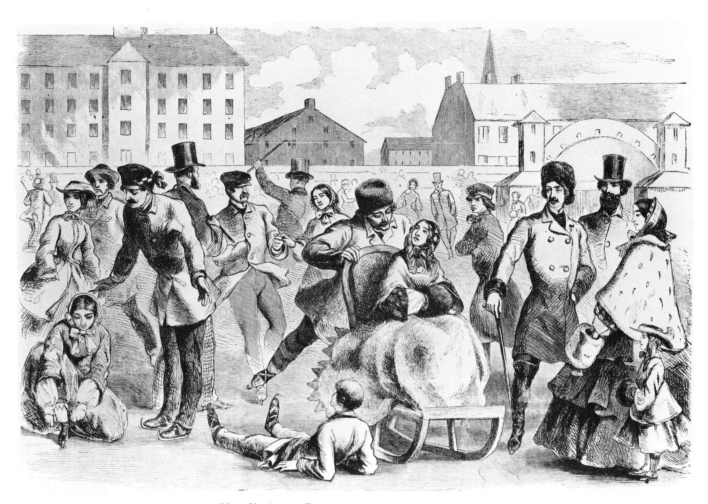

52. Skating at Boston
Harper's Weekly, March 12, 1859, 9¼″ x 13¾″.

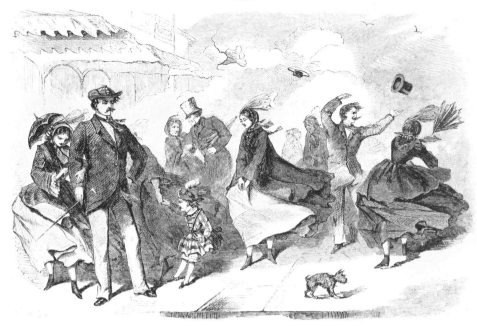

53. March Winds
Harper's Weekly, April 2, 1859, 5⅞″ x 9⅛″.

54. April Showers
Harper's Weekly, April 2, 1859, 5⅞″ x 9⅛″.

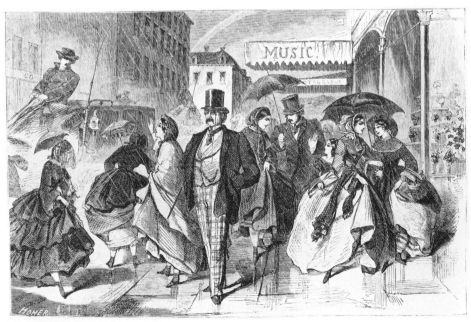

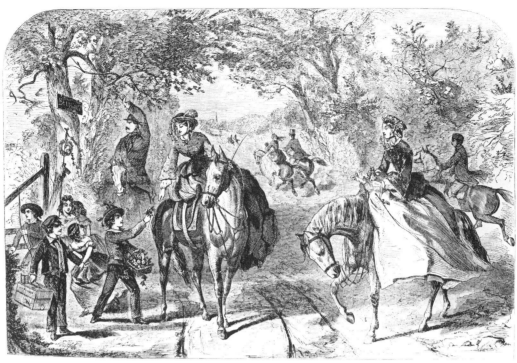

55. May-Day in the Country

Harper's Weekly, April 30, 1859, 9⅛" x 13¾".

56. August in the Country—The Seashore

Harper's Weekly, August 27, 1859, 9¼" x 13¾".

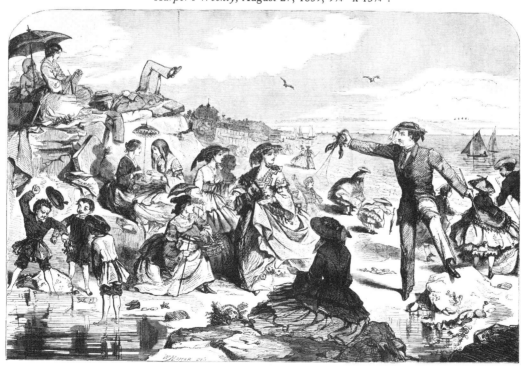

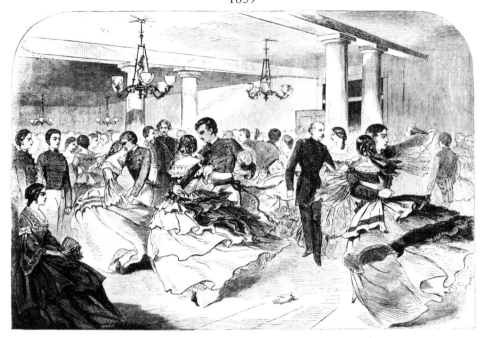

57. A Cadet Hop at West Point
Harper's Weekly, September 3, 1859, 9¼″ x 13⅞″.

58. The Grand Review at Camp Massachusetts, Near Concord
Harper's Weekly, September 24, 1859, 13⅝″ x 20¼″.

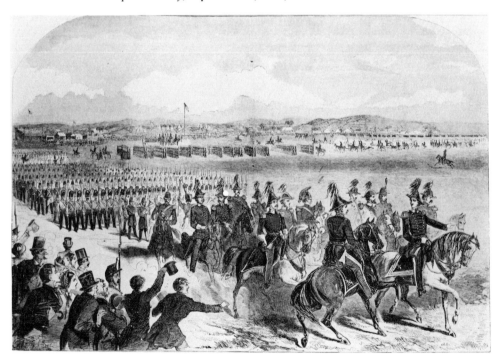

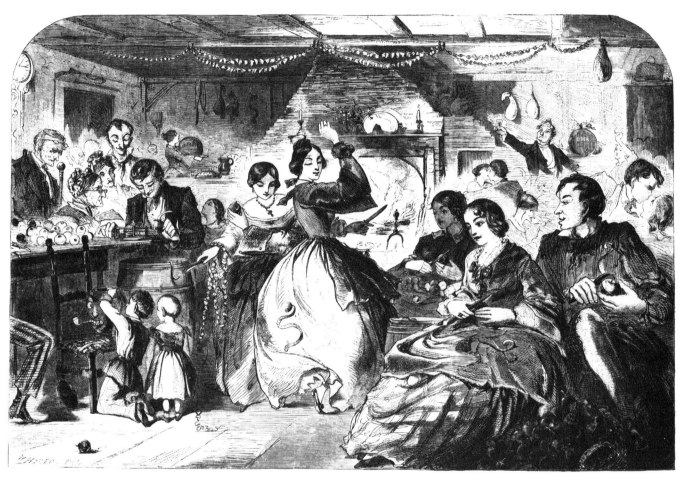

59. Fall Games—The Apple Bee
Harper's Weekly, November 26, 1859, 9⅛″ x 13¾″.

60. "A Merry Christmas and a Happy New Year"
Harper's Weekly, December 24, 1859, 13¾″ x 20″."

1860

61. The Sleighing Season—The Upset
Harper's Weekly, January 14, 1860, 9⅛″ x 13¾″.

62. A Snow Slide in the City
Harper's Weekly, January 14, 1860, 9⅛″ x 13¾″.

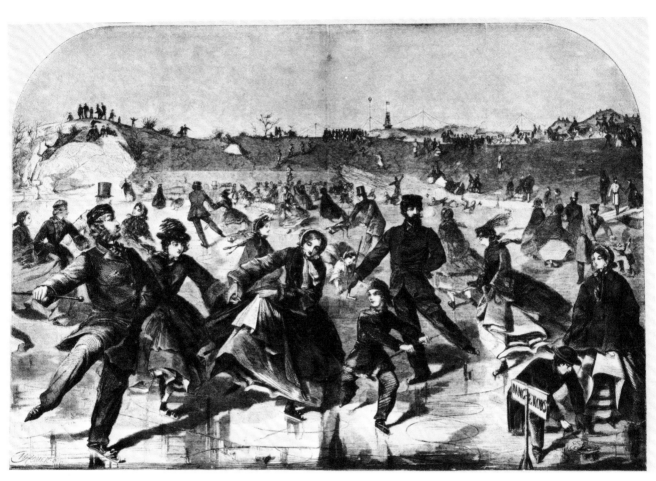

63. Skating on the Ladies' Skating-Pond in the Central Park, New York
Harper's Weekly, January 28, 1860, 13¾″ x 20⅛″.

64. Untitled Illustration.... A Woman Posting a Notice on a Tree

Harper's Weekly, February 18, 1860, 4⅛″ x 2¼″.

65. "Allow Me to Examine the Young Lady."

Harper's Weekly, February 18, 1860, 4⅜″ x 4½″.

66. The Meeting After the Marriage

Harper's Weekly, February 25, 1860, 4⅜″ x 3½″.

67. Mrs. Otcheson at the Piano

Harper's Weekly, March 3, 1860, 4⅜″ x 3½″.

68. The Buds

Harper's Weekly, March 3, 1860,
4½″ x 3½″.

69. On the Beach

Harper's Weekly, March 10, 1860,
4⅜″ x 3½″.

70. The Lady in Black

Harper's Weekly, March 17, 1860,
4⅜″ x 3⅜″.

71. Meadowbrook Parsonage

Harper's Weekly, March 17, 1860,
4½″ x 3⅜″.

72. Scene in Union Square, New York, on a March Day
 Harper's Weekly, April 7, 1860, 4¾″ x 6¾″.

73. The Drive in the Central Park, New York, September, 1860
 Harper's Weekly, September 15, 1860, 9½″ x 13¾″.

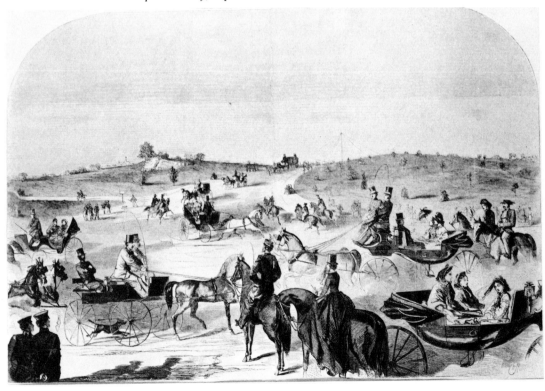

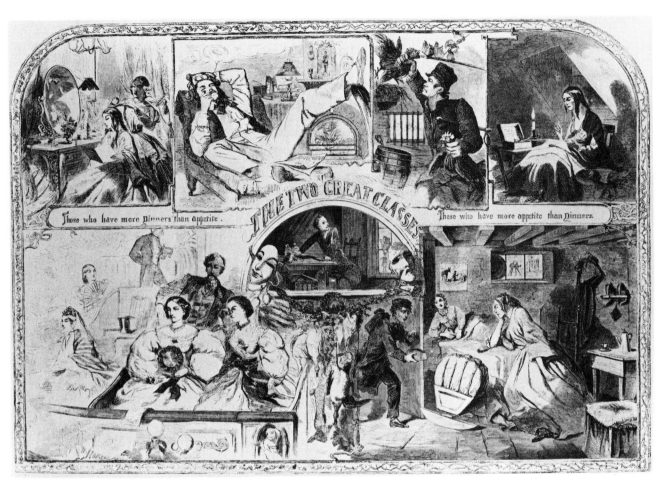

74. Thanksgiving Day, 1860—Two Great Classes of Society
Harper's Weekly, December 1, 1860, 14″ x 20¼″.

75. Expulsion of Negroes and Abolitionists from Tremont Temple, Boston,
Massachusetts on December 3, 1860
Harper's Weekly, December 15, 1860, 6⅞″ x 9¼″.

1861

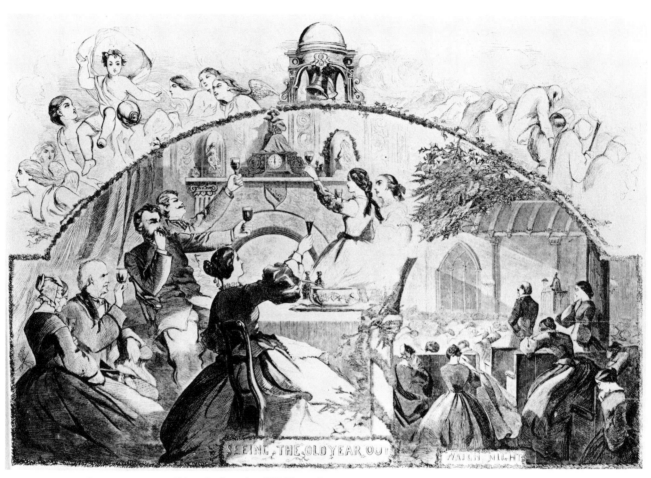

76. Seeing the Old Year Out
Harper's Weekly, January 5, 1861, 13¾″ x 20¼″.

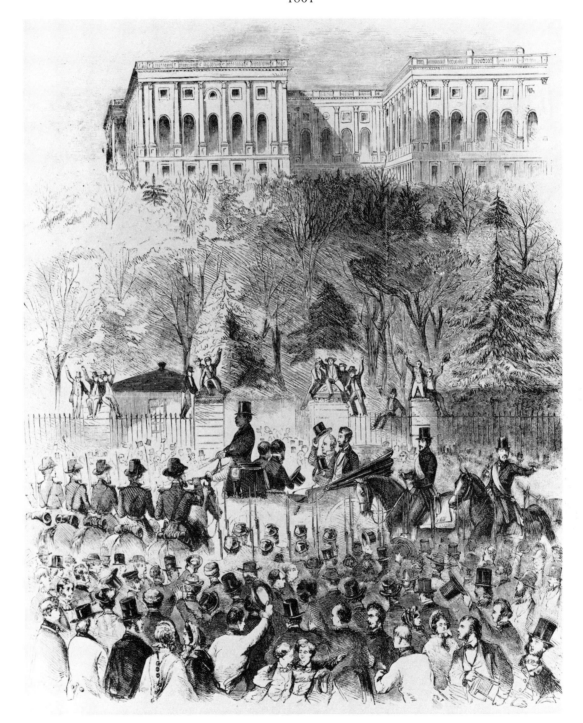

77. The Inaugural Procession at Washington Passing the Gate of The Capitol Grounds
Harper's Weekly, March 16, 1861, 10⅞″ x 9⅛″.

78. The Inauguration of Abraham Lincoln as President of the U.S. at the
Capitol, Washington, March 4, 1861
Harper's Weekly, March 16, 1861, 13¾″ x 20⅛″.

79. The Great Meeting in Union Square, New York, to Support the Government

Harper's Weekly, May 4, 1861, 9¼″ x 13⅞″.

80. The Seventy-Ninth Regiment (Highlanders) New York State Militia

Harper's Weekly, May 25, 1861, 9¼″ x 13⅞″.

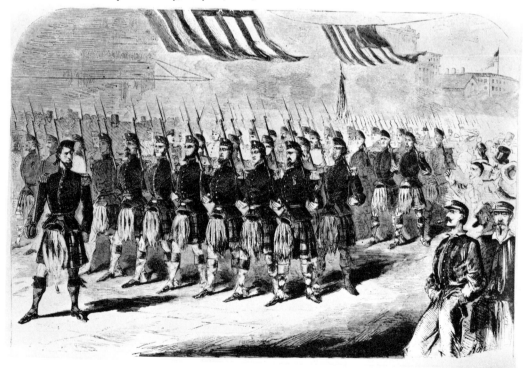

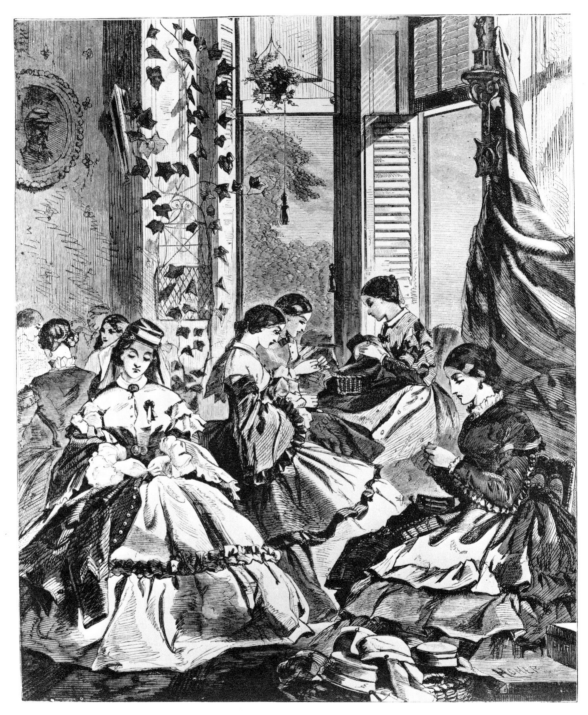

81. The War—Making Havelocks for the Volunteers
Harper's Weekly, June 29, 1861, 10⅞″ x 9¼″.

82. Crew of the U.S. Steam-Sloop "Colorado" Shipped at Boston, June, 1861
 Harper's Weekly, July 13, 1861, 9¼″ x 13¾″.

83. Filled Cartridges at the United States Arsenal,
 at Watertown, Massachusetts
 Harper's Weekly, July 20, 1861, 10⅞″ x 9¼″.

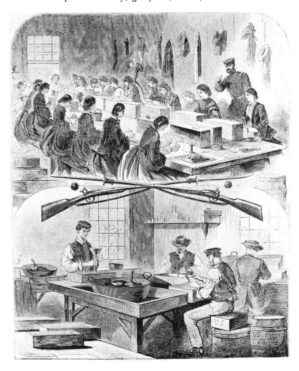

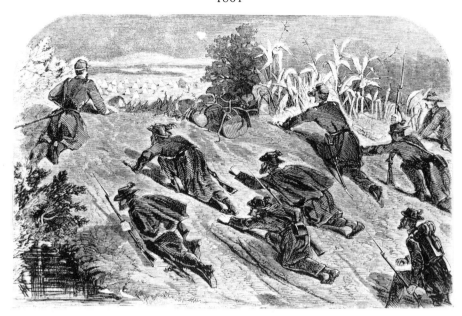

84. A Night Reconnaisance

 Harper's Weekly, October 26, 1861, 6⅞″ x 9¼″.

85. The Songs of the War

 Harper's Weekly, November 23, 1861, 14″ x 20″.

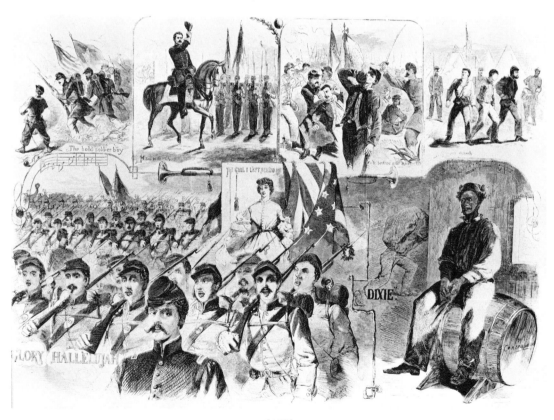

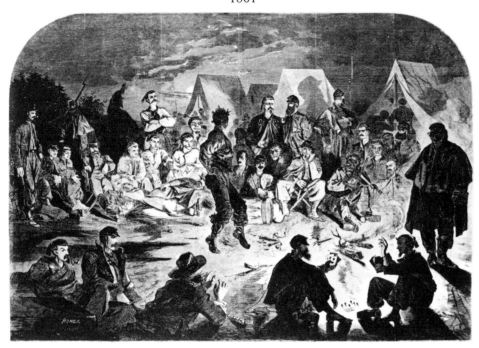

86. A Bivouac Fire on the Potomac

 Harper's Weekly, December 21, 1861, 13¾″ x 20¼″.

87. Great Fair Given at the Assembly Rooms, New York, December, 1861, in Aid of the City Poor

 Harper's Weekly, December 28, 1861, 13⅜″ x 20⅛″.

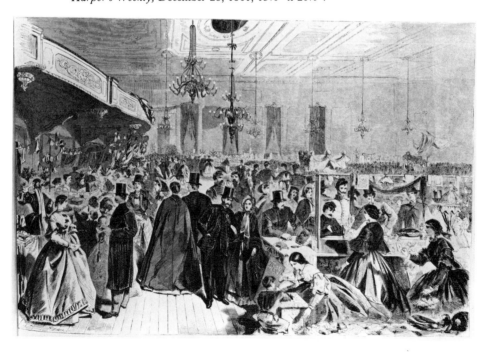

1862

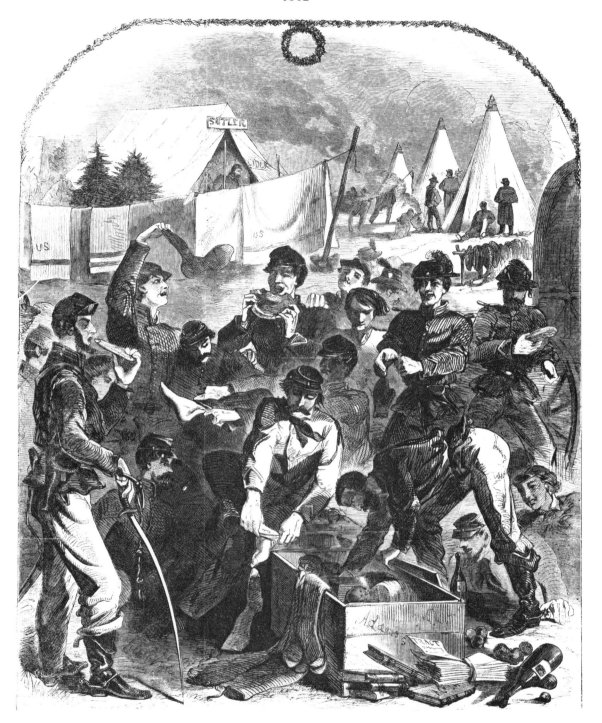

88. Christmas Boxes in Camp—Christmas, 1861
Harper's Weekly, January 4, 1862, 10⅞″ x 9⅛″.

89. Our Army Before Yorktown, Virginia
Harper's Weekly, May 3, 1862, 13¾″ x 20¾″.

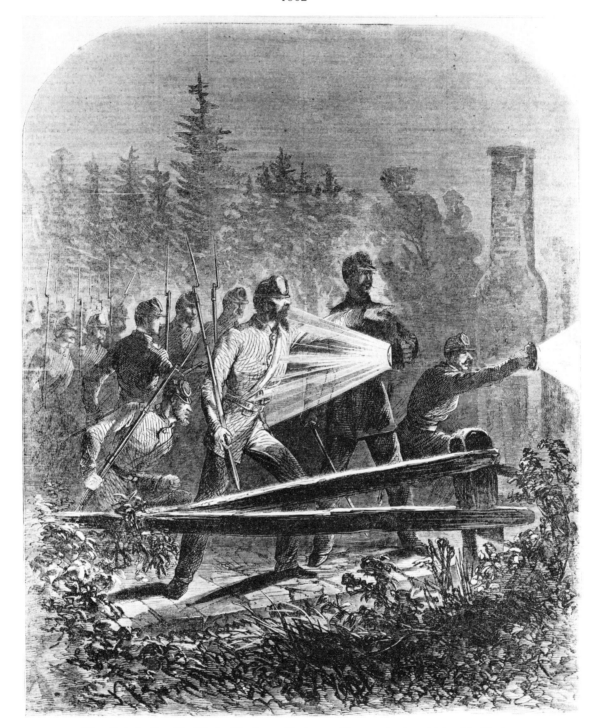

90. Rebels Outside Their Works at Yorktown Reconnoitering (sic) with Dark
Lanterns
Harper's Weekly, May 17, 1862, 10⅞″ x 9¼″.

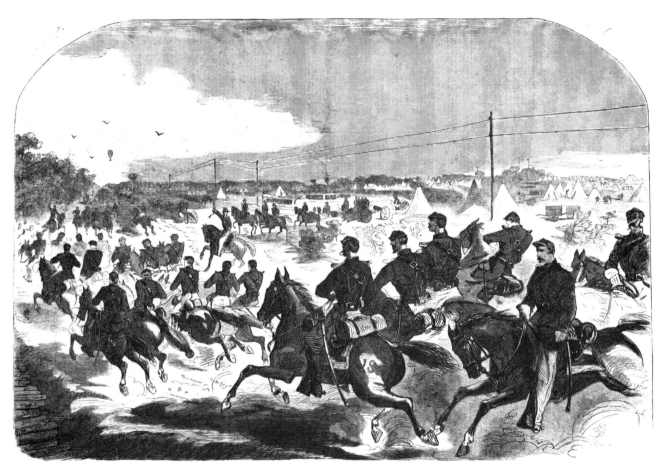

91. The Union Cavalry and Artillery Starting in Pursuit of the Rebels Up the
Yorktown Turnpike
Harper's Weekly, May 17, 1862, 9¼″ x 13¾″.

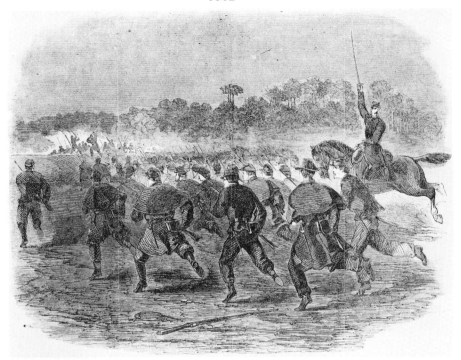

92. Charge of the First Massachusetts Regiment on a Rebel Rifle Pit Near Yorktown

Harper's Weekly, May 17, 1862, 9¼″ x 13¾″.

93. The Army of the Potomac—Our Outlying Picket in the Woods

Harper's Weekly, June 7, 1862, 6⅞″ x 9¼″.

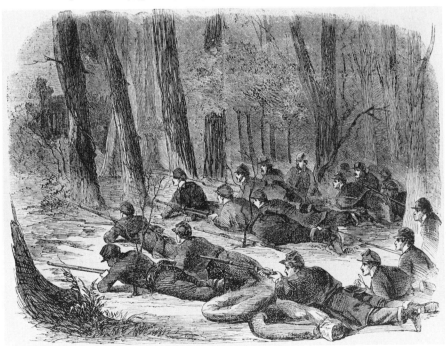

94. News from the War
Harper's Weekly, June 14, 1862, 13¼″ x 20¼″.

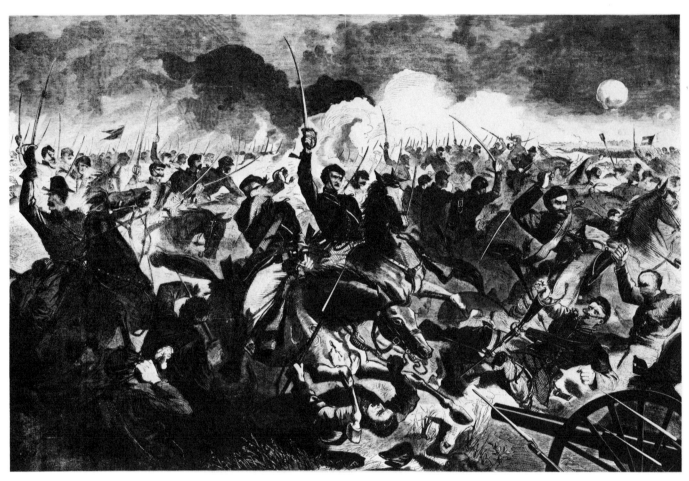

95. The War for the Union, 1862—A Cavalry Charge
Harper's Weekly, July 5, 1862, 13½″ x 20⅝″.

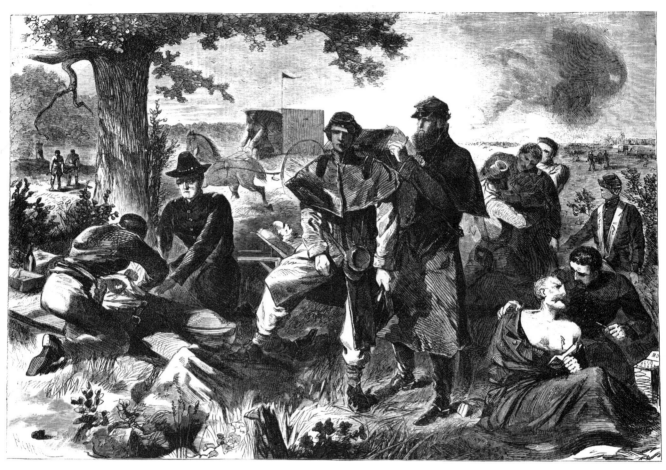

96. The Surgeon at Work at the Rear During an Engagement
Harper's Weekly, July 12, 1862, 9⅛″ x 13¾″.

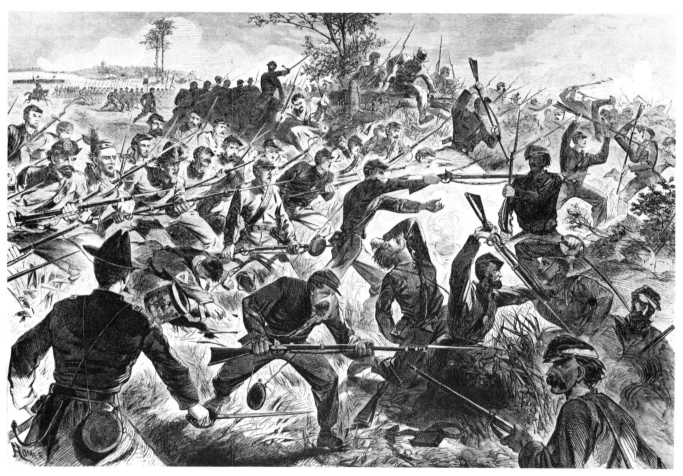

97. The War for the Union, 1862—A Bayonet Charge
Harper's Weekly, July 12, 1862, 13⅝″ x 20⅝″.

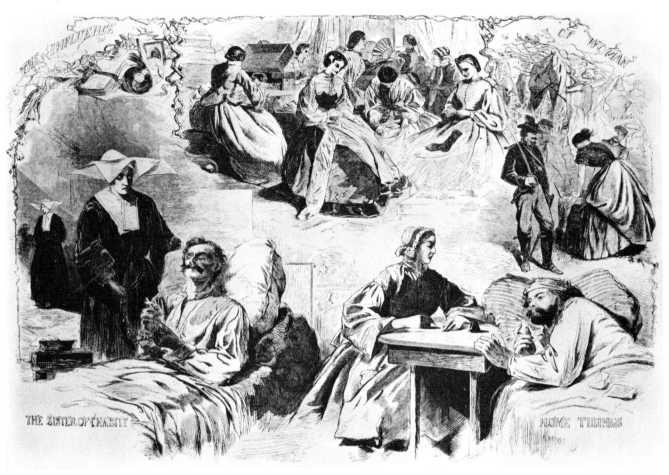

98. Our Women and the War
Harper's Weekly, September 6, 1862, 13⅝″ x 20⅝″.

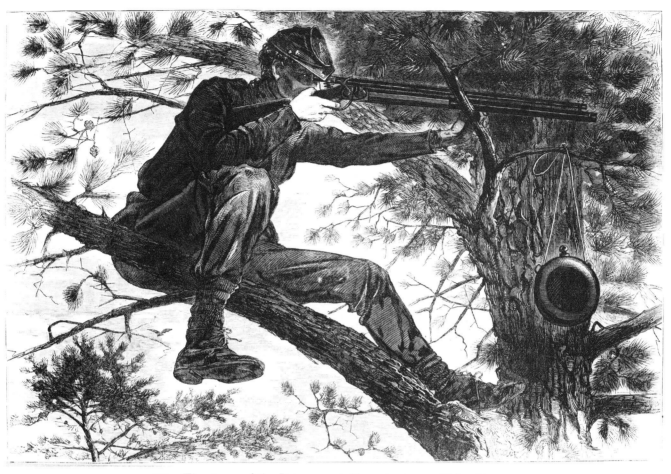

99. The Army of the Potomac—A Sharpshooter on Picket Duty
Harper's Weekly, November 15, 1862, 9⅛″ x 13¾″.

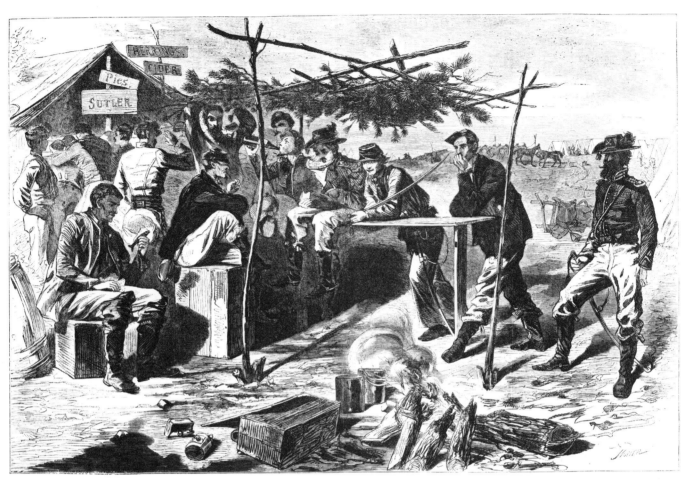

100. Thanksgiving in Camp

Harper's Weekly, November 29, 1862, 9⅛″ x 13¾″.

1863

101. A Shell in the Rebel Trenches
Harper's Weekly, January 17, 1863, 9⅛″ x 13¾″.

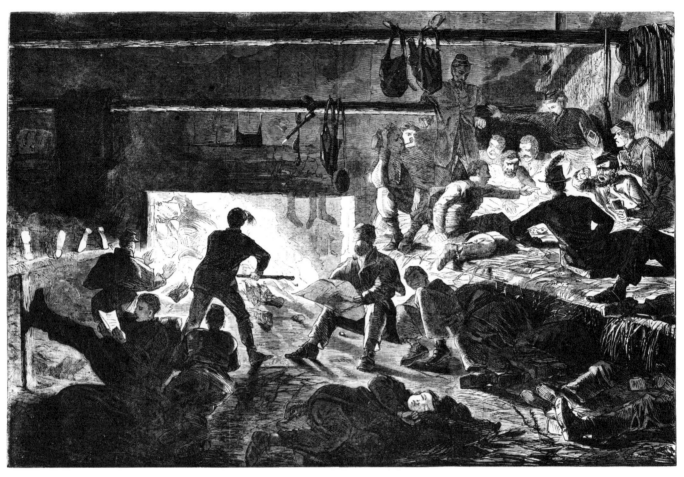

102. Winter-Quarters in Camp—The Inside of a Hut
Harper's Weekly, January 24, 1863, 9⅛″ x 13⅞″.

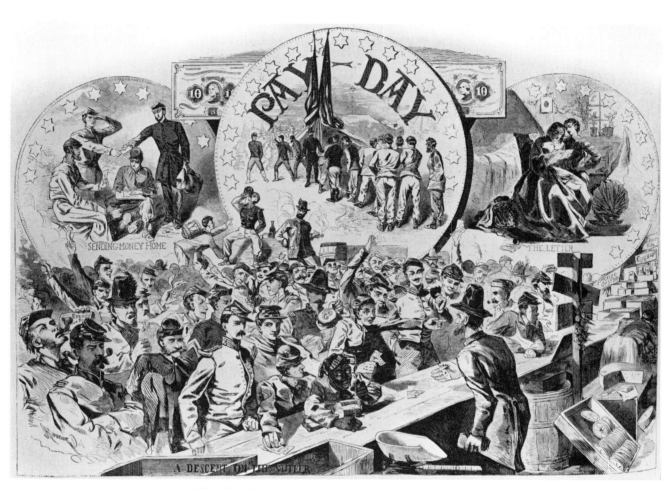

103. Pay-Day in the Army of the Potomac
Harper's Weekly, February 28, 1863, 13⅝″ x 20½″.

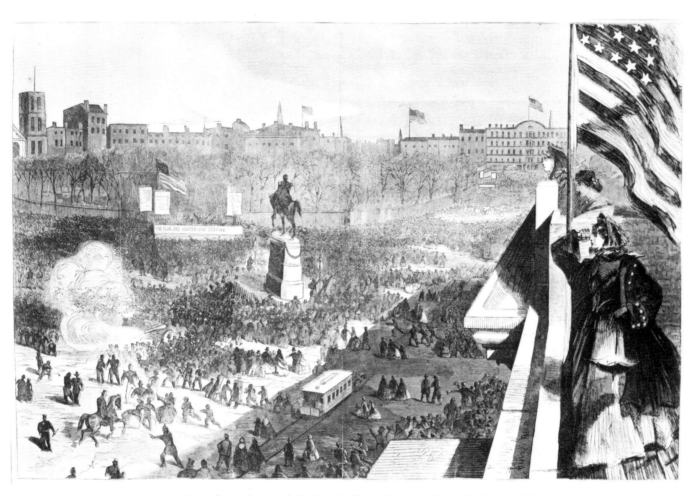

104. Great Sumter Meeting in Union Square, New York, April 11
Harper's Weekly, April 25, 1863, 9⅛″ x 13¾″.

105. The Approach of the British Pirate "Alabama"
Harper's Weekly, April 25, 1863, 13¾" x 9⅛".

[125]

106. Home from the War
Harper's Weekly, June 13, 1863, 9¼″ x 14″.

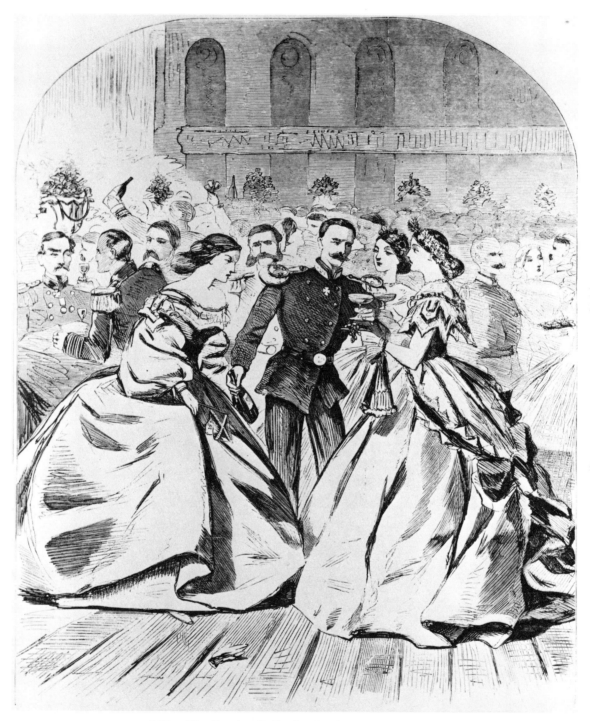

107. The Russian Ball—In The Supper Room
Harper's Weekly, November 21, 1863, 10¾″ x 9⅛″.

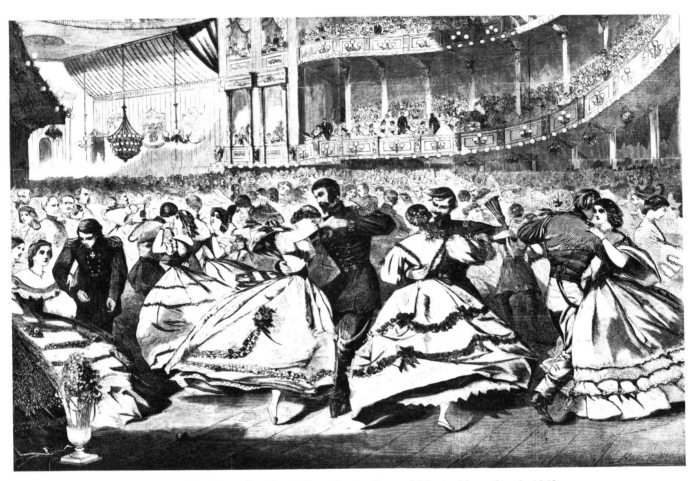

108. The Great Russian Ball at the Academy of Music, November 5, 1863
Harper's Weekly, November 21, 1863, 13⅛″ x 20⅜″.

1864

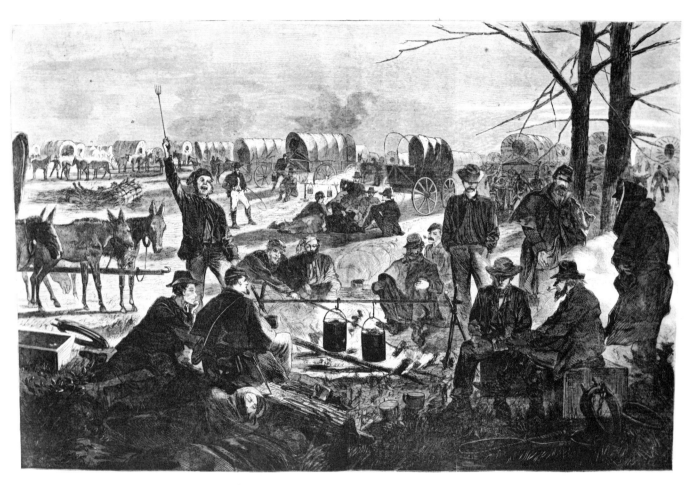

109. Halt of a Wagon Train
Harper's Weekly, February 6, 1864, 13⅛″ x 20⅜″.

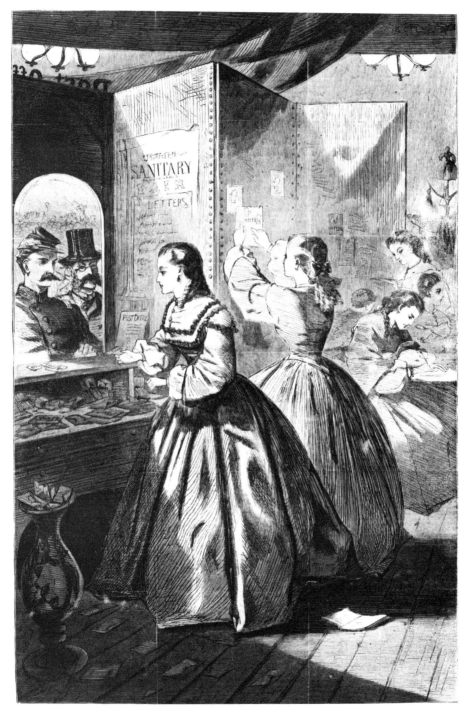

110.　"Anything for Me, if you Please?" Post-Office of the Brooklyn Fair
in Aid of the Sanitary Commission

Harper's Weekly, March 5, 1864, 13⅜" x 9⅛".

111. Thanksgiving-Day in the Army—After Dinner—The Wish-Bone
Harper's Weekly, December 3, 1864, 9¼″ x 13⅞″.

1865

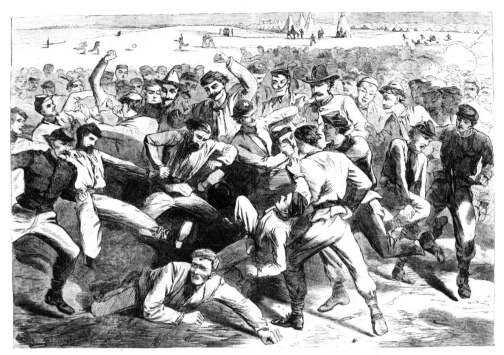

112. Holiday in Camp—Soldiers Playing "Foot-Ball"
Harper's Weekly, July 15, 1865, 9¼″ x 13¾″.

113. Our Watering-Places—The Empty Sleeve at Newport
Harper's Weekly, August 26, 1865, 9¼″ x 13¾″.

114. Our Watering-Places—Horse-Racing at Saratoga
Harper's Weekly, August 26, 1865, 9⅛″ x 13¾″.

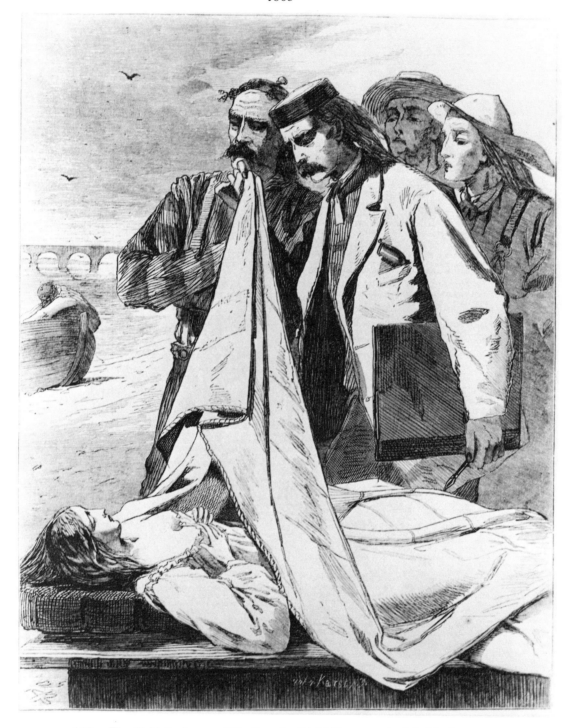

115. The Cold Embrace—"He Sees the Rigid Features, the Marble Arms, the Hands Crossed on the Cold Bosom"
Frank Leslie's Chimney Corner, June 24, 1865, 8⅜″ x 6⅝″.

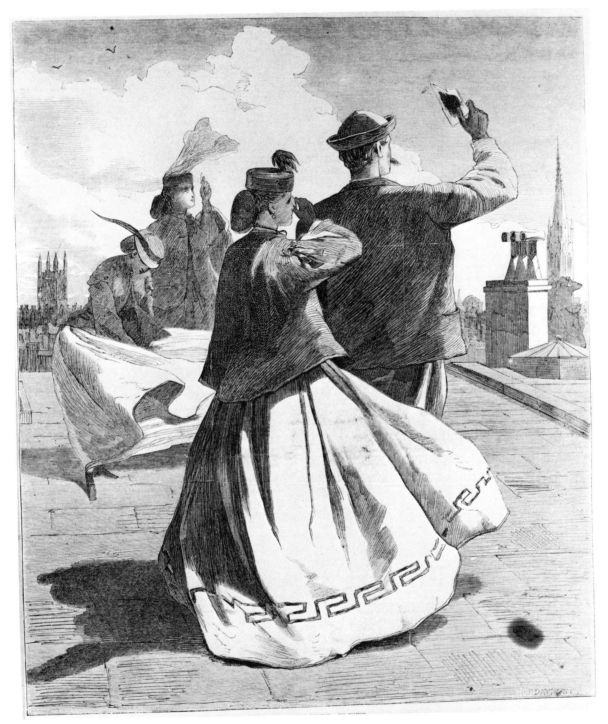

116. Looking at the Eclipse

Frank Leslie's Chimney Corner, December 16, 1865, 10¾″ x 9¼″.

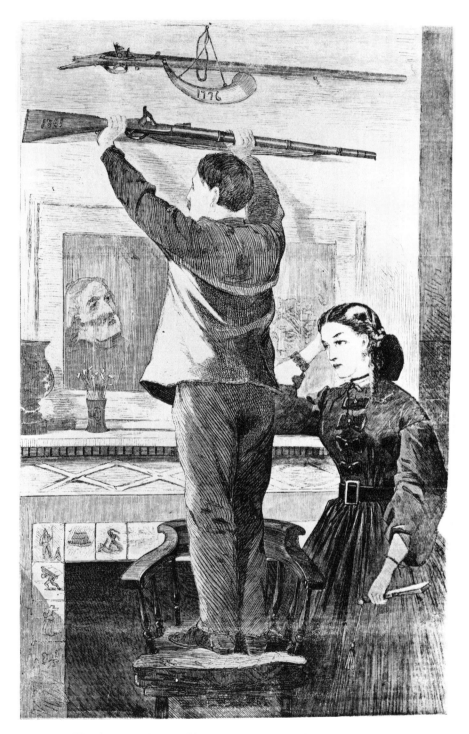

117. Thanksgiving Day— Hanging Up the Musket
Frank Leslie's Illustrated Newspaper, December 23, 1865, 14⅛″ x 9⅛″.

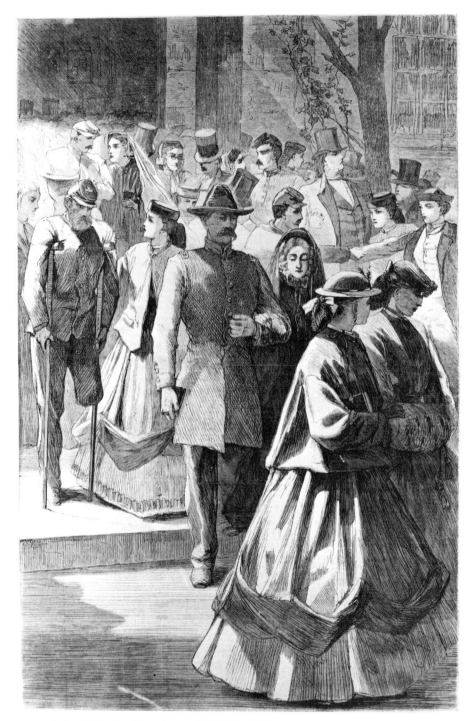

118. Thanksgiving Day—The Church Porch
Frank Leslie's Illustrated Newspaper, December 23, 1865, 13⅞″ x 9⅛″.

1866

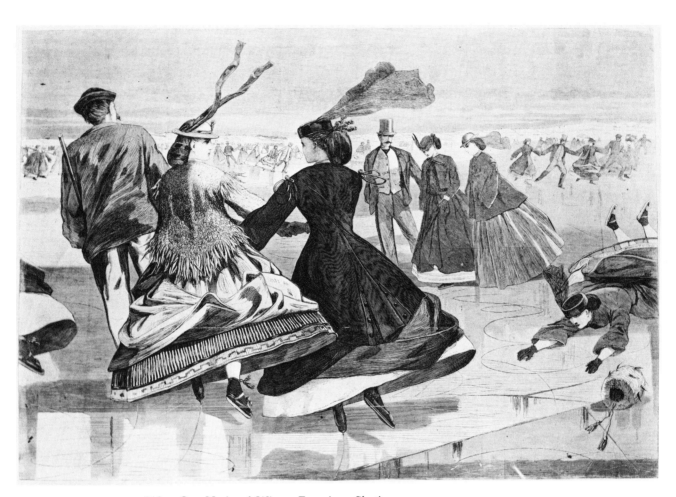

119. Our National Winter Exercise—Skating
Frank Leslie's Illustrated Newspaper, January 13, 1866, 14″ x 20½″.

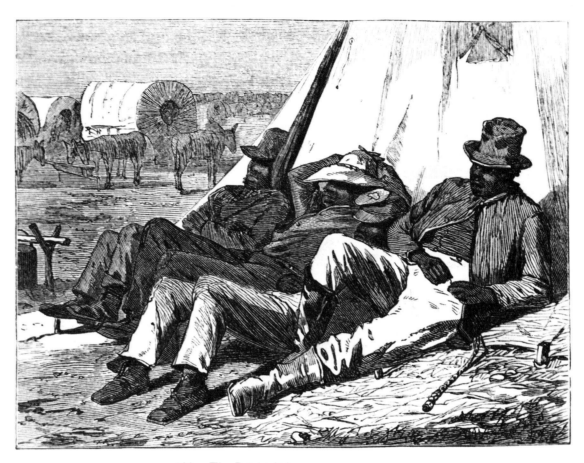

120. The Bright Side
Our Young Folks, July 1866, 2¾″ x 3⅝″.

1867

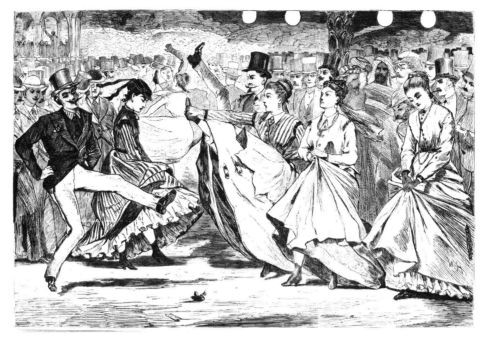

121. A Parisian Ball—Dancing at the Mabille, Paris
Harper's Weekly, November 23, 1867, 9⅛″ x 13¾″.

122. A Parisian Ball—Dancing at the Casino
Harper's Weekly, November 23, 1867, 9⅛″ x 13¾″.

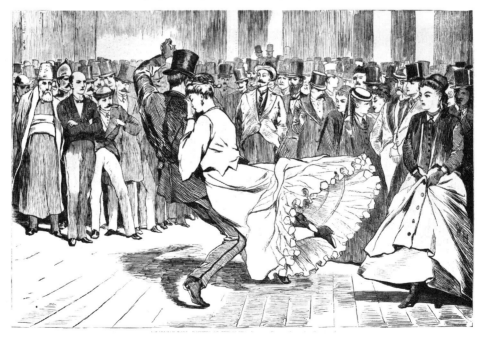

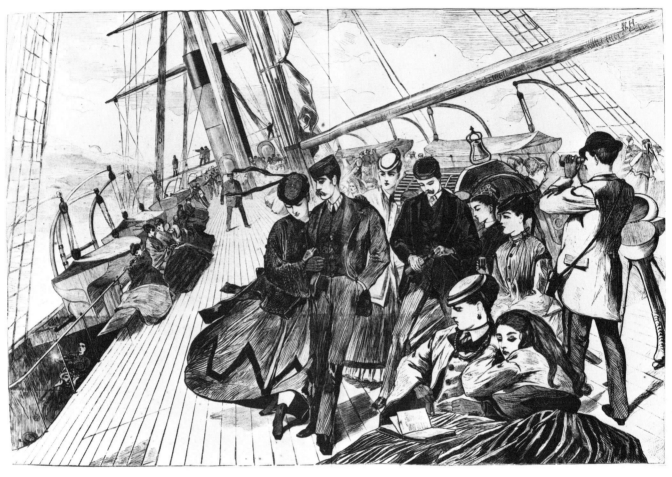

123. Homeward Bound

Harper's Weekly, December 21, 1867, 13⅞″ x 20⅜″.

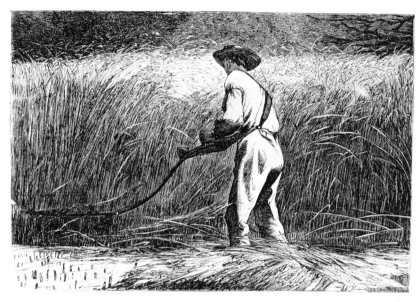

124. The Veteran in a New Field

Frank Leslie's Illustrated Newspaper, July 13, 1867, 4⅛″ x 6¼″.

125. Swinging on a Birch Tree

Our Young Folks, June 1867, 5⅞″ x 3⅝″.

126. The Bird-Catchers

Our Young Folks, August 1867, 3⅝″ x 5⅞″.

127. The Midnight Coast

The Riverside Magazine for Young People, January 1867, 5½″ x 5⅜″.

1868

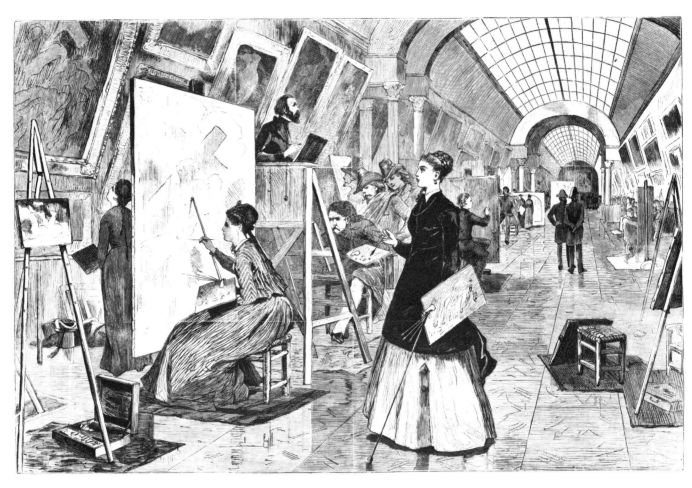

128. Art Students and Copyists in the Louvre Gallery, Paris
Harper's Weekly, January 11, 1868, 9″ x 13¾″.

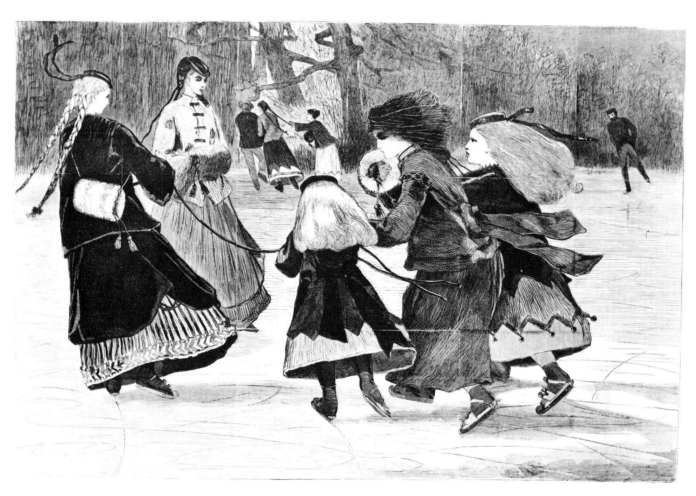

129. "Winter"—A Skating Scene
Harper's Weekly, January 25, 1868, 9″ x 13½″.

130. St. Valentine's Day—The Old Story in All Lands

Harper's Weekly, February 22, 1868, 13⅜″ x 9″.

131. The Morning Walk—The Young Ladies' School Promenading the Avenue
Harper's Weekly, March 28, 1868, 9″ x 13⅝″.

132. Fire-Works on the Night of the Fourth of July
Harper's Weekly, July 11, 1868, 9⅛″ x 13¾″.

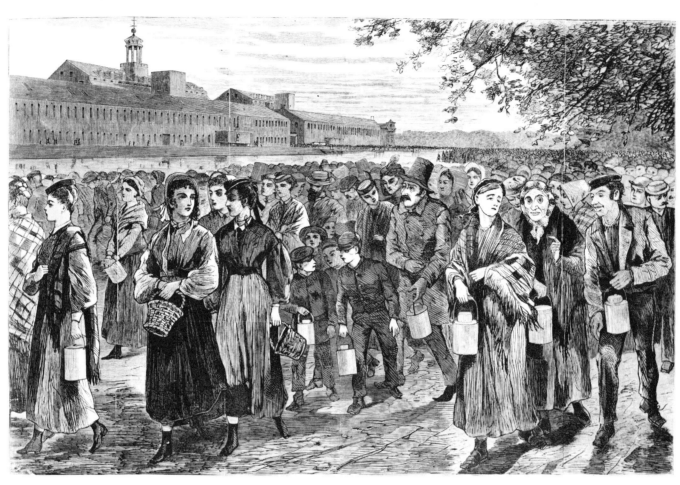

133. New England Factory Life—"Bell-Time"
Harper's Weekly, July 25, 1868, 8¾" x 12⅞".

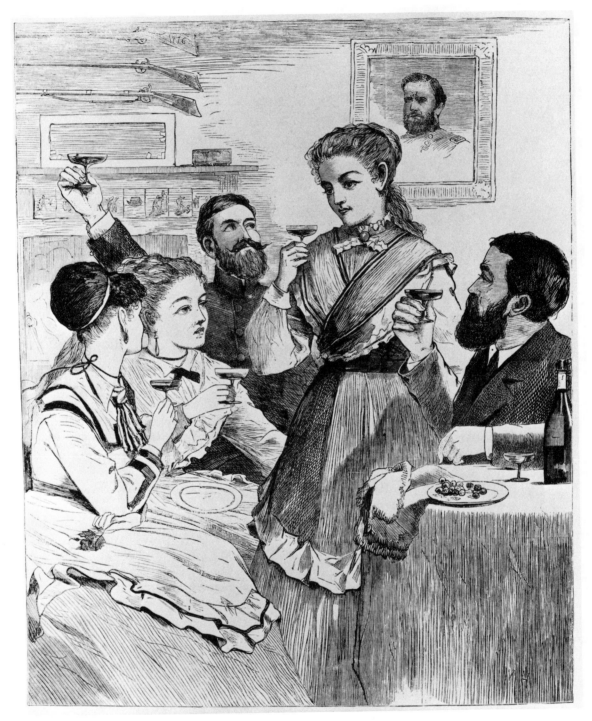

134. "Our Next President"—(U.S. Grant)
Harper's Weekly, October 31, 1868, 9⅛″ x 10⅞″.

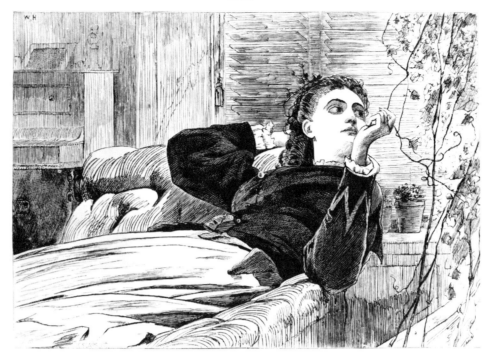

135. "She Turned Her Face to the Window."
The Galaxy, May 1868, 4⅞″ x 7″.

136. "You Are Really Picturesque, My Love."
The Galaxy, June 1868, 4⅝″ x 6⅞″.

137. Jessie Remained Alone at the Table
The Galaxy, July 1868, 4⅞″ x 6⅞″.

138. "Orrin, Make Haste, I Am Perishing!"
The Galaxy, August 1868, 4⅝″ x 6⅞″.

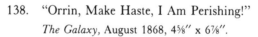

139. "I Cannot! It Would Be a Sin! A Fearful Sin!"
The Galaxy, September 1868, 6⅞″ x 4⅞″.

140. Opening Day in New York

Harper's Bazar, March 21, 1868, 13½″ x 20″.

141. The Fourth of July in Tompkins Square, New York—"The Sogers Are Coming!"

Harper's Bazar, July 11, 1868, 8⅛″ x 12¼″.

142. Blue Beard Tableau

Harper's Bazar, September 5, 1868
Fatima Enters the Forbidden Closet, 4⅛″ x 4⅛″.
What She Sees There, 3⅛″ x 8¼″.
Disposition of the Bodies, 3⅞″ x 4⅛″.

143. Our Minister's Donation Party
Harper's Bazar, December 19, 1868, 9¼″ x 13¾″.

144. Watching the Crows
Our Young Folks, June 1868, 5⅞″ x 3⅝″.

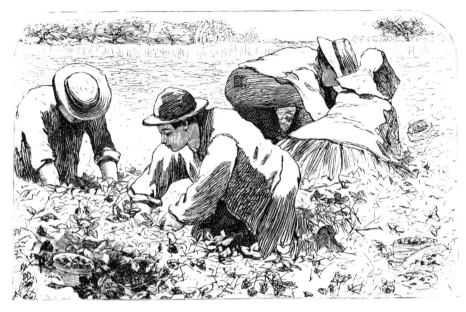

145. The Strawberry Bed
Our Young Folks, July 1868, 3⅜″ x 5⅝″.

146. Green Apples
Our Young Folks, August 1868, 5⅞″ x 3⅝″.

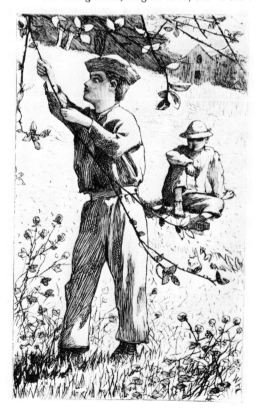

1869

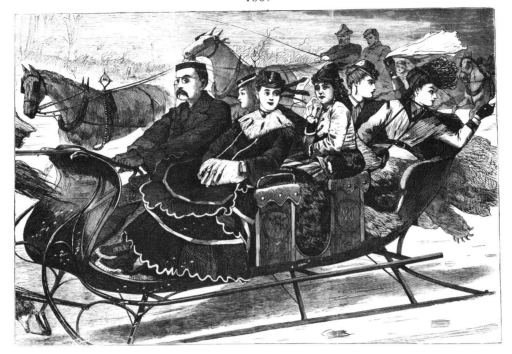

147. Christmas Belles
 Harper's Weekly, January 2, 1869, 9¹⁄₁₆″ x 13⅝″.

148. The New Year—1869
 Harper's Weekly, January 9, 1869, 9″ x 13¾″.

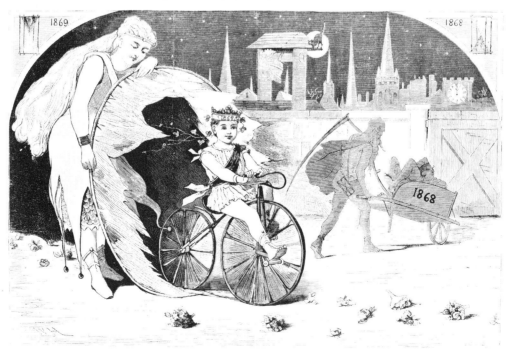

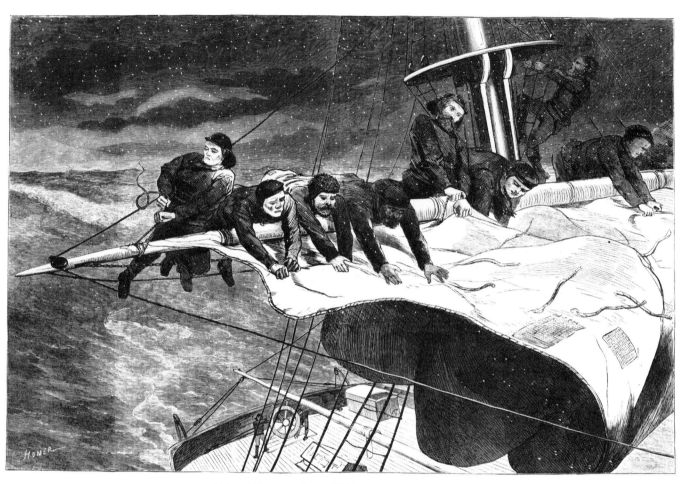

149. Winter at Sea—Taking in Sail Off the Coast
Harper's Weekly, January 16, 1869, 8⅞″ x 12⅞″.

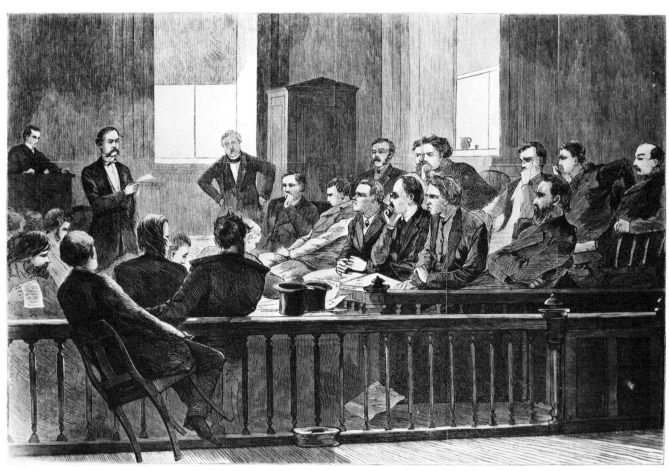

150. Jurors Listening to Counsel, Supreme Court, New City Hall, New York
Harper's Weekly, February 20, 1869, 9″ x 13⅝″.

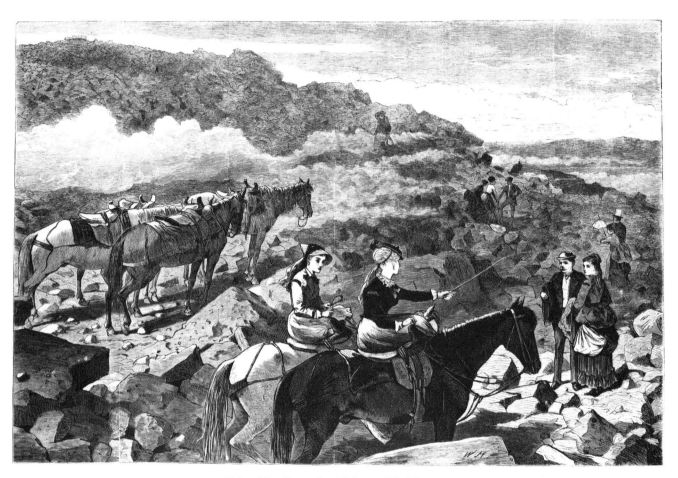

151. The Summit of Mount Washington
Harper's Weekly, July 10, 1869, 13¾″ x 9″.

152. "All in the Gay and Golden Weather"
 Appleton's Journal, June 12, 1869, 5½″ x 6½″.

153. The Artist in the Country
 Appleton's Journal, June 19, 1869, 6¼″ x 6⅝″.

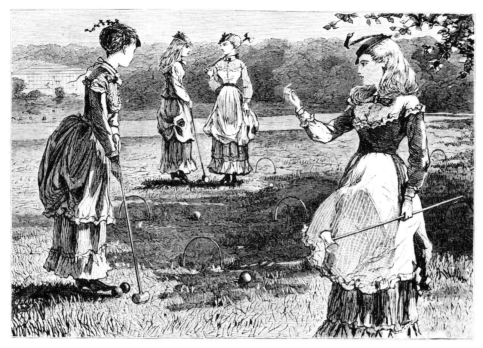

154. Summer in the Country
Appleton's Journal, July 10, 1869, 4½″ x 6½″.

155. On the Road to Lake George
Appleton's Journal, July 24, 1869, 6⅛″ x 6⅝″.

156. The Last Load

Appleton's Journal, August 7, 1869, 4½″ x 6½″.

157. The Picnic Excursion

Appleton's Journal, August 14, 1869, 6½″ x 9⅛″.

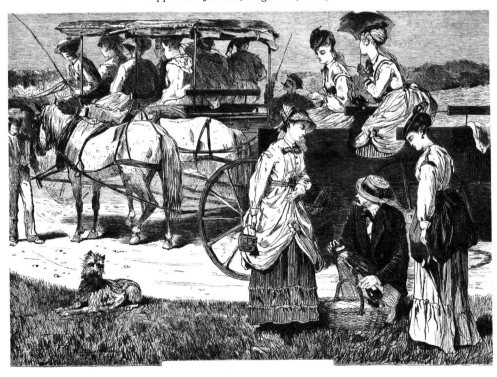

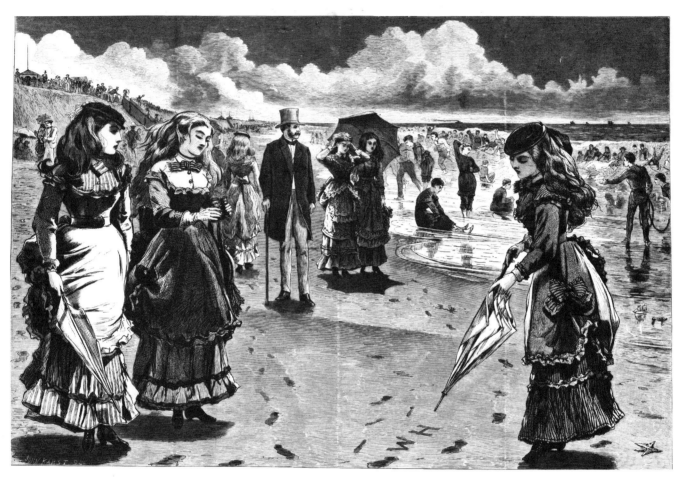

158. The Beach at Long Branch
Appleton's Journal, August 21, 1869, 13″ x 19⅜″.

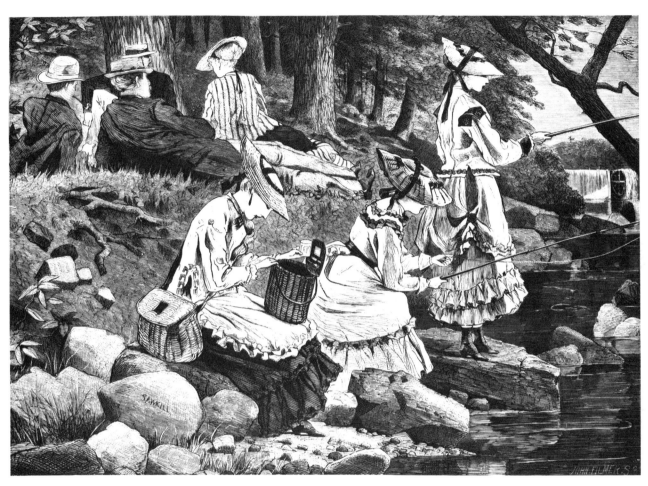

159. The Fishing Party
Appleton's Journal, October 2, 1869, 9″ x 13¾″.

160. "Hi! H-o-o-o! He Done Come. Jumboloro Tell You Fust."
The Galaxy, June 1869, 6⅞″ x 4⅞″.

161. "Come!"

The Galaxy, September 1869, 4¾″ x 6⅞″.

162. "I Call Them My Children—To Myself, Susan"
The Galaxy, October 1869, 4½″ x 6⅞″.

163. Weary and Dissatisfied with Everything
The Galaxy, November 1869, 7″ x 4⅜″.

164. In Came a Storm of Wind, Rain and Spray—and Portia
The Galaxy, December 1869, 6½″ x 4⅜″.

165. Waiting for Calls on New Year's Day
Harper's Bazar, January 2, 1869, 9″ x 13¾″.

166. What Shall We Do Next?
Harper's Bazar, July 31, 1869, 9⅛″ x 13⅜″.

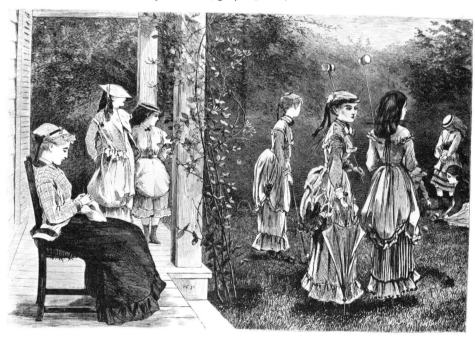

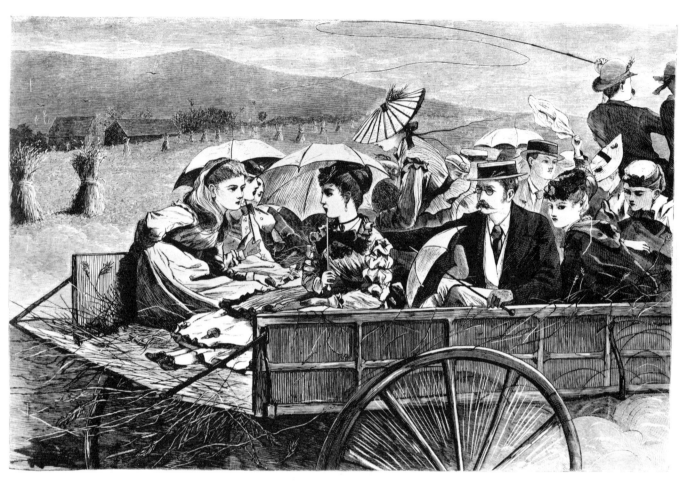

167. The Straw Ride
Harper's Bazar, September 25, 1869, 9⅛″ x 13⅞″.

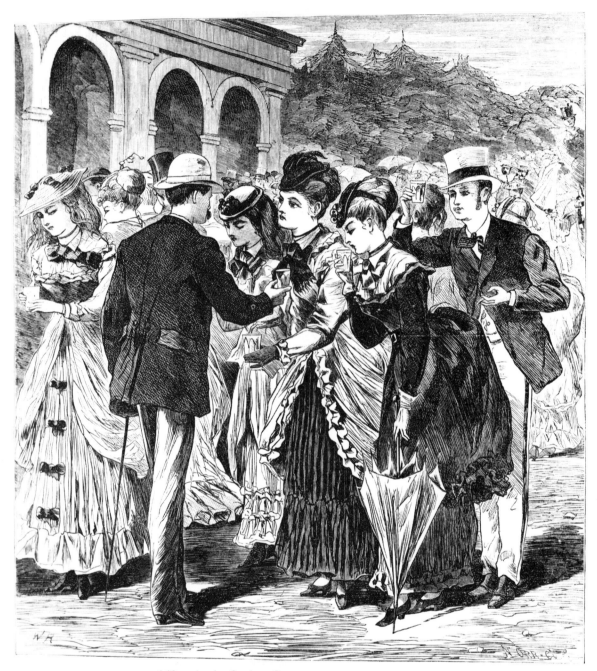

168. At the Spring: Saratoga
Hearth and Home, August 28, 1869, 9⅛″ x 8½″.

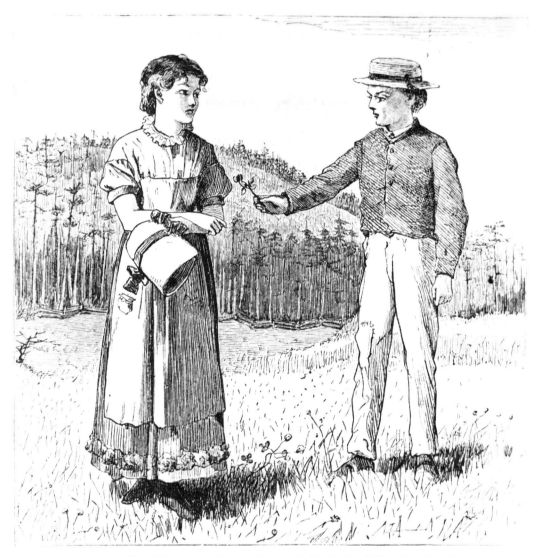

169. The Playmates—From Whittier's "Ballads of New England"
Our Young Folks, November 1869, 3⅝″ x 3⅝″.

1870

170. 1860–1870
Harper's Weekly, January 8, 1870, 13″ x 20⅜″.

171. "Tenth Commandment"
Harper's Weekly, March 12, 1870, 10½″ x 9″.

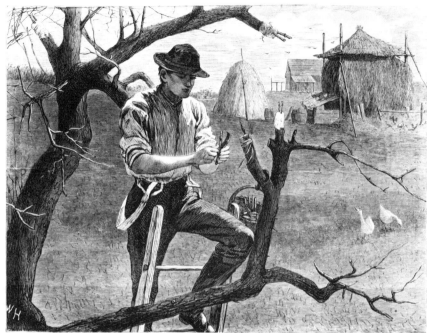

172. Spring Farm Work—Grafting

Harper's Weekly, April 30, 1870, 6⅞″ x 9⅛″.

173. Spring Blossoms

Harper's Weekly, May 21, 1870, 9⅛″ x 13⅞″.

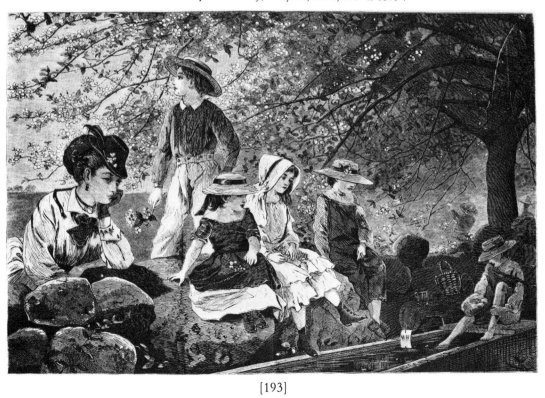

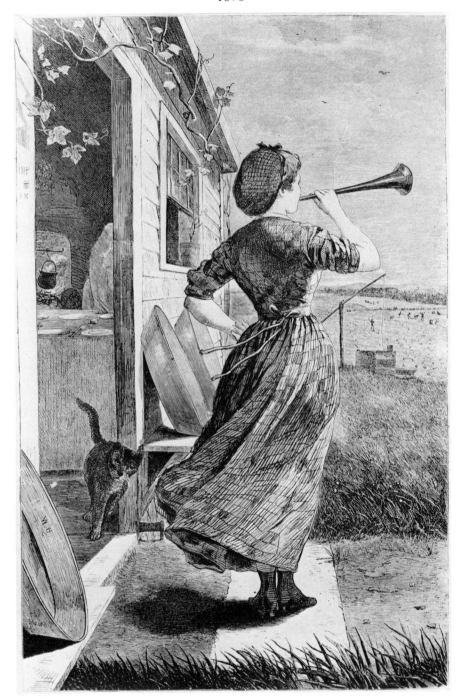

174. The Dinner Horn
Harper's Weekly, June 11, 1870, 13¾″ x 9″.

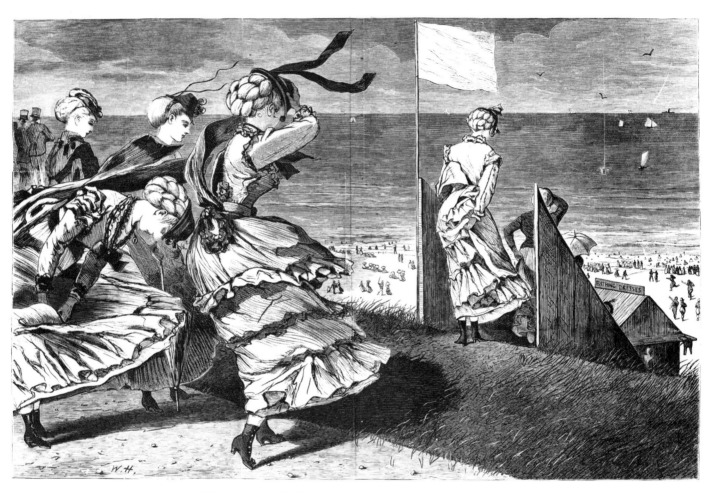

175. On the Bluff at Long Branch, at the Bathing Hour
Harper's Weekly, August 6, 1870, 8⅞″ x 13⅝″.

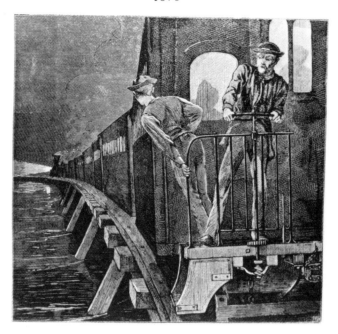

176. Danger Ahead
 Appleton's Journal, April 30, 1870, 6⅛″ x 6½″.

177. A Quiet Day in the Woods
 Appleton's Journal, June 25, 1870, 6⅛″ x 6½″.

178. High Tide

Every Saturday, August 6, 1870, 8⅞″ x 11¾″.

179. Low Tide

Every Saturday, August 6, 1870, 8⅞″ x 11¾″.

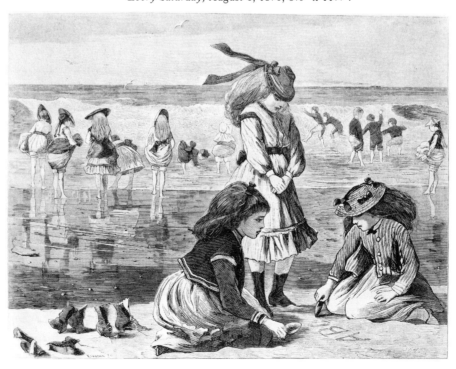

180. The Robin's Note
Every Saturday, August 20, 1870, 9″ x 8⅞″.

181. Chestnutting

Every Saturday, October 29, 1870, 11¾″ x 8¾″.

182. Trapping in the Adirondacks
Every Saturday, December 24, 1870, 8⅞″ x 11⅝″.

183. George Blake's Letter
The Galaxy, January 1870, 6½″ x 4½″.

184. Another Year by the Old Clock

Harper's Bazar, January 1, 1870, 15½″ x 11″.

185. The Coolest Spot in New England—Summit of Mount Washington
Harper's Bazar, July 23, 1870, 13¾″ x 9⅛″.

186. On the Beach at Long Branch
Harper's Bazar, September 3, 1870, 9″ x 13¾″.

1871

187. A Winter Morning—Shovelling Out

Every Saturday, January 14, 1871, 8⅞″ x 11¾″.

188. Deer-Stalking in the Adirondacks in Winter

Every Saturday, January 21, 1871, 8⅞″ x 11¾″.

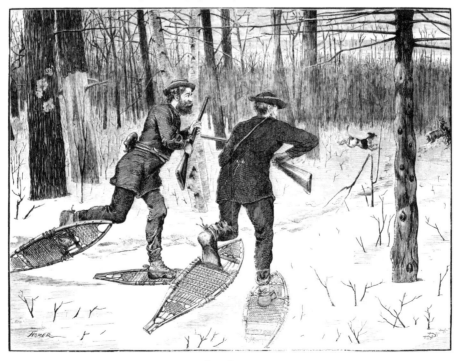

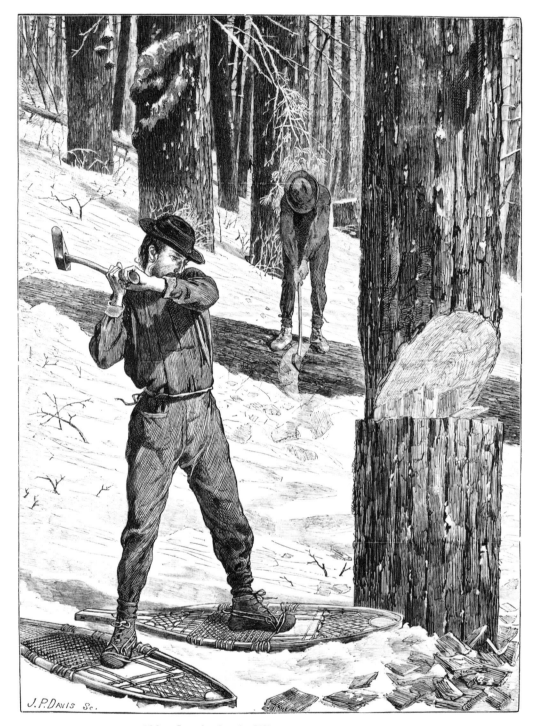

189. Lumbering in Winter

Every Saturday, January 28, 1871, 11⅝″ x 8⅞″.

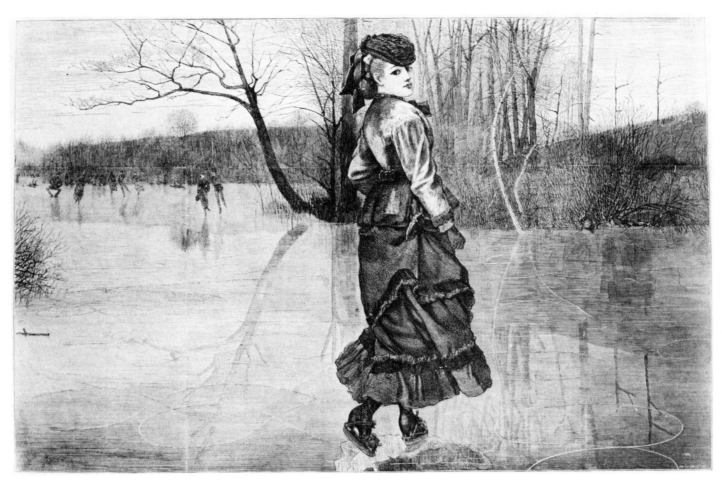

190. Cutting a Figure
Every Saturday, February 4, 1871, 11¹¹⁄₁₆″ x 18⅝″.

191. A Country Store—Getting Weighed
Every Saturday, March 25, 1871, 8⅞″ x 11⅝″.

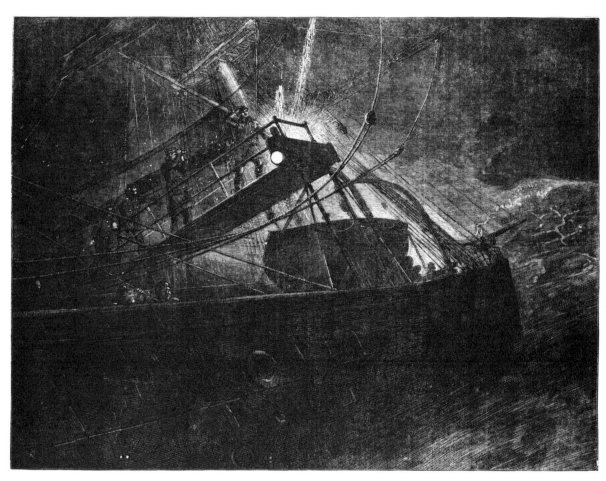

192. At Sea—Signalling a Passing Steamer
Every Saturday, April 8, 1871, 8¾″ x 11⅝″.

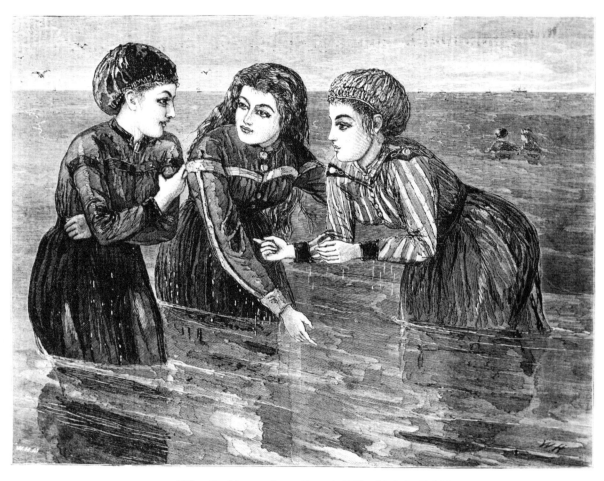

193. Bathing at Long Branch "Oh, Ain't It Cold"
Every Saturday, August 26, 1871, 9⅛″ x 11¾″.

1872

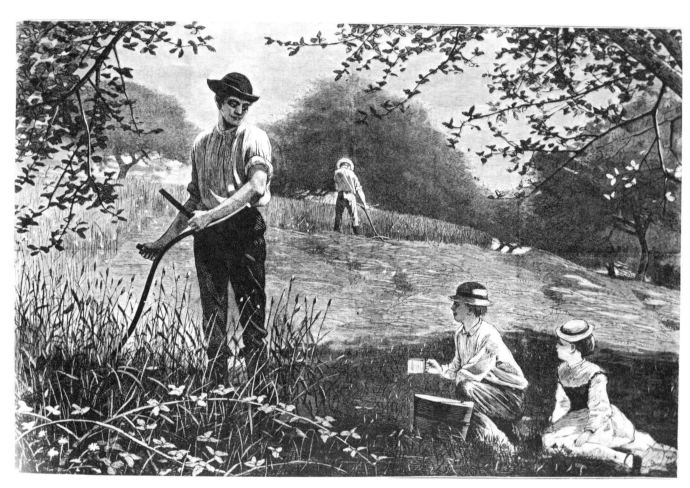

194. Making Hay

Harper's Weekly, July 6, 1872, 9⅛″ x 13⅞″.

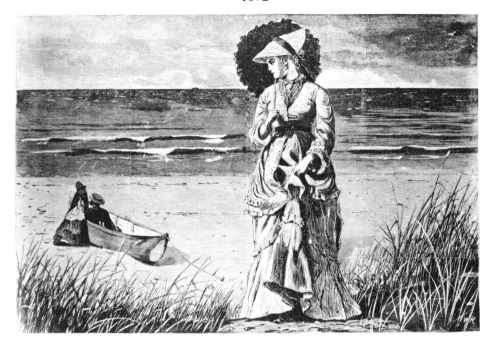

195. On the Beach—Two Are Company, Three Are None
Harper's Weekly, August 17, 1872, 9⅛″ x 13¾″.

196. Under the Falls, Catskill Mountains
Harper's Weekly, September 14, 1872, 9⅛″ x 13⅞″.

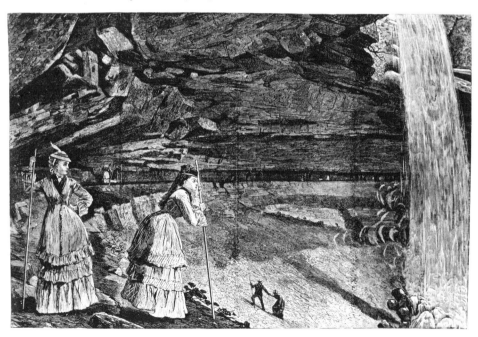

1873

197. The Wreck of the "Atlantic"—Cast Up by the Sea
Harper's Weekly, April 26, 1873, 9⅛″ x 13¾″.

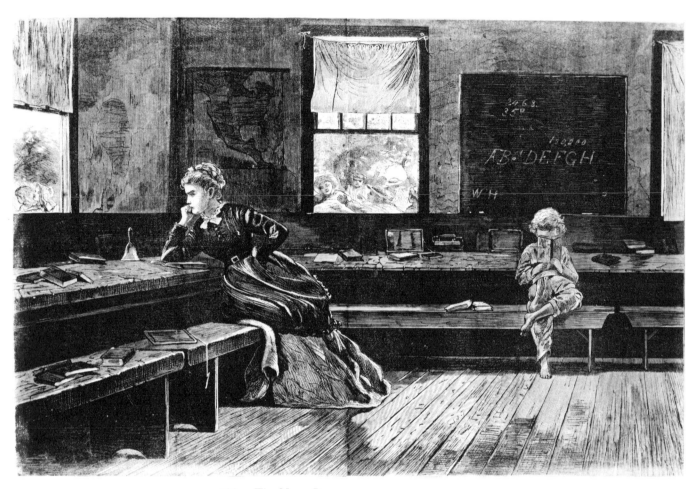

198. The Noon Recess

Harper's Weekly, June 28, 1873, 9⅛″ x 13⅝″.

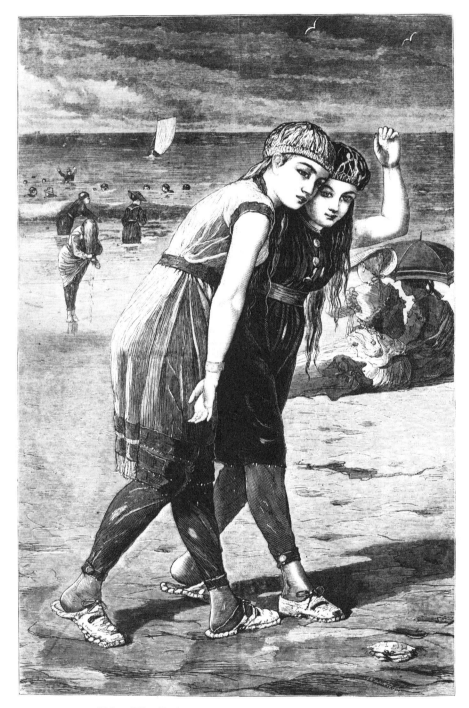

199. The Bathers
Harper's Weekly, August 2, 1873, 13¾″ x 9¼″.

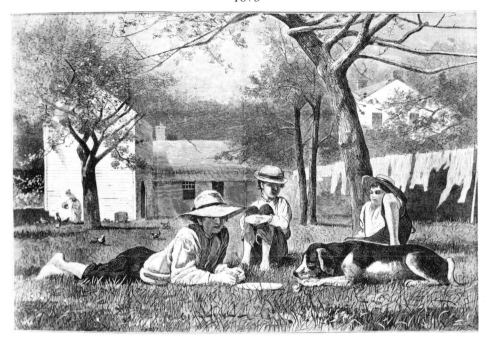

200. The Nooning
Harper's Weekly, August 16, 1873, 9″ x 13¾″.

201. Sea-Side Sketches—A Clam-Bake
Harper's Weekly, August 23, 1873, 9¼″ x 14″.

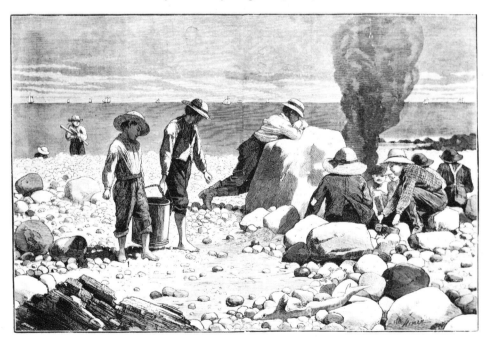

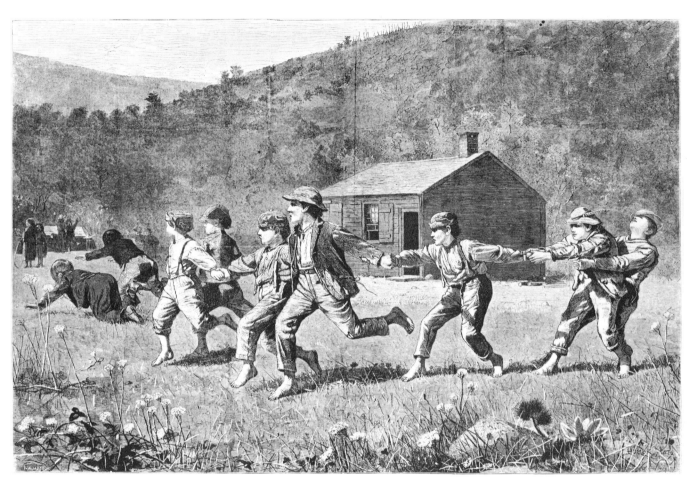

202. "Snap-the-Whip"

Harper's Weekly, September 20, 1873, 13⁹⁄₁₆″ x 20⅝″.

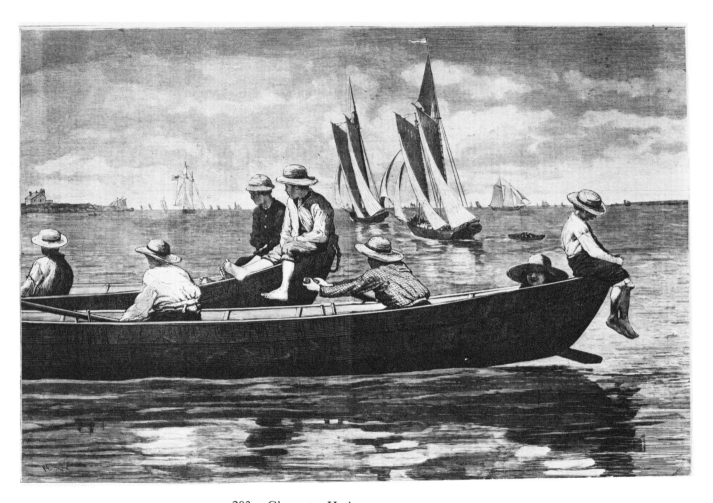

203. Gloucester Harbor
Harper's Weekly, September 27, 1873, 9⅜″ x 14″.

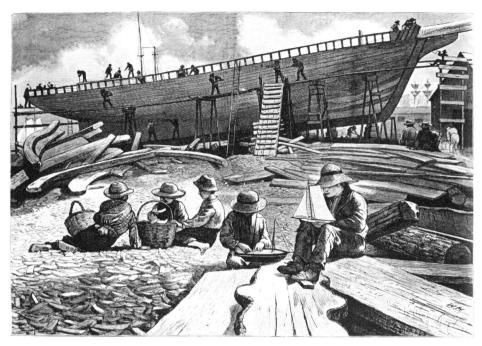

204. Shipbuilding, Gloucester Harbor
Harper's Weekly, October 11, 1873, 9⅜″ x 13¾″.

205. "Dad's Coming!"
Harper's Weekly, November 1, 1873, 9¼″ x 13½″.

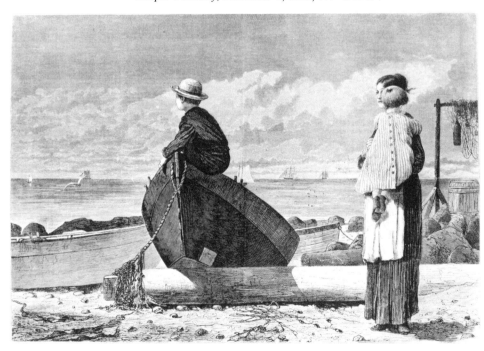

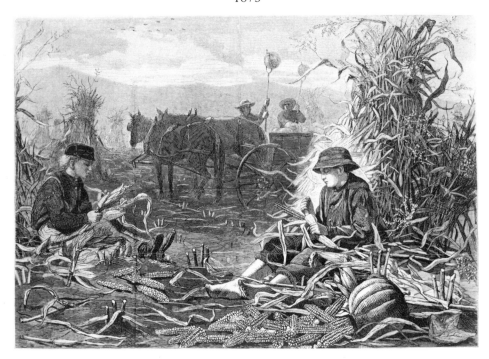

206. The Last Days of Harvest
 Harper's Weekly, December 6, 1873, 9¼″ x 13⅜″.

207. The Morning Bell
 Harper's Weekly, December 13, 1873, 9⅛″ x 13½″.

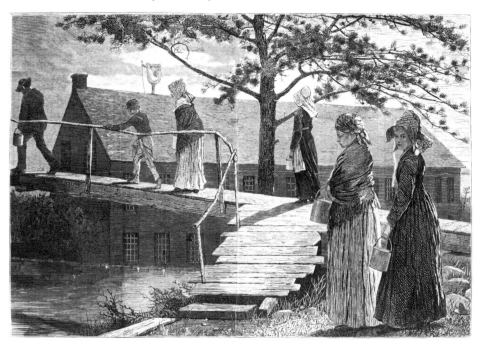

1874

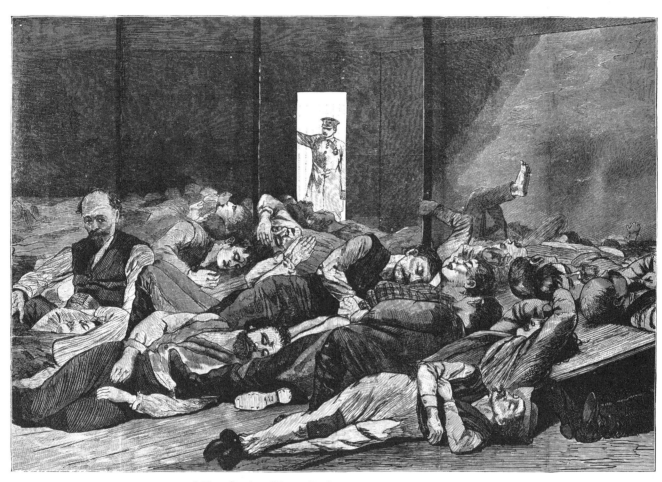

208. Station-House Lodgers
Harper's Weekly, February 7, 1874, 9⅛″ x 13½″.

THE WATCHMAN.

THE TOWER NINE O'CLOCK BELL A FIRE

209. Watch-Tower, Corner of Spring and Varick Streets, New York
Harper's Weekly, February 28, 1874, 13″ x 9⅛″.

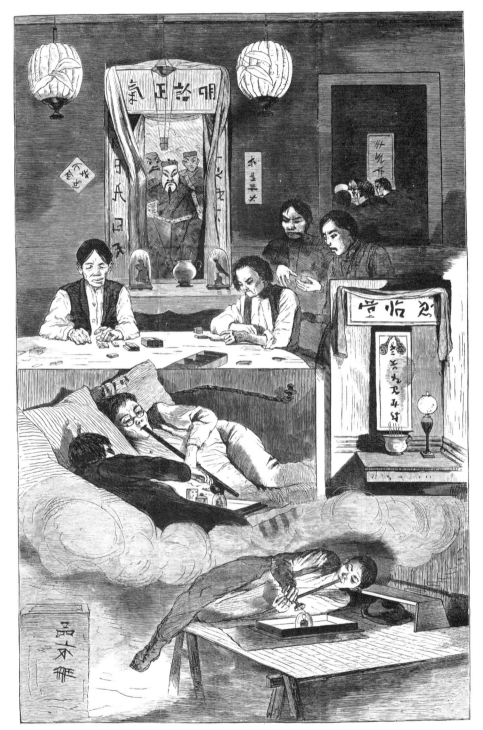

210. The Chinese in New York—Scene in a Baxter Street Club-House
Harper's Weekly, March 7, 1874, 10⅞″ x 9⅛″.

211. New York Charities—St. Barnabas House, 304 Mulberry Street
Harper's Weekly, April 18, 1874, 9⅛″ x 13⅜″.

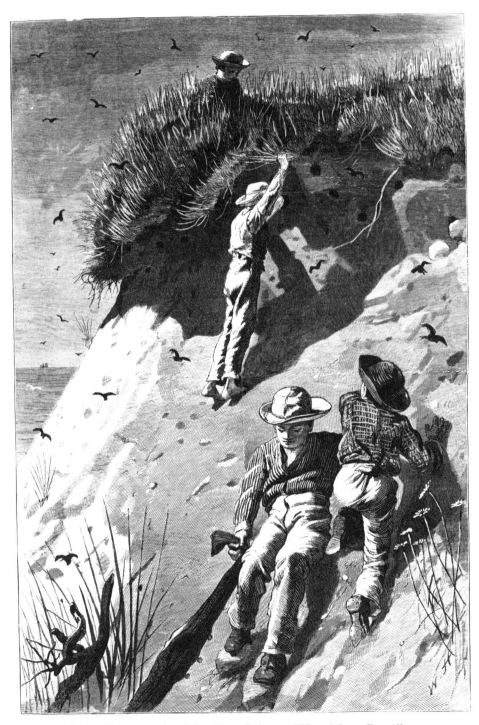

212. Raid on a Sand-Swallow Colony—"How Many Eggs?"
Harper's Weekly, June 13, 1874, 13⅜″ x 9⅛″.

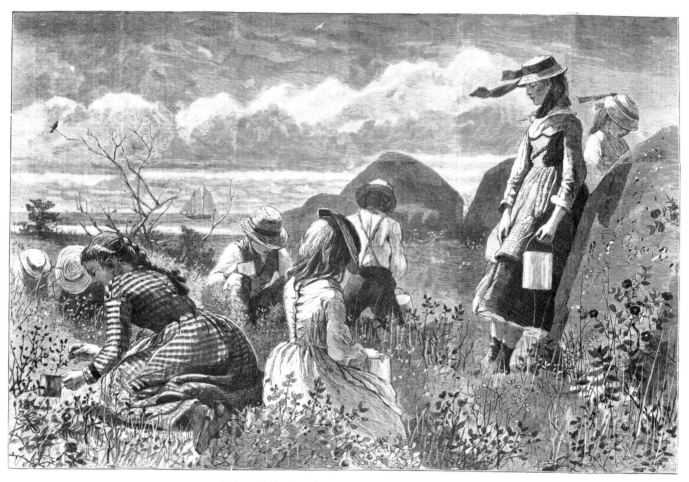

213. Gathering Berries
Harper's Weekly, July 11, 1874, 9⅛″ x 13½″.

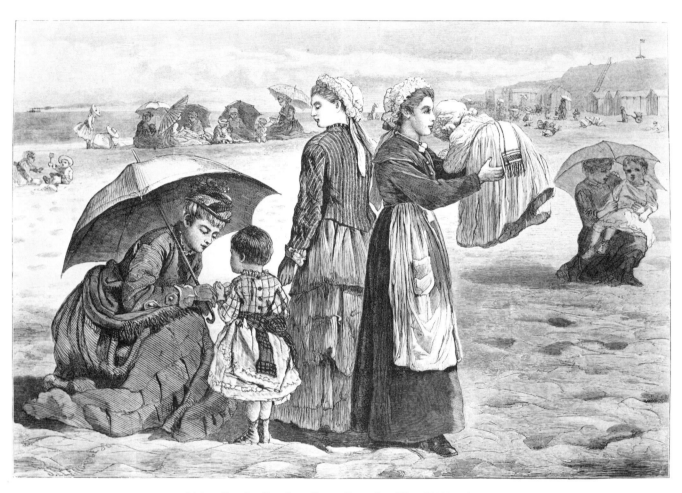

214. On the Beach at Long Branch—The Children's Hour
Harper's Weekly, August 15, 1874, 9¼″ x 13⅜″.

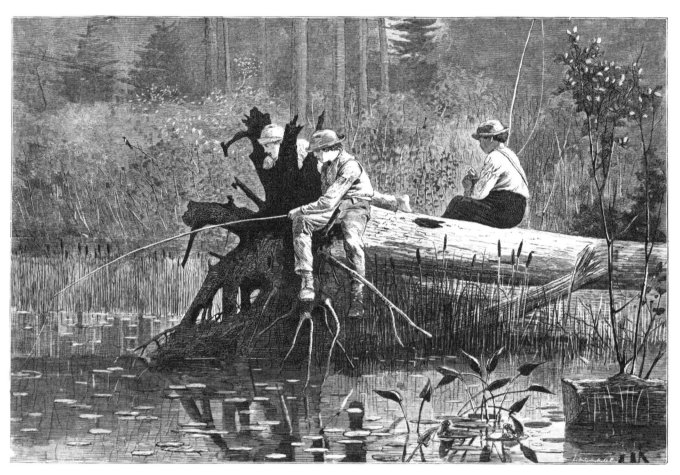

215. Waiting for a Bite
Harper's Weekly, August 22, 1874, 9⅛″ x 13¾″.

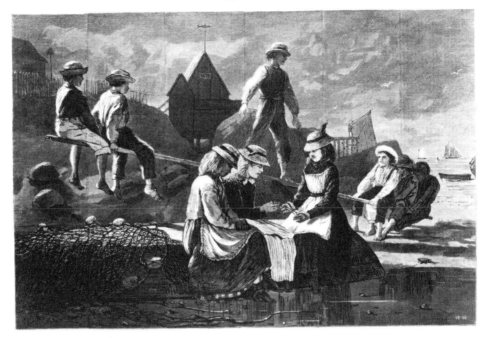

216. See-Saw—Gloucester, Massachusetts
Harper's Weekly, September 12, 1874, 9⅛″ x 13¾″.

217. Flirting on the Seashore and on the Meadow
Harper's Weekly, September 19, 1874, 9⅛″ x 13½″.

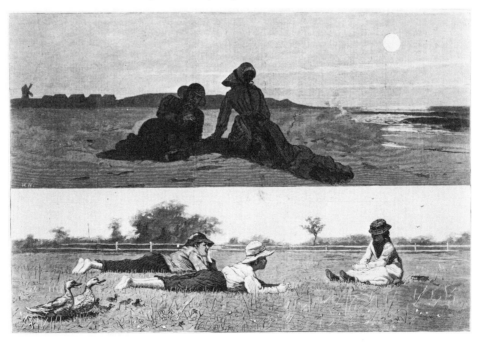

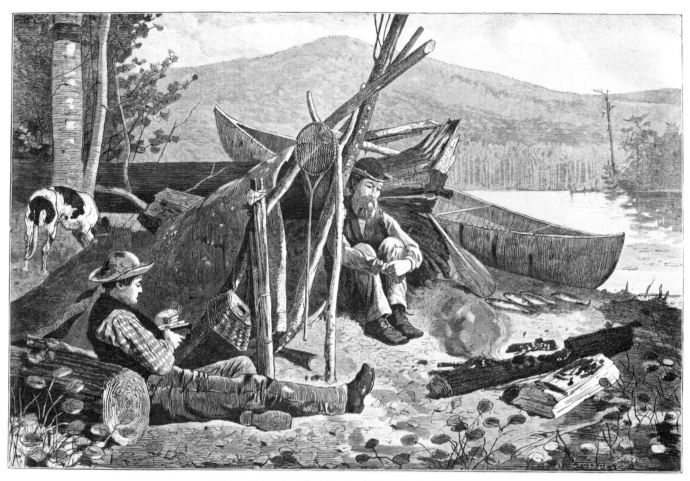

218. Camping Out in the Adirondack Mountains
Harper's Weekly, November 7, 1874, 9⅛″ x 13¾″.

1875

219. The Battle of Bunker Hill—Watching the Fight from Copp's Hill
in Boston

Harper's Weekly, June 26, 1875, 9⅛″ x 13⅝″.

220. The Family Record

Harper's Bazar, August 28, 1875, 12″ x 8⅛″.

Chronology

A biographical chronology which lists in summary form some of the key events in Homer's life in chronological order is offered here for those who may have become interested in his wood engravings without having familiarized themselves with the other aspects of his long career. A perusal of these facts will assist such readers in placing his career as an illustrator in the context, or perspective, of his achievements as a whole. A chronology may also serve a useful function if it enables readers who are familiar with Homer's career to refer to or confirm certain facts which are not easily remembered, or to refer to them in connection with the checklist of engravings.

1836 Born in Boston, February 24, at No. 25 Friend Street, near Faneuil Hall, to Charles Savage Homer, Sr., and Henrietta Maria Benson Homer.

1842 Homer family moved to a house on Massachusetts Avenue, Cambridge, in the vicinity of Harvard College.

1854 Apprenticed, at age eighteen, to J. H. Bufford, lithographer, Boston.

1857 Completed his apprenticeship at Bufford's on his twenty-first birthday. Left to become a free-lance illustrator. Rented studio in Ballou's Pictorial Building. Sent first engravings to *Ballou's Pictorial* and *Harper's Weekly.*

1859 Moved to New York in the autumn.

1861 Night student at the National Academy of Design under Professor Thomas Seir Cummings. Studio in the New York University Building, Washington Square. Studied painting with Frédéric Rondel. March, covered Lincoln's inauguration. October, sent by *Harper's* as an artist-correspondent to cover General George McClellan's Army of the Potomac.

1862 On the Peninsula Campaign, Virginia, April and May. Wood engravings of the Civil War for *Harper's,* and initial oil paintings, e.g.: *A Sharpshooter on Picket Duty.*

1863–1865 Occasional trips to the war front.

1864 First rural paintings. Elected Associate Member of the National Academy of Design.

1865 Elected full member of the National Academy, and member of the Century Club, New York.

[243]

1866 Exhibited *Prisoners from the Front,* first widely acclaimed oil. Sailed for France in the fall, visited Paris and countryside.

1867 Returned from France late in the year.

1868 Summer, rendered White Mountain scenes in both oil and wood engraving, e.g.: *Bridle Path.*

1869 Returned to the White Mountains in the summer. Oil, *Long Branch, New Jersey.*

1870 First visit to Baker's Farm in the Adirondacks. Engraving, *Trapping in the Adirondacks.* Stayed at Long Branch, New Jersey, summer.

1872 Moved to Tenth Street studios. Painted noted oil, *"Snap-the-Whip."*

1873 Summer at Gloucester, Massachusetts. Important watercolor series and engravings of seaside activities: *Berry Pickers,* watercolor, and *Gathering Berries,* engraving, for *Harper's.*

1874 June, returned to Adirondacks; rendered watercolors; first exhibit with Water Color Society.

1875 Final wood engraving for *Harper's.* Returned to Petersburg, Virginia, July; started oil studies of blacks: *The Carnival, A Visit from the Old Mistress.* First visit to Prout's Neck, Maine, during honeymoon of younger brother, Arthur.

1876 Exhibited oil, *Snap the Whip,* at Centennial Exposition, Philadelphia. Painted famous oil, *Breezing Up.*

1878 Summer, rendered watercolors at Valentine family Houghton Farm, Mountainville, New York. Exhibited oil, *Snap the Whip,* at Paris Universal Exposition.

1879 Summer, visited older brother, Charles, and family, at West Townsend, near Belmont, Massachusetts. Rural studies.

1880 Summer at Gloucester, Massachusetts, painted important watercolor series.

1881 Spring, second European trip, to Tynemouth, England, on North Sea coast, near Newcastle. Important watercolors and drawings of fisher folk.

1882 Returned from Tynemouth to New York in November.

1883 Visited Atlantic City, early summer, studied Coast Guard rescue activities. Moved permanently, from New York to new studio-home at Prout's Neck, Maine. Began noted series of marine paintings with *The Life-Line,* finished and exhibited the following year.

1884 Started important marines, *The Fog Warning* (1885), *Eight Bells* (1886), *The Herring Net* (1885), and watercolor studies of the Prout's Neck cliffs. December, first trip to Nassau, Bahamas.

1885 Stayed in Nassau January and February; visited Santiago de Cuba in March; important tropical watercolors.

1886 Fished, painted watercolors, St. John's River area, Florida, in January. Charter member of North Woods Club, Essex County, Adirondacks.

1887–1889 Brief instruction in etching; did unique series based on oil and watercolor paintings, *A Voice from the Cliffs, The Life-Line,* etc. The venture was unsuccessful financially, abandoned.

1889 Painted outstanding watercolors summer and fall in Adirondacks: *Trout Breaking.*

1890 Returned to Florida; watercolors.

1890 Early part of year in Florida; watercolors. Painted first pure marines in oil at Prout's Neck, *Sunlight on the Coast, A Summer Night,* and *Winter Coast.* Started *A Signal of Distress,* December.

1891–1892 Watercolors, summer and fall, Adirondacks. Painted noted oil, *The West Wind* (1891).

1893 Finished *The Fox Hunt.* Visited the World's Columbian Exposition at Chi-

cago in the summer; received a gold medal for *The Gale;* painted *Fountains at Night.*

1894 June, painted watercolors in Adirondacks: *Waterfall in the Adirondacks; The North Woods.* Pennsylvania Academy of the Fine Arts purchased *The Fox Hunt* for $1,200. Summer and fall painted noted group of marines: *Artist's Studio in an Afternoon Fog; Moonlight, Wood's Island Light; High Cliff, Coast of Maine; Weatherbeaten; Below Zero.*

1895 Important visit to Quebec City and Province of Quebec, August and September. Painted watercolors at Lake Tourilli and Roberval, Lake St. John, Upper Saguenay River Valley: *Trout Fishing Lake St. John; A Good Pool, Saguenay River; Homer's Cabin, Tourilli Club; Bear Breaking Through a Canoe.* Painted marine masterpieces, *Cannon Rock* and *The Northeaster.*

1896 Exhibited *The Wreck* at the Carnegie International at Pittsburgh; received a gold medal and purchase award of $5,000. Painted *The Lookout—"All's Well."*

1897 Returned to Quebec Province, summer, painted watercolors.

1898 December, in Nassau. *Rum Cay; Tornado, Bahamas.*

1899 Stayed in Nassau January and February; December in Bermuda. Continued noted tropical watercolor series: *The Turtle Pound; Sloop, Bermuda.* Completed tropical oil: *The Gulf Stream.* Sale of the Thomas B. Clarke Collection, including thirty-one pictures by Homer.

1900 Painted watercolors in Adirondacks in June; oil of *Eastern Point.* Exhibited *A Summer Night* at Universal International Exposition, Paris; bought by the French government. Brother Charles awarded a bronze medal for achievements in chemistry. Finished *On a Lee Shore, Eastern Point* and *West Point.*

1901 Watercolors, Bermuda; oil painting of *Searchlight, Harbor Entrance, Santiago de Cuba.*

1902 In Quebec Province in August. Important watercolors at Lake St. John and Saguenay River area: *Shooting the Rapids at Grand Discharge.* Painted oil, *Early Morning After a Storm at Sea.* Awarded Temple Gold Medal by Pennsylvania Academy of the Fine Arts for *The Northeaster.*

1903–1904 Painted watercolors at Homosassa River, Florida, December, 1903 through March, 1904: *The Turkey Buzzard, The Shell Heap, Homosassa River.* Oils: *Kissing the Moon* and *A Summer Squall.*

1905 Painted last signed and dated watercolor: *Diamond Shoal.*

1906 First serious illness during the summer. *The Gulf Stream* purchased by the Metropolitan Museum for $4,500.

1907 Repainted and finished Tynemouth oil, *Early Evening.*

1908 Last Florida trip, March. Suffered paralytic stroke in May. Recovered. In Adirondacks during the summer. Last watercolor: *The Wrecked Schooner.*

1909 Finished *Right and Left;* November, signed final oil marine: *Driftwood.*

1910 Died, September 29, at Prout's Neck at age of seventy-four. Cremated. Ashes buried in Mt. Auburn Cemetery, Cambridge, near boyhood home.

Checklist

The checklist which follows was compiled as a practical aid to museum curators and directors, art historians, scholars, art dealers, students, librarians, collectors, connoisseurs, and others who are interested in the authentication of the wood engravings designed by Winslow Homer as illustrations for magazines. In making the selection the originality of the artist was stressed over copy work. Therefore the considerable body of portraits which Homer did from photographs, as the titles often state, was omitted, as was the group of illustrations based on photographs. In neither area was the artist able to be fully creative.

The checklist was limited further by the use of 1875 as a cutoff date. Most scholars agree that the process of wood engraving for magazine illustrations, as it had been known in its best decades, declined after 1875 among artists in general, and that Homer was no exception. For reasons which are considered in the text, Homer may also have used up his interest and inspiration for this medium by that time.

A checklist of this type is based on the work of others who have been especially interested in the wood engravings of Winslow Homer over a period of decades, particularly Allen Evarts Foster, Mary Bartlett Cowdrey, Barbara Gelman, and the preeminent Homer authority, Lloyd Goodrich. Also referred to were the list of Perry Walton, the opinions of Edgar Preston Richardson, and the expertise of private collectors who have devoted years to the process of forming outstanding collections of the wood engravings, notably the Reverend and Mrs. Frederick Peet Taft, Dr. and Mrs. Mavis Kelsey, and the late Ray Austrian.

Inasmuch as their several services were weighed and cross-checked in the formation of conclusions, the checklist is a consensus. It will, however, vary from title to title according to the extent of agreement about each attribution. As in a Supreme Court decision, numbers are weighed in the balance. To permit the reader to form an opinion, a system of symbols was used below each title on a picture by picture basis, with F, C, G, and L.G. representing a reasonable degree of concurrence, for example, by respectively Foster,

Cowdrey, Gelman, and Goodrich. Where some difference of opinion is unavoidable, the more agreement the better.

The terminology of distinctions, or shades of preference, ranges from "undoubtedly" through "probably," and "possibly" to "doubtful," "questionable," or a flat "No!." These opinions are often accompanied by reasons for their determination, either a general or specific reference to style, execution, signature, or other relevant evidences.

These nuances of assessment were not included here, as this is not a Catalogue Raisonné which marshals all possible evidence and often fills a volume and is a lifetime of work. The shades of meaning were carefully considered, nevertheless. A title was therefore included even though only one authority argued on its behalf when the reasons of that scholar were persuasive.

A checklist derives from a process of elimination, or a cumulative procedure, with a graduated set of certainties. In the case of the engravings of Homer's day, when there was little motive for forging, the appearance of the designer's name or initials within the boundary of the block is an excellent sign of validity. Hence the evidence of the block has been listed in each instance.

Further proof of legitimacy appears when the artist's name was printed with the title, as in the cases where the subject is followed by "Drawn by Winslow Homer" or similar recognition. This sign has also been included whenever found.

A third form of support may frequently be found in the text, where credit for a design was often given by such words as, "Drawn expressly for us by Winslow Homer." This helpful, often illuminating support, has been included with each title whenever available, for the engravings are usually exhibited today in framed and matted form, but without the presence of the text which originally accompanied them. It has therefore been supplied in summary words.

When the three main types of support—signature, the inclusion of the artist's name in the printed title, and credit in a textual reference—are all or partly present, a checklist can be compiled with certainty. Wherever all such evidence is absent, the assessment of style alone determines a decision. Those with less experience must then turn to scholars for an "educated opinion." This procedure can never be dismissed from a world of art which is never fully documented. When there was a cause for pause given by the range of opinion among experts, it seemed better to err on the side of caution. A longer checklist could have been offered. The aim, in this case, was to omit titles about which there was widespread and positive doubt, but retain for further study those which were favored by some with good reasons. No harm will have been done if they are consigned for a later judgment to a place in the limbo of discredited or tried but discarded works of art. In sum, the weighing of authenticity by style rather than documentation is, and always will be, an ongoing process. This particular checklist can only be a contribution for the present time.

All dimensions of engravings are in inches, with height preceding width.

Checklist

Two hundred and three of the wood engravings included in this book are reproduced from the Winslow Homer Collection, in the Bowdoin College Museum of Art. The remaining seventeen engravings are reproduced by courtesy of the Rev. and Mrs. Frederick Peet Taft.

1857

Ballou's Pictorial Drawing-Room Companion, Vol. XII

1 CORNER OF WINTER, WASHINGTON AND SUMMER STREETS, BOSTON
Block: W. H.–Damoreau
June 13, 1857, p. 369, 7¼x9½
Text: "by Winslow Homer, a promising young artist of this city"
F137, C1, G2

Vol. XIII

2 THE FOUNTAIN ON BOSTON COMMON
Block: Homer–Damoreau
Aug. 15, 1857, p. 97, cover, 7¼x9½
Text: "Our Artist, Mr. Homer"
F139, C2, G9

3 A BOSTON WATERING-CART
Sept. 12, 1857, p. 161, cover, 7¼x9½
Text: "Our Artist, Mr. Homer"
F140, C3, G10

4 VIEW IN SOUTH MARKET STREET, BOSTON
Block: Homer–Damoreau Sc.
Oct. 3, 1857, p. 209, cover, 7¼x9½
Text: "Our Artist, Mr. Homer"
F142, C4, G12

5 EMIGRANT ARRIVAL AT CONSTITUTION WHARF, BOSTON
Block: Homer–Damoreau
Oct. 31, 1857, p. 273, cover, 5½x9½
F145, C5, G15

6 BOSTON EVENING STREET SCENE, AT THE CORNER OF COURT AND BRATTLE STREETS
Block: Homer
Nov. 7, 1857, p. 289, cover, 6⅜x9⅜
Text: "Mr. Homer has drawn"
F146, C6, G16

7 HUSKING PARTY FINDING THE RED EARS
Block: Homer–Damoreau
Nov. 28, 1857, p. 344, 6⅜x9⅜
F148, C7, G18

8 BLIND MAN'S BUFF
Nov. 28, 1857, p. 344, 4½x7
F147, G17

9 FAMILY PARTY PLAYING AT FOX AND GEESE
Block: Homer–Damoreau
Nov. 28, 1857, p. 345, 5⅜x9⅜
F149, C8, G19

10 COASTING OUT OF DOORS
Block: W. Homer–Fox
Nov. 28, 1857, p. 345, 4½x7
F150, C9, G20

Harper's Weekly, Vol. I

11 (1) THE MATCH BETWEEN THE SOPHS AND FRESHMEN—THE OPENING
Block: W. Homer
Aug. 1, 1857, pp. 488–489, 6x21½
F1,2,3,4,5, C10, G4,5,6,7,8
On the same pages:

12 (2) Freshmen
7x5
13 (3) Sophs
7x5
14 (4) Juniors
7x5
15 (5) Seniors
7x5

1858

Ballou's Pictorial, Vol. XIV

16 The "Cold Term," Boston—Scene, Corner of Milk and Washington Streets
Block: H
Mar. 27, 1858, p. 193, 6⅞x9⅜
Text: "an original sketch made for us by Mr. Homer"
 F151, C11, G21

Vol. XV

17 Class Day, at Harvard University, Cambridge, Mass.
July 3, 1858, p. 1, 5½x9⅜
Text: "The sketch on this page is from the pencil of Mr. Homer"
 F152, C12, G24
Collection of the Rev. and Mrs. Frederick Peet Taft
18 Camp Meeting Sketches (four separate blocks): Landing at the Cape
Aug. 21, 1858, p. 120, 5x9⅜
Text: "From drawings made expressly for us by Mr. Homer"
 F153, C13(a), G25
19 Camp Meeting Sketches: Morning Ablutions
Block: Peirce

Aug. 21, 1858, p. 120, 5x9⅜
 F153, C13(b), G26
20 Camp Meeting Sketches: Cooking
Aug. 21, 1858, p. 121, 5x9⅜
 F153, C13(c), G27
21 Camp Meeting Sketches: The Tent
Aug. 21, 1858, p. 121, 5x9⅜
 F153, C13(d), G28

Harper's Weekly, Vol. II

22 Spring in the City
Block: WH
Apr. 17, 1858, p. 248, 9⅛x13¾
 F6, C14, G22
23 The Boston Common
Block: Homer, Del.
May 22, 1858, p. 329, 9¼x14
 F7, C15, G23
24 A Picnic by Land
June 5, 1858, p. 360, 9⅛x13¾
 L.G.7a
25 The Bathe at Newport
Block: Homer Del.
Sept. 4, 1858, p. 568, 9¼x13¾
 F8, C16, G29
26 Picnicking in the Woods
Block: Homer
Sept. 4, 1858, p. 569, 9¼x13¾
 F9, C17, G30
27 Husking the Corn in New England
Block: Homer Del.
Nov. 13, 1858, p. 728, 9¼x13⅞
 F10, C18, G32, L.G.37
28 Driving Home the Corn
Block: Homer Del.
Nov. 13, 1858, p. 729, 5⅞x9¼
 F11, C19, G33
29 The Dance After the Husking
Block: W.H.
Nov. 13, 1858, p. 729, 6x9¼
 F12, C20, G34
30 Thanksgiving Day—Ways and Means

Block: Homer
Nov. 27, 1858, p. 760, 6⅞x9¼
F13, C21, G35

31 THANKSGIVING DAY—ARRIVAL AT THE
OLD HOME
Nov. 27, 1858, p. 760, 6¼x9¼
F14, G36

32 THANKSGIVING DAY—THE DINNER
Nov. 27, 1858, p. 761, 6⅞x9¼
F15, G37

33 THANKSGIVING DAY—THE DANCE
Nov. 27, 1858, p. 761, 6½x9¼
F16, G38

34 CHRISTMAS—GATHERING EVERGREENS
Block: Homer Del.
Dec. 25, 1858, p. 820, 5⅞x9⅛
F17, C22, G40

35 THE CHRISTMAS-TREE
Block: W.H.
Dec. 25, 1858, p. 820, 5⅞x9⅛
F18, C23, G41

36 SANTA CLAUS AND HIS PRESENTS
Block: W.H.
Dec. 25, 1858, p. 821, 5¾x9⅛
F19, C24, G42

37 CHRISTMAS OUT OF DOORS
Block: W.H.
Dec. 25, 1858, p. 821 6x9⅛
F20, C25, G43

1859

Ballou's Pictorial, Vol. XVI

38 SKATING ON JAMAICA POND, NEAR
BOSTON
Block: Homer-Hayes
Jan. 29, 1859, p. 65, 5½x9½
Text: "The graceful picture below was
drawn expressly for us by Mr. Homer."
F159, C26, G47

39 SLEIGHING IN HAYMARKET SQUARE,
BOSTON
Block: W. H.-Hayes
Jan. 29, 1859, p. 72, 5x9⅜
Text: "Our artist, Mr. Homer, has
faithfully executed the commission we
gave him."
F160, C27, G48

40 SLEIGHING ON THE ROAD, BRIGHTON,
NEAR BOSTON
Block: Damoreau
Jan. 29, 1859, p. 72, 5x9⅜
Text: "Our artist Mr. Homer has
faithfully executed the commission we
gave him."
F161, C28, G49

41 TROTTING ON THE MILL DAM, BOSTON
Block: Damoreau
Feb. 12, 1859, p. 105, 5x9½
F163, G51

42 LA PETITE ANGELINA AND MISS C.
THOMPSON AT THE BOSTON MUSEUM
Block: Homer
Mar. 12, 1859, p. 168, 4½x6¾
Text: "The accompanying picture . . .
was drawn expressly for us by Mr.
Homer."
F167, C29, G56

43 EVENING SKATING SCENE AT THE
SKATING PARK, BOSTON
Mar. 12, 1859, p. 168, 4⅞x9¼
Text: "The accompanying . . . picture
was drawn expressly for us by Mr.
Homer."
F168, C30, G57

44 THE NEW TOWN OF BELMONT,
MASSACHUSETTS
Block: Homer-Damoreau
Apr. 23, 1859, p. 264, 4⅞x9¼
Text: "The accompanying view . . . was
drawn expressly for the Pictorial by Mr.
Homer."
F172, C31, G63
Collection of the Rev. and Mrs.

Frederick Peet Taft

45 THE WONDERFUL DUTTON CHILDREN
Block: W.H.–Tarbell Sc.
May 14, 1859, p. 305, 6¾x5
Text: "... from a drawing made
expressly for us by Mr. Homer."
F171, G66

46 SCENE ON THE BACK BAY LANDS,
BOSTON
Block: W. H.–Tarbell
May 21, 1859, p. 328, 5x9½
Text: "Mr. Homer has selected for
illustration...."
F175, C32, G67

47 THE AQUARIAL GARDENS, BROMFIELD
STREET, BOSTON
Block: W. Homer–Damoreau Sc.
May 28, 1859, p. 335, cover, 6½x9⅜
Text: "The accompanying engraving is
from a drawing made expressly for us by
Mr. Homer."
F176, C33, G68

48 CRICKET PLAYERS ON BOSTON COMMON
June 4, 1859, p. 360, 5½x9½
Text: "The ... picture below was drawn
for us expressly by Mr. Homer."
F177, C34, G69
Collection of the Rev. and Mrs.
Frederick Peet Taft

Vol. XVII

49 CAMBRIDGE CATTLE MARKET
Block: WH–Peirce
July 2, 1859, p. 8, 6x9½
Text: "... our artist, Mr. Homer."
F25S, C35, G72
Collection of the Rev. and Mrs.
Frederick Peet Taft

50 FOURTH OF JULY SCENE ON BOSTON
COMMON
July 9, 1859, p.17, cover, 5½x9½
Text: "... our artist, Mr. Homer."
F26S, C36, G73

51 "BOSTON STREET CHARACTERS"
Block: W. Homer Del.
July 9, 1859, p. 24, 13½x9½
F27S, C37, G74

Harper's Weekly, Vol. III

52 SKATING AT BOSTON
Mar. 12, 1859, p. 173, 9¼x13¾
Text: "by a correspondent residing in
Boston."
F21, G55, L.G.

53 MARCH WINDS
Block: Homer Del.
April 2, 1859, p. 216, 5⅞x9⅛
F22, C38, G60

54 APRIL SHOWERS
Block: Homer
April 2, 1859, p. 217, 5⅞x9⅛
F23, C39, G61

55 MAY-DAY IN THE COUNTRY
April 30, 1859, p. 280, 9⅛x13¾
F24, G64, L.G.

56 AUGUST IN THE COUNTRY—THE SEA-
SHORE
Block: W. Homer. Del.
Aug. 27, 1859, p. 553, 9¼x13¾
F25, C40, G76

57 A CADET HOP AT WEST POINT
Block: Homer
Sept. 3, 1859, p. 568, 9¼x13⅞
F26, C41, G77

58 THE GRAND REVIEW AT CAMP
MASSACHUSETTS, NEAR CONCORD
Block: W. Homer Del.
Sept. 24, 1859, pp. 616–617, 13⅝x20¼
F27, C42, G78

59 FALL GAMES—THE APPLE BEE
Block: W. Homer Del.
Nov. 26, 1859, p. 761, 9⅛x13¾
F28, C43, G79

60 "A MERRY CHRISTMAS AND A HAPPY
NEW YEAR"

Block: W. Homer Del.
Dec. 24, 1859, pp. 824–825, 13¾x20
F29, C44, G81

1860

Harper's Weekly, Vol. IV

61 THE SLEIGHING SEASON—THE UPSET
Block: W. Homer
Jan. 14, 1860, p. 24, 9⅛x13¾
F30, C45, G82

62 A SNOW SLIDE IN THE CITY
Block: Homer Del.
Jan. 14, 1860, p. 25, 9⅛x13¾
F31, C46, G83

63 SKATING ON THE LADIES' SKATING-POND
IN THE CENTRAL PARK, NEW YORK
Block: W. Homer Del.
Jan. 28, 1860, pp. 56–57, 13¾x20⅛
F32, C47, G84, L.G.38

64 UNTITLED ILLUSTRATION... A WOMAN
POSTING A NOTICE ON A TREE
Block: Unsigned
Feb. 18, 1860, p. 97, 4⅛x2¼
Text: (In the issue of Feb. 11, 1860, p.
81, there is an announcement that a
new serial entitled "The Mistress of the
Parsonage" by Ella Rodman, with
illustrations by Winslow Homer, will
commence in the next number.)
F1-S, C48, G85

65 "ALLOW ME TO EXAMINE THE YOUNG
LADY."
Block: Unsigned
Feb. 18, 1860, cover, p. 97, 4⅜x4½
F2-S, C49, G86

66 THE MEETING AFTER THE MARRIAGE
Block: Homer
Feb. 25, 1860, p. 124, 4⅜x3½
F4-S, C50, G88

67 MRS. OTCHESON AT THE PIANO
Mar. 3, 1860, p. 14, 4⅜x3½
Block: Unsigned
F6-S, C52, G90

68 THE BUDS
Block: W. H.
Mar. 3, 1860, p. 141, 4½x3½
F5-S, C51, G89

69 ON THE BEACH
Block: Unsigned
Mar. 10, 1860, p. 157, 4⅜x3½
F7-S, C53, G91

70 THE LADY IN BLACK
Block: H
Mar. 17, 1860, p. 164, 4⅜x3⅜
F8-S, C54, G92

71 MEADOWBROOK PARSONAGE
Mar. 17, 1860, p. 164, 4½x3⅜
F9-S, C55, G93

72 SCENE IN UNION SQUARE, NEW YORK,
ON A MARCH DAY
Block: Homer
Apr. 7, 1860, p. 224, 4¾x6¾
F33, C56, G95

73 THE DRIVE IN THE CENTRAL PARK,
NEW YORK, SEPTEMBER, 1860
Block: W. Homer
Sept. 15, 1860, pp. 584–585, 9½x13¾
F34, C57, G97

74 THANKSGIVING DAY, 1860—THE TWO
GREAT CLASSES OF SOCIETY
Block: W. Homer
Dec. 1, 1860, pp. 760–761, 14x20¼
F35, C58, G100

75 EXPULSION OF NEGROES AND
ABOLITIONISTS FROM TREMONT TEMPLE,
BOSTON, MASSACHUSETTS ON DECEMBER
3, 1860
Dec. 15, 1860, p. 788, 6⅞x9¼
F15-S, G102

1861

Harper's Weekly, Vol. V

76 SEEING THE OLD YEAR OUT
Block: Homer
Jan. 5, 1861, pp. 8–9, 13¾x20¼
F37, C59, G105, L.G.

77 THE INAUGURAL PROCESSION AT
WASHINGTON PASSING THE GATE OF
THE CAPITOL GROUNDS
Mar. 16, 1861, p. 161, 10⅞x9⅛
F39, G108, L.G.

78 THE INAUGURATION OF ABRAHAM
LINCOLN AS PRESIDENT OF THE U.S. AT
THE CAPITOL, WASHINGTON, MARCH 4,
1861
Mar. 16, 1861, pp. 168–169, 13¾x20⅛
Text: "from a drawing made on the
spot"
F41, G110, L.G.

79 THE GREAT MEETING IN UNION SQ.
NEW YORK, TO SUPPORT THE
GOVERNMENT
May 4, 1861, p. 277, 9¼x13⅞
L.G.

80 THE SEVENTY-NINTH REGIMENT
(HIGHLANDERS) NEW YORK STATE
MILITIA
Block: Homer
May 25, 1861, p. 329, 9¼x13⅞
F43, C60, G114

81 THE WAR—MAKING HAVELOCKS FOR
THE VOLUNTEERS
Block: Homer
June 29, 1861, p. 401, 10⅞x9¼
F45, C61, G116

82 CREW OF THE U.S. STEAM-SLOOP
"COLORADO" SHIPPED AT BOSTON,
JUNE, 1861
Block: Homer
July 13, 1861, p. 439, 9¼x13¾
F46, C62, G117

83 FILLING CARTRIDGES AT THE UNITED

STATES ARSENAL, AT WATERTOWN,
MASSACHUSETTS
Block: Homer
July 20, 1861, p. 449, 10⅞x9¼
F20-S, C63, G118

84 A NIGHT RECONNAISANCE
Oct. 26, 1861, p. 673, 6⅞x9¼
L.G.46c

85 THE SONGS OF THE WAR
Block: Homer Del.
Nov. 23, 1861, pp. 744–745, 14x20
F47, C64, G120

86 A BIVOUAC FIRE ON THE POTOMAC
Block: Homer
Dec. 21, 1861, pp. 808–809, 13¾x20¼
F48, C65, G121, L.G.39

87 GREAT FAIR GIVEN AT THE CITY
ASSEMBLY ROOMS, NEW YORK,
DECEMBER, 1861,
IN AID OF THE CITY POOR
Block: W. Homer
Dec. 28, 1861, pp. 824–825, 13⅜x20⅛
F49, C66, G122

1862

Harper's Weekly, Vol. VI

88 CHRISTMAS BOXES IN CAMP—CHRISTMAS,
1861
Block: Homer
Jan. 4, 1862, p. 1, 10⅞x9⅛
F50, C67, G123

89 OUR ARMY BEFORE YORKTOWN,
VIRGINIA—FROM SKETCHES BY MR. A.
R. WAUD AND MR. WINSLOW HOMER
May 3, 1862, pp. 280–281, 13¾x20¾
F52, C68, G125

90 REBELS OUTSIDE THEIR WORKS AT
YORKTOWN RECONNOITRING (sic) WITH
DARK LANTERNS—SKETCHED BY MR.

Winslow Homer
May 17, 1862, p. 308, 10⅞x9¼
F53, C69, G126

91 The Union Cavalry and Artillery
Starting in Pursuit of the Rebels up
the Yorktown Turnpike—Sketched
by Mr. W. Homer
Block: W. H.
May 17, 1862, p. 308, 9¼x13¾
F54, C70, G127

92 Charge of the First Massachusetts
Regiment on a Rebel Rifle Pit Near
Yorktown—Sketched by Mr. W.
Homer
May 17, 1862, p. 309, 9¼x13¾
F55, C71, G128

93 The Army of the Potomac—Our
Outlying Picket in the Woods—
Sketched by Mr. W. Homer
June 7, 1862, p. 359, 6⅞x9¼
F56, C72a, G129

94 News from the War—Drawn by Our
Special Artist, Mr. Winslow Homer
Block: Homer Del.
June 14, 1862, pp. 376–377, 13¼x20¼
F57, C73, G130

Harper's Weekly, Vol. VII

95 The War for the Union, 1862—A
Cavalry Charge
Block: Homer Del.
July 5, 1862, pp. 424–425, 13½x20⅝
F58, C74, G131, L.G.41

96 The Surgeon at Work at the Rear
During an Engagement
Block: Homer
July 12, 1862, p. 436, 9⅛x13¾
F59, C75, G132

97 The War for the Union, 1862—A
Bayonet Charge
Block: Homer
July 12, 1862, pp. 440–441 13⅝x20⅝
F60, C76, G133, L.G.41

98 Our Women and the War
Sept. 6, 1862, pp. 568–569, 13⅝x20⅝
F61, G134, L.G.

99 The Army of the Potomac—A
Sharpshooter on Picket Duty—From
a Painting by Winslow Homer, Esq.
Block: Homer
Nov. 15, 1862, p. 724, 9⅛x13¾
F62, C77, G135, L.G.42

100 Thanksgiving in Camp
Block: Homer
Nov. 29, 1862, p. 764, 9⅛x13¼
F63, C78, G136

1863

101 A Shell in the Rebel Trenches
Block: Homer Del.
Jan. 17, 1863, p. 36, 9⅛x13¾
Text: "a well-aimed shell . . . such as
Mr. Homer has depicted."
F64, C79, G137

102 Winter-Quarters in Camp—The
Inside of a Hut
Jan. 24, 1863, p. 52, 9⅛x13⅞
Text: "Mr. Homer shows us the interior
of a hut."
F65, C80, G138

103 Pay-Day in the Army of the
Potomac—Drawn by Mr. Homer
Block: Homer Del.
Feb. 28, 1863, pp. 136–137, 13⅝x20½
F66, C81, G139

104 Great Sumter Meeting in Union
Square, New York, April 11
Block: Unsigned
Apr. 25, 1863, p. 260, 9⅛x13¾
F22-S, G141, L.G.

105 The Approach of the British Pirate
"Alabama"
Block: Homer Del.
Apr. 25, 1863, p. 268, 13¾x9⅛

F67, C82, G140, L.G.43

106 Home from the War
Block: H
June 13, 1863, p. 381, 9¼x14
F68, C82-1, G142

107 The Russian Ball—In the Supper
Room
Nov. 21, 1863, p. 737, 10¾x9⅛
F69, G143, L.G.

108 The Great Russian Ball at the
Academy of Music, November 5, 1863
Block: Homer
Nov. 21, 1863, pp. 774–775 13⅛x20⅜
F70, C83, G144, L.G.44

1864

Harper's Weekly, Vol. VIII

109 Halt of a Wagon Train
Feb. 6, 1864, pp. 88–89 13⅛x20⅜
F71, C84, G145, L.G.

110 "Anything for Me, If You Please?"
Post-Office of the Brooklyn Fair in
Aid of the Sanitary Commission
Block: Homer
Mar. 5, 1864, p. 156, 13⅝x9⅛
F72, C85, G146

111 Thanksgiving-Day in the Army—
After Dinner—The Wishbone—
Drawn by Winslow Homer
Dec. 3, 1864, p. 780, 9¼x13⅞
F75, C86, G149

1865

Harper's Weekly, Vol. IX

112 Holiday in Camp—Soldiers Playing
"Foot-Ball"—Sketched by Winslow
Homer

July 15, 1865, p. 444, 9¼x13¾
F76, C87, G151

113 Our Watering-Places—The Empty
Sleeve at Newport
Aug. 26, 1865, p. 532, 9¼x13¾
F77, C88, G152

114 Our Watering-Places—Horse-Racing
at Saratoga—Drawn by Winslow
Homer
Aug. 26, 1865, p. 533, 9⅛x13¾
F78, C89, G153

Frank Leslie's Chimney Corner, Vol. I

115 The Cold Embrace—"He Sees the
Rigid Features, the Marble Arms,
the Hands Crossed on the Cold
Bosom"
Block: John Karst Sc.
June 24, 1865, p. 49, 8⅜x6⅝
F30-S, G150
Collection of the Rev. and Mrs.
Frederick Peet Taft

Vol. II

116 Looking at the Eclipse—By Homer
Block: J.P. Davis Sc.
Dec. 16, 1865, p. 37, 10¾x9¼
F31S, C90, G154
Collection of the Rev. and Mrs.
Frederick Peet Taft

Frank Leslie's Illustrated Newspaper, Vol.
XXI

117 Thanksgiving Day—Hanging Up the
Musket
Dec. 23, 1865, p. 216, 14⅛x9⅛
F213, G155
Collection of the Rev. and Mrs.
Frederick Peet Taft

118 Thanksgiving Day—The Church
Porch

Dec. 23, 1865, p. 217, 13⅞x9⅛
F214, G156
Collection of the Rev. and Mrs.
Frederick Peet Taft

1866

Frank Leslie's Illustrated Newspaper, Vol.
XXI

119 OUR NATIONAL WINTER EXERCISE—
SKATING
Block: H
Jan. 13, 1866, pp. 264-265, 14x20½
F215, C91, G157, L.G.45

Our Young Folks, Vol. II

120 THE BRIGHT SIDE
July, 1866, p. 396, 2¾x3⅝
Text: "copied by the artist from the
original painting entitled 'The Bright
Side.' Prepared for Thos. Bailey
Aldrich's article 'Among Our Studios'."
F217, C92, G158

1867

Harper's Weekly, Vol. XI

121 A PARISIAN BALL—DANCING AT THE
MABILLE, PARIS—DRAWN BY WINSLOW
HOMER
Block: W.H.
Nov. 23, 1867, p. 744, 9⅛x13¾
F79, C93, G163, L.G.48
122 A PARISIAN BALL—DANCING AT THE
CASINO—DRAWN BY WINSLOW HOMER
Block: W.H.
Nov. 23, 1867, p. 745, 9⅛x13¾
F80, C94, G164, L.G.49

123 HOMEWARD BOUND—DRAWN BY
WINSLOW HOMER
Block: W.H.
Dec. 21, 1867, pp. 808-809, 13⅞x20⅜
F81, C95, G165, L.G.50

Frank Leslie's Illustrated Newspaper, Vol.
XXIV

124 THE VETERAN IN A NEW FIELD—FROM
A PAINTING BY HOMER
July 13, 1867, p. 268, 4⅛x6¼
Text: ". . . an illustration of Mr.
Homer's excellent . . . picture."
F216, C96, G161
Collection of the Rev. and Mrs.
Frederick Peet Taft

Our Young Folks, Vol. III

125 SWINGING ON A BIRCH TREE—DRAWN
BY WINSLOW HOMER
Block: HW (*sic*)
June, 1867, Frontispiece opp. p. 321,
5⅞x3⅝
F218, C97A, G160, L.G.46
126 THE BIRD-CATCHERS—DRAWN BY
WINSLOW HOMER
Block: W.H.
Aug., 1867, Frontispiece opp. p. 449,
3⅝x5⅞
(also in *Atlantic Almanack,* 1870)
F219, C98a, G162, L.G.47

The Riverside Magazine for Young People,
Vol. I

127 THE MIDNIGHT COAST
Block: John Andrew
Jan. 1867, p. 14, 5½x5⅜
Text: (Illustration assigned to Homer in
index of volume I)
F224, C99a, G159

1868

Harper's Weekly, Vol. XII

128 ART-STUDENTS AND COPYISTS IN THE
LOUVRE GALLERY, PARIS—DRAWN BY
WINSLOW HOMER
Jan. 11, 1868, p. 25, 9x13¾
Text: "One of Mr. Winslow Homer's
studies of art-life in Paris, made during
his late residence in the French capital."
F82, C100, G166, L.G.51

129 "WINTER"—A SKATING SCENE—DRAWN
BY WINSLOW HOMER
Jan. 25, 1868, p. 52, 9x13½
F83, C101, G167, L.G.52

130 ST. VALENTINE'S DAY—THE OLD STORY
IN ALL LANDS—DRAWN BY WINSLOW
HOMER
Block: W.H.
Feb. 22, 1868, p. 124, 13⅝x9
F84, C102, G168

131 THE MORNING WALK—THE YOUNG
LADIES' SCHOOL PROMENADING THE
AVENUE—DRAWN BY WINSLOW HOMER
Block: W.H.
Mar. 28, 1868, p. 201, 9x13⅝
Text: "Our artist has represented one of
the many schools of New York City
passing through Madison Square: Note
the French sign!"
F85, C103, G170

132 FIRE-WORKS ON THE NIGHT OF THE
FOURTH OF JULY—DRAWN BY WINSLOW
HOMER
Block: W.H.
July 11, 1868, p. 445, 9⅛x13¾
F86, C104, G177

133 NEW ENGLAND FACTORY LIFE—"BELL
TIME"—DRAWN BY WINSLOW HOMER
July 25, 1868, p. 472, 8¾x12⅞
Text: "The scene is sketched at
Lawrence, Massachusetts."
F87, C105, G178

134 "OUR NEXT PRESIDENT"—(U.S.
GRANT)—DRAWN BY WINSLOW HOMER
Oct. 31, 1868, cover, p. 689, 9⅛x10⅞
F88, C106, G183

*The Galaxy, An Illustrated Magazine of
Entertaining Reading,* Vol. V

135 "SHE TURNED HER FACE TO THE
WINDOW"—DRAWN BY WINSLOW
HOMER
Block: W.H.–E. Sears Sc.
May, 1868, opp. p. 581, 4⅞x7
F191, C107, G171, L.G.

136 "YOU ARE REALLY PICTURESQUE, MY
LOVE"—DRAWN BY WINSLOW HOMER
Block: WH
June, 1868, opp. p. 719, 4⅝x6⅞
F192, C108, G172, L.G.

Vol. VI

137 JESSIE REMAINED ALONE AT THE
TABLE—DRAWN BY WINSLOW HOMER
Block: WH
July, 1868, opp. p. 68, 4⅞x6⅞
F193, C109, G174, L.G.
Collection of the Rev. and Mrs.
Frederick Peet Taft

138 "ORRIN, MAKE HASTE, I AM
PERISHING!"—DRAWN BY WINSLOW
HOMER
Block: W.H.
Aug., 1868, opp. p. 217, 4⅝x6⅞
F194, C110, G179

139 "I CANNOT! IT WOULD BE A SIN! A
FEARFUL SIN!"—DRAWN BY WINSLOW
HOMER
Sept., 1868, opp. p. 341, 6⅞x4⅞
F195, C111, G181, L.G.

*Harper's Bazar: A Repository of Fashion,
Pleasure, and Instruction,* Vol. I

140 OPENING DAY IN NEW YORK

Block: WH
Mar. 21, 1868, pp. 328–329, 13½x20
Text: "Our artist, Mr. Homer"
 F202, C112, G169, L.G.
Collection of the Rev. and Mrs.
Frederick Peet Taft

141 THE FOURTH OF JULY IN TOMPKINS
 SQUARE, NEW YORK—"THE SOGERS
 ARE COMING!"—DRAWN BY WINSLOW
 HOMER
 Block: WH
 July 11, 1868, p. 588, 8⅛x12¼
 F203, C113, G176, L.G.
 Collection of the Rev. and Mrs.
 Frederick Peet Taft

142 BLUE BEARD TABLEAU (three separate
 blocks:)

 FATIMA ENTERS THE FORBIDDEN CLOSET
 Block: Unsigned
 4⅛x4⅛

 WHAT SHE SEES THERE
 Block: WH
 3⅛x8¼

 DISPOSITION OF THE BODIES (INVISIBLE
 TO THE SPECTATORS)
 Block: WH
 3⅞x4⅛
 Sept. 5, 1868, p. 717
 Text: "That clever artist, Mr. Homer,
 has graphically illustrated a tableau."
 F204, C114, G182

143 OUR MINISTER'S DONATION PARTY
 Block: W.H.d.
 Dec. 19, 1868, p. 952, 9¼x13¾
 F205, G184

Our Young Folks, Vol. IV

144 WATCHING THE CROWS—DRAWN BY
 WINSLOW HOMER
 Block: J.P. Davis, Sc.
 June, 1868, Frontispiece, opp. p. 321,
 5⅞x3⅝

 F220, C115, G173, L.G.53
145 THE STRAWBERRY BED—DRAWN BY
 WINSLOW HOMER
 Block: W.H.
 July, 1868, Frontispiece, opp. p. 385,
 3⅝x5⅝
 F221, C116a, G175, L.G.54
146 GREEN APPLES—DRAWN BY WINSLOW
 HOMER
 Block: W, incomplete H
 Aug., 1868, Frontispiece opp. p. 449,
 5⅞x3⅝
 F222, C117a, G180, L.G.55

1869

Harper's Weekly, Vol. XIII

147 CHRISTMAS BELLES—DRAWN BY
 WINSLOW HOMER
 Jan. 2, 1869, p. 8, 9$\frac{1}{16}$x13⅝
 F89, C118, G186, L.G.56
148 THE NEW YEAR–1869—DRAWN BY
 WINSLOW HOMER
 Block: W.H.
 Jan. 9, 1869, p. 20, 9x13¾
 F90, C119, G187
149 WINTER AT SEA—TAKING IN SAIL OFF
 THE COAST—DRAWN BY WINSLOW
 HOMER
 Block: Homer
 Jan. 16, 1869, p. 40, 8⅞x12⅞
 F91, C120, G188, L.G.58
150 JURORS LISTENING TO COUNSEL,
 SUPREME COURT, NEW CITY HALL, NEW
 YORK—DRAWN BY WINSLOW HOMER
 Feb. 20, 1869, p. 120, 9x13⅝
 Text: "Mr. Homer's characteristic
 drawing"
 F92, C121, G189
151 THE SUMMIT OF MOUNT WASHINGTON—
 DRAWN BY WINSLOW HOMER

Block: WH
July 10, 1869, p. 441, 13¾x9
F93, C122, G194, L.G.59

Appleton's Journal of Literature, Science and Art, Vol. I

152 "All in the Gay and Golden Weather"
Block: W.H.–Langridge Sc.
June 12, 1869, p. 321, cover, 5½x6½
Text: A poem by Alice Cary.
F126, C123A, G191

153 The Artist in the Country—By Winslow Homer
Block: W.H.–J. Karst
June 19, 1869, p. 353, cover, 6¼x6⅝
F127, C124A, G192

154 Summer in the Country
Block: J. Karst
July 10, 1869, p. 465, 4½x6½
Text: "But Mr. Homer, in his sketch."
F128, C125, G193

155 On the Road to Lake George—By Winslow Homer
Block: WH
July 24, 1869, p. 513, cover, 6⅛x6⅝
F129, C126, G195

156 The Last Load
Block: J. Filmer
Aug. 7, 1869, p. 592, 4½x6½
Text: ". . . in Mr. Homer's sketch."
F130, C127, G197

157 The Picnic Excursion—By Winslow Homer
Block: H
Aug. 14, 1869, p. 624, 6½x9⅛
F131, C128, G198, L.G.

Vol. II

158 The Beach at Long Branch
Block: WH–John Karst Sc.

Aug. 21, 1869, folded supplement, 13x9⅜
F132, C129, G199, L.G.60

159 The Fishing Party—By Winslow Homer
Block: John Filmer Sc.
Oct. 2, 1869, folded supplement, 9x13¾
F133, C130, G204, L.G.61

The Galaxy, Vol. VII

160 "Hi! H-o-o-o! He Done Come. Jumboloro Tell You Fust"—Drawn by Winslow Homer.
Block: WH
June, 1869, opp. p. 23, 6⅞x4⅞
Text: A story by J.W. DeForest, *"The Duchesne Estate."*
F196, C131, G190, L.G.

Vol. VIII

161 "Come!"—Drawn by Winslow Homer
Sept., 1869, opp. p. 293, 4¾x6⅞
Text: Nos. 161–164 illustrate Annie Edwards' serial, "Susan Fielding."
F197, C132a, G201

162 "I Call Them My Children—To Myself, Susan"—Drawn by Winslow Homer
Oct., 1869, opp. p. 437, 4½x6⅞
F198, C133a, G203

163 Weary and Dissatisfied with Everything—Drawn by Winslow Homer
Nov., 1869, opp. p. 581, 7x4⅜
F199, C134, G205

164 In Came a Storm of Wind, Rain and Spray—and Portia—Drawn by Winslow Homer
Dec., 1869, opp. p. 725, 6½x4⅜
F200, C135, G207

Harper's Bazar, Vol. II

165 WAITING FOR CALLS ON NEW-YEAR'S
DAY
Jan. 2, 1869, p. 9, 9x13¾
F206, C136, G185, L.G.57

166 WHAT SHALL WE DO NEXT?—DRAWN
BY WINSLOW HOMER
Block: W.H.
July 31, 1869, p. 488, 9⅛x13⅜
F207, C137, G196
Collection of the Rev. and Mrs. Frederick
Peet Taft

167 THE STRAW RIDE
Sept. 25, 1869, p. 620, 9⅛x13⅞
F208, C138, G202
Collection of the Rev. and Mrs.
Frederick Peet Taft.

Hearth and Home, Vol. I

168 AT THE SPRING: SARATOGA
Block: WH–N. Orr Co. Sc.
Aug. 28, 1869, p. 561, cover, 9⅛x8½
F32S, C139, G200, L.G.
Collection of the Rev. and Mrs.
Frederick Peet Taft

Our Young Folks, Vol. V

169 THE PLAYMATES— DRAWN BY WINSLOW
HOMER—FROM WHITTIER'S "BALLADS OF
NEW ENGLAND"
Nov., 1869, opp. p. 760, 3⅝x3⅝
F223, C140, G206

1870

Harper's Weekly, Vol. XIV

170 1860–1870
Block: Homer Del.

Jan. 8, 1870, pp. 24–25, 13x20⅜
F94, C141, G210

171 "TENTH COMMANDMENT"—WINSLOW
HOMER
Block: W.H.
Mar. 12, 1870, p. 161, cover, 10½x9
F95, C142, G211, L.G.62

172 SPRING FARM WORK—GRAFTING—FROM
A DRAWING BY WINSLOW HOMER
Block: W.H.
Apr. 30, 1870, p. 276, 6⅞x9⅛
F96, C143, G213

173 SPRING BLOSSOMS—DRAWN BY WINSLOW
HOMER
Block: WH (twice)
May 21, 1870, 9⅛x13⅞
F97, C144, G214, L.G.63

174 THE DINNER HORN—DRAWN BY
WINSLOW HOMER
Block: WH
June 11, 1870, p. 377, 13¾x9
F98, C145, G215, L.G.64

175 ON THE BLUFF AT LONG BRANCH, AT
THE BATHING HOUR—DRAWN BY
WINSLOW HOMER
Block: WH
Aug. 6, 1870, p. 504, 8⅞x13⅝
F99, C146, G220, L.G.66

Appleton's Journal, Vol. III

176 DANGER AHEAD—BY WINSLOW HOMER
Block: WH
Apr. 30, 1870, p. 477, cover, 6⅛x6½
F134, C147, G212, L.G.

177 A QUIET DAY IN THE WOODS—BY
WINSLOW HOMER
Block: WH–J. Karst
June 25, 1870, p. 701, cover, 6⅛x6½
F135, C148, G216, L.G.

Every Saturday, Vol. I, New Series

178 HIGH TIDE—FROM A PAINTING BY

WINSLOW HOMER
Block: Homer
Aug. 6, 1870, p. 504, 8⅞x11¾
 F179, C149, G218

179 LOW TIDE—FROM A PAINTING BY
WINSLOW HOMER
Block: W.H. Kingdon, Sc.
Aug. 6, 1870, p. 505, 8⅞x11¾
 F180, C150, G219

180 THE ROBIN'S NOTE—BY WINSLOW
HOMER
Block: Homer
Aug. 20, 1870, p. 529, cover, 9x8⅞
 F181, C151, G221

181 CHESTNUTTING—BY WINSLOW HOMER
Block: Homer
Oct. 29, 1870, p. 700, 11¾x8¾
Text:
"The picture by Winslow Homer . . ."
 F182, C152, G223, L.G. 67

182 TRAPPING IN THE ADIRONDACKS—
DRAWN BY WINSLOW HOMER
Block: Homer–J.P. Davis Sc.
Dec. 24, 1870, p. 849, 8⅞x11⅝
 F183, C153, G224

The Galaxy, Vol. IX

183 GEORGE BLAKE'S LETTER—DRAWN BY
WINSLOW HOMER
Block: WH
Jan. 1870, frontispiece 6½x4½
Text: "Illustrating the last installment of
'Susan Fielding.' by Annie Edwards"
(cf. nos. 161–164)
 F201, C154, G208, L.G.

Harper's Bazar, Vol. III

184 ANOTHER YEAR BY THE OLD CLOCK
Block: WH
Jan. 1, 1870, p. 1, cover, 15½x11
 F209, C155, G209
Collection of the Rev. and Mrs.

Frederick Peet Taft

185 THE COOLEST SPOT IN NEW ENGLAND—
SUMMIT OF MOUNT WASHINGTON—
DRAWN BY WINSLOW HOMER
Block: W.H.
July 23, 1870, p. 473, 13¾x9⅛
 F210, C156, G217, L.G.65

186 ON THE BEACH AT LONG BRANCH
Sept. 3, 1870, p. 569, 9x13¾
 F211, L.G.

1871

Every Saturday, Vol. II, New Series

187 A WINTER MORNING—SHOVELLING
OUT—DRAWN BY WINSLOW HOMER
Block: W.H.–G.A. Avery Sc.
Jan. 14, 1871, p. 32, 8⅞x11¾
 F184, C157, G225, L.G.68

188 DEER-STALKING IN THE ADIRONDACKS IN
WINTER—DRAWN BY WINSLOW HOMER
Block: Homer
Jan. 21, 1871, p. 57, 8⅞x11¾
 F185, C158, G226, L.G.69

189 LUMBERING IN WINTER—DRAWN BY
WINSLOW HOMER
Block: J.P. Davis Sc.
Jan. 28, 1871, p. 89, 11⅝x8⅞
 F186, C159, G227, L.G.70

190 CUTTING A FIGURE—DRAWN BY
WINSLOW HOMER
Block: W. Homer–W. H. Morse
Feb. 4, 1871, pp. 116–117, 11¹¹⁄₁₆x18⅝
Text: "Mr. Homer's charming double-
page illustration."
 F187, C160, G228, L.G.71

191 A COUNTRY STORE—GETTING WEIGHED
Block: W.H.–W.J. Linton Sc.
Mar. 25, 1871, p. 272, 8⅞x11⅝
 F188, C161, G229

192 AT SEA—SIGNALLING A PASSING

STEAMER—DRAWN BY WINSLOW HOMER
Apr. 8, 1871, p. 321, 8¾x11⅝
F189, C162, G230

Vol. III, New Series

193 BATHING AT LONG BRANCH "OH, AIN'T
IT COLD"—DRAWN BY WINSLOW HOMER
Block: W.H.–WHM (Probably W.H.
Morse)
Aug. 26, 1871, p. 213, 9⅛x11¾
F190, C163, G231

1872

Harper's Weekly, Vol. XVI

194 MAKING HAY—DRAWN BY WINSLOW
HOMER
July 6, 1872, p. 529, 9⅛x13⅞
Text: "Mr. Winslow Homer's Beautiful
Picture"
F100, C164, G232, L.G.
195 ON THE BEACH—TWO ARE COMPANY,
THREE ARE NONE—DRAWN BY
WINSLOW HOMER
Block: W.H.
Aug. 17, 1872, p. 636, 9⅛x13¾
F101, C165, G233, L.G.72
196 UNDER THE FALLS, CATSKILL
MOUNTAINS—FROM A PAINTING BY
WINSLOW HOMER
Sept. 14, 1872, p. 721, 9⅛x13⅞
F102, C166, G234

1873

Harper's Weekly, Vol. XVII

197 THE WRECK OF THE ATLANTIC—CAST

UP BY THE SEA—DRAWN BY WINSLOW
HOMER
Block: W.H.
Apr. 26, 1873, p. 345, 9⅛x13¾
F103, C167, G235, L.G.73
198 THE NOON RECESS—DRAWN BY
WINSLOW HOMER
Block: WH
June 28, 1873, p. 549, 9⅛x13⅝
F104, C168, G236, L.G.74
199 THE BATHERS—FROM A PICTURE BY
WINSLOW HOMER
Block: Redding, Sc.
Aug. 2, 1873, p. 725, 13¾x9¼
F105, C169, G237, L.G.75
200 THE NOONING—DRAWN BY WINSLOW
HOMER
Block: WH
Aug. 16, 1873, p. 725, 9x13¾
F106, C170, G238, L.G.76
201 SEA-SIDE SKETCHES—A CLAM-BAKE
Block: W. Homer–Redding Sc.
Aug. 23, 1873, p. 740, 9¼x14
F107, C171, G239, L.G.77
202 "SNAP-THE-WHIP"—DRAWN BY
WINSLOW HOMER
Block: Homer 1873 Lagarde Sc.
Sept. 20, 1873, pp. 824–825, 13⁹⁄₁₆x20⅝
Text: "Our illustration is engraved from
the original picture."
F108, C172, G240, L.G.78
203 GLOUCESTER HARBOR—DRAWN BY
WINSLOW HOMER
Block: HW (*sic*)
Sept. 27, 1873, p. 844, 9⅜x14
F109, C173, G241, L.G.79
204 SHIPBUILDING, GLOUCESTER HARBOR—
DRAWN BY WINSLOW HOMER
Block: W.H.
Oct. 11, 1873, p. 900, 9⅜x13¾
F110, C173, G242, L.G.80
205 "DAD'S COMING!"—DRAWN BY WINSLOW
HOMER

Nov. 1, 1873, p. 969, 9¼x13½
 F111, C175, G243,L.G.81

206 THE LAST DAYS OF HARVEST—DRAWN
BY WINSLOW HOMER
Dec. 6, 1873, p. 1092, 9¼x13⅜
 F112, C176, G244, L.G.82

207 THE MORNING BELL—DRAWN BY
WINSLOW HOMER
Dec. 13, 1873, p. 1116, 9⅛x13½
 F113, C177, G245, L.G.83

1874

Harper's Weekly, Vol. XVIII

208 STATION-HOUSE LODGERS—FROM A
DRAWING BY WINSLOW HOMER
Feb. 7, 1874, p. 132, 9⅛x13½
 F114, C178, G246, L.G.84

209 WATCH-TOWER, CORNER OF SPRING AND
VARICK STREETS, NEW YORK—DRAWN
BY WINSLOW HOMER
Feb. 28, 1874, p. 196, 13x9⅛
(a) The Watchman
(b) The Tower
(c) The Bell
(d) Nine O'clock Bell
(e) A Fire
 F115, C179, G247

210 THE CHINESE IN NEW YORK—SCENE IN
A BAXTER STREET CLUB-HOUSE—
DRAWN BY WINSLOW HOMER
Mar. 7, 1874, p. 212, 10⅞x9⅛
 F116, C180, G248

211 NEW YORK CHARITIES—ST. BARNABAS
HOUSE, 304 MULBERRY STREET—
DRAWN BY WINSLOW HOMER
Block: W. H.–Bross
Apr. 18, 1874, p. 336, 9⅛x13⅜
 F117, C181, G249

212 RAID ON A SAND-SWALLOW COLONY—

"HOW MANY EGGS?"—DRAWN BY
WINSLOW HOMER
Block: WH–Lagarde
June 13, 1874, p. 496, 13⅜x9⅛
 F118, C182, G250, L.G.85

213 GATHERING BERRIES—DRAWN BY
WINSLOW HOMER
Block: Lagarde Sc.
July 11, 1874, p. 584, 9⅛x13½
 F119, C183, G251, L.G.86

214 ON THE BEACH AT LONG BRANCH—THE
CHILDREN'S HOUR—DRAWN BY
WINSLOW HOMER
Block: J.L. Langridge Sc.
Aug. 15, 1874, p. 672, 9¼x13⅝
 F120, C184, G252

215 WAITING FOR A BITE—DRAWN BY
WINSLOW HOMER
Block: Lagarde Sc.
Aug. 22, 1874, p. 693, 9⅛x13¾
 F121, C185, G253, L.G.87

216 SEE-SAW—GLOUCESTER,
MASSACHUSETTS—DRAWN BY WINSLOW
HOMER
Block: W.H.
Sept. 12, 1874, p. 757, 9⅛x13¾
 F122, C186, G254, L.G.88

217 FLIRTING ON THE SEASHORE AND ON THE
MEADOW—DRAWN BY WINSLOW HOMER
Block: W.H.
Sept. 19, 1874, p. 780, 9⅛x13½
 F123, C187, G255

218 CAMPING OUT IN THE ADIRONDACK
MOUNTAINS—DRAWN BY WINSLOW
HOMER
Block: W.H.–Lagarde Sc.
Nov. 7, 1874, p. 920, 9⅛x13¾
 F124, C188, G256

1875

Harper's Weekly, Vol. XIX

219 THE BATTLE OF BUNKER HILL—
WATCHING THE FIGHT FROM COPP'S
HILL, IN BOSTON—DRAWN BY WINSLOW
HOMER
Block: W.H.
June 26, 1875, p. 517, 9⅛x13⅝
F125, C189, G257, L.G.89

Harper's Bazar, Vol. VIII

220 THE FAMILY RECORD—DRAWN BY
WINSLOW HOMER, NA.
Aug. 28, 1875, p. 561, 12x8⅛
F212, C190, G258, L.G.
Collection of the Rev. and Mrs.
Frederick Peet Taft

Selected Bibliography

One of the premises of this book is that Homer was able over a fairly long career to follow two obviously different paths, but that the early and later chapters of his life were related. This selected bibliography was composed to reflect that conception. It therefore was made up of books which deal with Homer's life broadly and books which treat the background of American art in his time. However, owing to the major theme dealt with here, a number of studies of wood engraving and the graphic arts, probably more than would normally be included, have been added. Taken together they should provide the reader with a wider view of the subject than can be encompassed in a single volume and a limited subject.

Beam, Philip C. *Winslow Homer*. McGraw-Hill Book Company, New York, London, Toronto, Sydney, 1975.

_____. *Winslow Homer at Prout's Neck*. Little Brown and Company, Boston and Toronto, 1966.

Cowdrey, Mary Bartlett. *Winslow Homer: Illustrator* (catalogue). Smith College Museum of Art, Northampton, Massachusetts, 1951.

Cox, Kenyon. *Winslow Homer*. Privately Printed, New York, 1914.

Downes, William Howe. *The Life and Works of Winslow Homer*. Houghton Mifflin Company, Boston, 1911.

Flexner, James Thomas. *The World of Winslow Homer*. Time, Inc., New York, 1966.

Gardner, Albert Ten Eyck. *Winslow Homer, American Artist: His World and His Work*. Clarkson N. Potter, New York, 1961.

Gelman, Barbara. *The Wood Engravings of Winslow Homer*. Bounty Books and Crown Publishers, Inc., New York, 1969.

Goodrich, Lloyd: *American Watercolor and Winslow Homer*. The Walker Art Center, Minneapolis, 1945.

_____. *Graphic Art of Winslow Homer*. Museum of Graphic Art, New York, 1968.

_____. *Winslow Homer*. The Whitney Museum and the Macmillan Company, New York, 1944.

Green, Samuel. *American Art: A Historical Survey*. Ronald Press, New York, 1966.

Grossman, Julian. *Echo of a Distant Drum: Winslow Homer and the Civil War*. Abrams, New York, 1974.

Hannaway, Patti. *Winslow Homer in the*

Tropics. Westover, Richmond, Virginia, 1973.

Hoopes, Donelson F. *Winslow Homer Watercolors.* Watson-Guptill Publications, New York, 1969.

James, Henry. "On Some Pictures Lately Exhibited." *The Galaxy,* vol. 20, July 1875, pp. 88–97.

Kelsey, Mavis Parrott, M.D. *Winslow Homer Graphics from the Mavis P. and Mary Wilson Kelsey Collection of Winslow Homer Graphics, the Museum of Fine Arts, Houston.* Introduction by David F. Tatham, edited by Katherine S. Howe (catalogue). The Museum of Fine Arts, Houston, Texas, 1977.

McClanathan, Richard. *The American Tradition in the Arts.* Harcourt, Brace and World, Inc., New York, 1968.

McCoubrey, John W. *American Tradition in Painting.* George Braziller, New York, 1963.

Mendelowitz, Daniel. *A History of American Art.* Holt, Rinehart and Winston, Inc., New York, 1970.

Newhall, Beaumont. *The History of Photography from 1839 to the Present Day.* Muse-um of Modern Art, New York, 1964.

Novak, Barbara. *American Painting of the 19th Century.* Frederick A. Praeger, New York, 1969.

Prown, Jules. *American Painting from Its Beginnings to the Armory Show.* Rizzoli International, Geneva, 1969.

Richardson, Edgar Preston. *Painting in America: The Story of 450 Years.* Crowell, New York, 1956.

Ross, John, and Romanov, Clare. *The Complete Printmaker.* Macmillan, New York, 1972.

Sheldon, G. W. *Hours with Art and Artists.* New York, 1882.

West, Richard V. *Language of the Print* (catalogue). Bowdoin College Museum of Art, Brunswick, Maine, 1969.

Williams, Hermann Warner. *The Civil War: The Artists' Record* (catalogue). Corcoran Gallery of Art, Washington, D.C. and the Museum of Fine Arts, Boston, 1961.

Wilmerding, John. *Winslow Homer.* Frederick A. Praeger, New York, 1972.

Zigrosser, Carl. *The Book of Fine Prints.* Crown Publishers, Inc., New York, 1956.

Index

Page numbers in italic refer to illustrations.

Index

Index

Index

Index